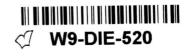

MUSEO
SALVATORE FERRAGAMO

GRETA GARBO

the mystery of style

edited by Stefania Ricci

SKIRA

Cover
Greta Garbo photographed by
Clarence Sinclair Bull in the
film *As You Desire Me*, 1932

Art Director
Studio Contri Toscano

Editing
Anna Albano

Translations
Emily Ligniti

Photographs
Roberto Quagli

First published in Italy
in 2010 by
Skira Editore S.p.A.
Palazzo Casati Stampa
via Torino 61
20123 Milano
Italy
www.skira.net

Printed and bound in Italy.
First edition

ISBN: 978-88-572-0580-9

Distributed in North America
by Rizzoli International
Publications, Inc., 300 Park
Avenue South, New York,
NY 10010, USA.
Distributed elsewhere
in the world by Thames and
Hudson Ltd., 181A High
Holborn, London WC1V
7QX, United Kingdom

This volume has been published on the occasion of the exhibition, promoted and organized by Museo Salvatore Ferragamo, *Greta Garbo. The Mystery of Style* La Triennale di Milano, 28 February – 4 April 2010

Photo Credits

Banca Dati dell'Archivio Storico Foto Locchi Firenze: pp. 37, 38
Black Archives: pp. 26, 31, 105, 106, 119, 145–146, 150
Cecil Beaton Studio Archive at Sotheby's: pp. 39, 143, 148, 212
Contrasto: pp. 20, 27, 42, 51 (top right), 78, 79, 83, 84 (left), 87, 124
Contrasto - Eyedea press: pp. 51 (bottom left), 88, 112, 118
Contrasto - Keystone: pp. 25, 61, 147, 151
Corbis - Bettmann: pp. 22 (left), 32 (left), 43, 51 (top left), 58, 64 (bottom left), 65 (bottom left), 115 (left), 129, 144, 149, 150
Corbis - Condé Nast Archive: pp. 12, 19, 152
Corbis - John Springer Collection: p. 51 (left)
Corbis - Robert Levin: p. 84 (right)
Corbis - Sygma: p. 102
M.G.M. Collection Sunset Boulevard/Corbis: pp. 24 (top), 40, 43 (left), 46 (top left), 59, 86 (right), 95, 102, 103, 109, 113, 127
Gaston Paris / Roger–Viollet: p. 18
Getty Images - Hulton Archive: cover, pp. 8, 28, 29, 34, 44–45, 46, 49, 54–57, 72, 74, 75–77, 80–82, 86 (left), 89, 91, 96–97, 98, 100–101, 103 (top left and bottom right), 104, 108, 111, 115 (right), 116
Getty Images - Popperfoto: pp. 60 (left), 85
Getty Images - Time & Life Picture: p. 65 (top left)
Rex Features: pp. 50, 60 (centre), 90, 107, 117, 130–131
The Kobal Collection: pp. 16, 32, 33, 53, 114, 153
By kind concession of Greta Garbo's family: pp. 21, 23 (left), 30, 36, 40, 60 (right), 63, 64 (top left), 66, 71, 73, 99, 121–123, 125–126, 128, 135
By kind concession of Gary and Manya Drobnack: pp. 62, 65 (top right)
By kind concession of Valentina Schlee Estate: p. 67
©Image courtesy of The Drexel Historic Costume Collection and The Drexel Digital Museum Project http://digmuse.cis.drexel.edu. Photography by Dave Gehosky: p. 134
By kind concession of The Museum at the Fashion Institute of Technology, New York, Gift of Metro-Goldwyn-Mayer, Inc., ©The Museum at FIT: pp. 136, 137 (detail), 138, 139 (left)
By kind concession of Swedish Film Institute: p. 132 (left)
By kind concession of Mr John Lebold Collection: p. 132 (right)
By kind concession of Collections La Cinémathèque française/Jaime Ocampo Rangel: pp.133, 139 (right)

The Museo Salvatore Ferragamo is at the disposal of any copyright holders concerning the iconographic sources which have not been identified.

Acknowledgements

The Museo Salvatore Ferragamo would like to express its sincerest gratitude to the beloved niece of Greta Garbo, Gray Gustafsson Reisfield, to her husband Donald Reisfield and to their family for the love shown in safeguarding the artistic, cultural and historical legacy of Greta Garbo and for having generously placed at disposal this precious legacy so that this project could happen. Special thanks to Craig Reisfield and to Gray Horan who worked assiduously for this exhibition.

Craig Reisfield
Ginette Reisfield
Gray Horan
Richard Horan
Scott Reisfield
Derek Reisfield
Garrett Horan
Trevor Horan
Wyatt Horan
Camille Reisfield
Sophie Reisfield
Harriet Brown and Company, Inc.
Christine Sovich, Sovich Minch, LLP

The authors wish to thank:
Joyce Aimee, Jan-Erik Billinger, Markus Blomfeldt, Charlyne Carrère, Marco Casebasse, Ann Coppinger, Fred Dennis, Sonia Dingilian, Gary and Manya Drobnack, Tod Fischer, Laura Fusi, John LeBold, Lucia Mattolini, Deborah Nadoolman Landis, Michel Romand-Monnier, Michal Rabinowitz, Debbie Raynolds, Clare Sauro, Valerie Steele, Serge Toubiana

Special thanks also to Leith Adams, Kevin Jones, Anna Locori, Kathi Martin, Beth Werling who patiently helped in researching the sources and the film costumes

The exhibition has been realized with the contribution of:
Aon Spa
Arterìa
Epson
Savitransport

CONTENTS

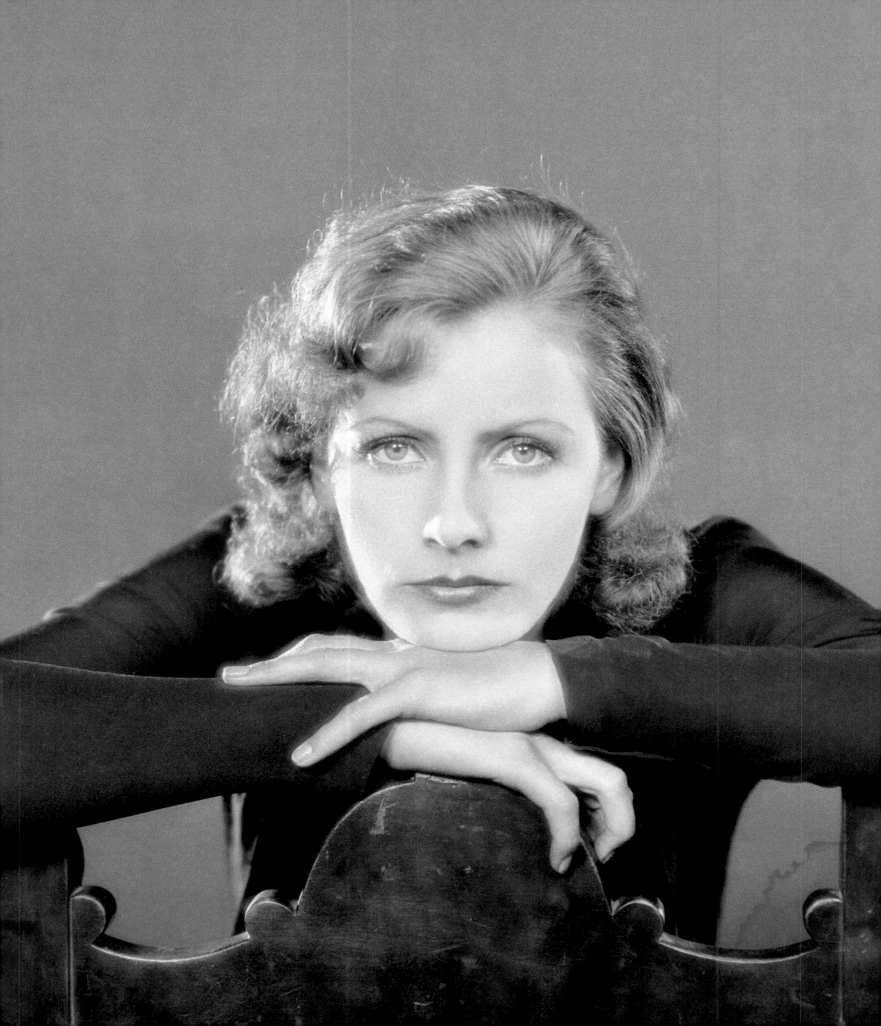

FOREWORD

I n the summer of 2006, Craig Reisfield came to the Museo Salvatore Ferragamo as a tourist with his family. The museum was still located on the second floor of Palazzo Spini Feroni in Florence, the historic headquarters since 1938 of the Salvatore Ferragamo business, before moving to the palace's basement in December of that year, into a vaster area that is directly accessible from the street.

At that time, anyone who crossed the threshold of the museum still had to pass in front of my office. Therefore, it was quite easy for Craig to introduce himself and tell me he was the son of Greta Garbo's niece, the actress's sole heiress.

Our conversation carried on for over an hour, and on that occasion we spoke for the first time of dedicating an exhibition to Greta Garbo, since her heirs, Craig and his siblings, owned her entire wardrobe and personal effects. I spoke about an analogous project of great success, back in 1999 and once again in collaboration with family members, regarding Audrey Hepburn, a legendary customer of Salvatore Ferragamo, just as Greta Garbo had been. That case as well involved a show concentrated on Hepburn's style and not a retrospective. In fact, among the main objectives of a museum tied to a fashion company, as is the Museo Salvatore Ferragamo, there are the conception and organization of events and exhibitions, which, as fashion requires, must be characterized by an innovative subject or, at least, point of view. Audrey Hepburn was a reserved woman and, in respect for her and her children, the Museo Salvatore Ferragamo had no interest in invading her privacy, in narrating anecdotes, in baring her intimate relationships. The actress was presented as a style icon, the woman of true great elegance; we displayed her scene and personal clothing, together for the first time.

Audrey Hepburn was the muse of Givenchy and of many other fashion designers; she was often considered not only an actress but also a model. Her movies, directed by great filmmakers such as Billy Wilder, still appear in film libraries and on TV rather frequently. And, though reaching the height of fame between the 1950s and 1960s, a period that on various occasions influenced the fashion of later years, she still remains a very popular figure.

Things would be different with Greta Garbo. Having belonged to a period of transition between silent films and talkies, Garbo's movies were seldom visible and therefore mostly unknown by the general audience, perhaps with the exception of *Camille*. The type of woman the actress interpreted on the silver screen, the clothes she wore, designed by Gilbert Adrian, belonged to a period that was distant from contemporary models and fashion, even though they were extraordinary.

Greta Garbo photographed by Clarence Sinclair Bull, 1 August 1927

But nonetheless, Greta Garbo has remained a legend, one of the great myths of the twentieth century, as Roland Barthes wrote — perhaps more sophisticated and intellectual than others, but in any event always a myth.

A few months after Greta Garbo's death, in November 1990, when Sotheby's auctioned the paintings, the works of art, the furniture found in her home, an immense crowd rushed to see the exposition, curious to enter the intimacy of a diva who never gave in to the press or her audience. The prices of the works were sky-high, because they had belonged to her, the mysterious, solitary woman.

Moreover, Greta Garbo was a great customer of Ferragamo, among the most esteemed. Salvatore Ferragamo in his autobiography, *Shoemaker of Dreams,* issued in London in 1957, when the actress had been absent from the silver screen for some time, dedicated more space to her than to any other celebrated customer of his. With his incredible ability of understanding the personality of others, Ferragamo offers a description of the woman that is totally different from the one that appeared in newspapers. He defines her as cordial, affable, intelligent. Ferragamo even uses the adjective "delightful". Instead, the photos taken by the paparazzi and the comments of magazines and newspapers made her appear like a crabby person, a recluse, not very keen on nurturing relations. The distance between image and reality could not have been greater.

There was also another aspect that played in favour of an exhibition. How Greta Garbo the woman was a person, more than a mystery, who knew how to separate her profession from her private life, and who, once she had left the roles of the different heroines she had played on-screen, expressed the desire to be left alone and live a normal life; as in her way of dressing there existed an enormous gap between what the actress wore in films and what she preferred far from the cameras. In everyday life, Greta Garbo used quite unconventional clothing even when it was designer, comfortable, practical, well made, with good fabric and few frills, combining, if need be, ordinary outfits with trendy accessories and garments. She possessed an innate confidence of taste and a style based on simplicity that was quite personal, perfect for her and her figure. In the end, her calm style had created a model of refined elegance and a fashion.

It is precisely this everyday clothing — the one kept by her heirs and never placed on display — in addition to her natural understatement, to her reserved personality, joined with a great ability to manage her own image and dealings with the film industry, to distance herself from the world of images that had nonetheless assured her success, which turned her into a figure that is still contemporary. And I would add perfectly in line with the identity of the Ferragamo brand, which, in addition to design innovation and aesthetics, is based on the quality of the workmanship and materials used, on the functionality and comfort of the products.

The reasons were therefore more than valid to carry forth the idea of an exhibition that, after almost four years from that first meeting, has reached its time. The lovely retrospective held one year ago at the Metropolitan of New York and the Museum of the City of New York and dedicated to Valentina, the *couturière* of New York's high society, who beginning in the 1940s was the creator of many clothes that are on display in this exhibition and photographed in this catalogue, along with a general tendency in today's fashion of rediscovering handmade items, minimal clothing, and above all quality accessories, which borrow from men's models laces, flat heels, comfort, have paved the way for this project, which was made possible with the collaboration of many museums and private collections, but above all to Greta Garbo's nieces and nephews, especially Craig and Gray. Thanks to their generous lending, their enthusiasm and personal involvement in making this exhibition a reality, the legend of Greta Garbo is still alive, portending dreams and ideas.

Stefania Ricci
Director, Museo Salvatore Ferragamo

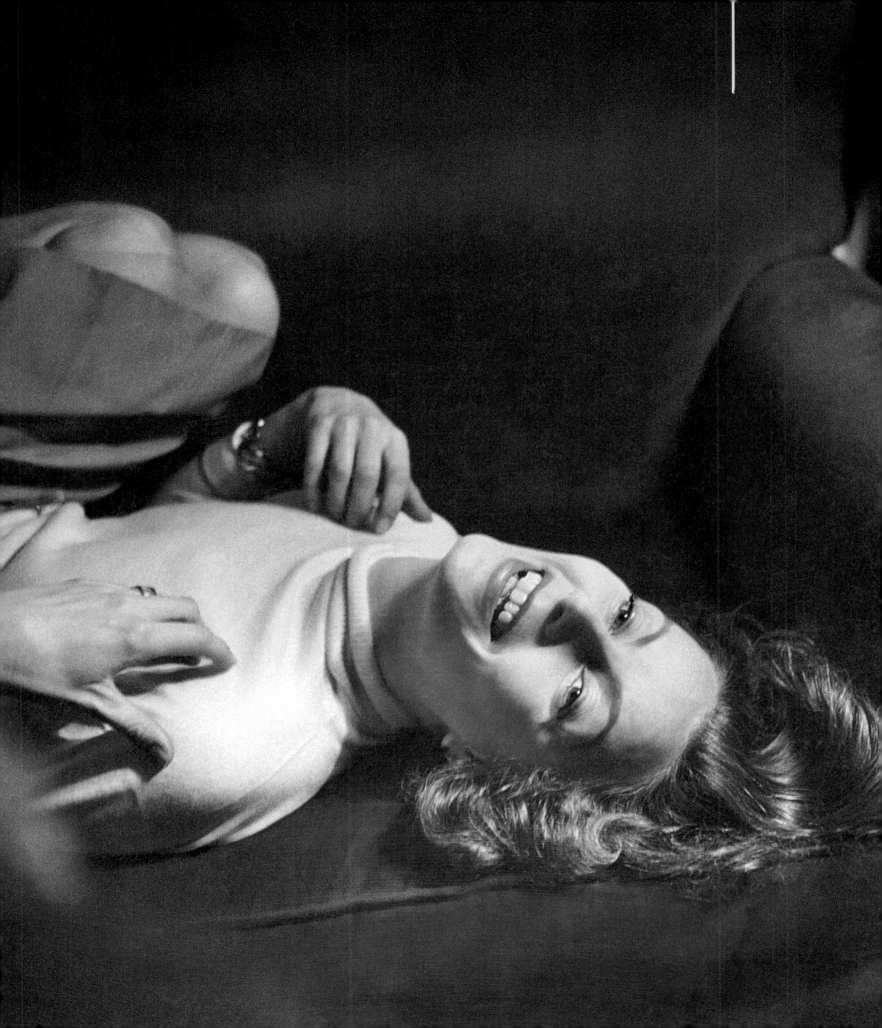

GRAY HORAN
A SENSE OF STYLE: MODERN, TIMELESS AND ELEGANT

Garbo and my mother, Garbo's only niece, arrived at Caneel Bay, a luxurious hotel in the Virgin Islands, for their annual Caribbean vacation. At their beachside villa they would welcome the day with yoga poses. With the morning sunrise, Garbo, with her trademark wide-brimmed straw hat and over-sized sunglasses, took a long walk down the beach and a refreshing swim in the azure blue sea — a sea as magnificently clear and blue as her eyes. Back on the veranda Garbo would look for the native island woman who delivered room service. "Here comes the breakfast hat!," she'd announce watching the old woman balance a huge breakfast tray on top of her head while navigating the narrow path. "Amazing! Not a drop is ever spilled. Anything is possible."

They would feast on yogurt, pineapples and strong coffee with maybe just a *skvätt* (Swedish for *a splash*) of warmed milk. I don't know if Garbo adored anything better than a perfectly ripened pineapple, well perhaps caviar.

Garbo insisted on wearing pants to the hotel's dining room. My mother was a bit concerned that all the ladies would be flaunting their jewels and resort-wear gowns. Unabashed, Garbo made her entrance in drawstring pants, espadrilles and a cashmere turtleneck. Yes, Garbo thought a thin layer of cashmere was just the ticket for a breezy Caribbean evening.

The bejeweled necks of her fellow guests craned to witness the arrival of the famed movie star. It was a startling ensemble, but Garbo's casual chic proved more of an inspiration than a shock. Gowns, high-heels and jewels would no longer rule the dining room, at least not during Garbo's stay. The very next evening there was a complete transformation of the attire worn to the dining room. As was her tendency, Garbo had once again liberated the dress code. Her modernity was infectious. If Garbo could pull it off, well, then other women could at least try.

Garbo infected my fashion sense as well. The most important thing she taught me is that I should dress for myself, just as she always did. She taught me that clothing was wonderful, that quality was essential, and that comfort was important.

"There's nothing attractive about the suffering face of a girl with ill-fitting shoes," she would caution me, grimacing at my fashionable high-heeled boots. Garbo stockpiled custom-made shoes made from the softest leather. She had delicate feet, but she needed her footwear to stand up to her penchant for walking, or "trotting" as she used to say, along miles of city sidewalks and over acres of marble museum gallery floors. She liked to be able to move freely, especially if the sudden appearance of stalking paparazzi required a sudden dash.

New York, April 1946. Photo by Cecil Beaton

At seventeen I took a leave term during the month of January from my all-girls boarding school to intern in New York City. I had one slight problem when I reported to my office, which was located just a few blocks from Garbo's apartment. I could type at lightning speed, but I was woefully under-dressed. My schoolgirl wardrobe was greatly in need of an upgrade.

Garbo came to my rescue. She had some clothes for me. Garbo and I were the exact same size, down to our narrow size 8 feet. Lucky me! On a break from my responsibilities, I walked briskly through the cold to Garbo's apartment.

Garbo had selected six beautiful wool suits, all meticulously sewn and all featuring elegant jackets paired with fashionable skirts. At that point in her life, Garbo wore pants exclusively, so anything in her closet with a skirt was of no interest to her anymore, no matter how costly or classic. The goldmine of couture clothing was thrilling for me. I could now turn out appropriately dressed for any occasion my job required. When my office handled the New York visit of His Royal Highness, Prince Phillip, the husband of the Queen of England, on behalf of The World Wildlife Fund, I escorted the press corps into the theatre of Lincoln Center wearing Garbo's charcoal grey Givenchy suit.

Before heading off with my windfall of clothing, Garbo suggested we had time for a coffee party, a Swedish tradition that calls for coffee and a cardamom-flavored pastry that is absolutely the best thing to enjoy on a cold winter morning.

We drank our coffee in her warm living room that looked out over the East River and the United Nations tower. The sumptuous wood-paneled walls were stacked high with Garbo's collection of Renoirs and other colorful French Impressionist and German Expressionist paintings.

I showed Garbo an article, *10 Different Ways to Wear The Same Scarf,* from a fashion magazine that I had in my purse. It featured a model wearing a scarf as a turban, a sarong, a shawl and about three or four different halter-top-like configurations — each with detailed instructions for the folding and knotting required. Garbo loved it and immediately went to her scarf drawers so that we could try to copy the techniques in the magazine and maybe even invent a few ourselves.

Not everyone has a set of drawers devoted specifically to scarves, but Garbo did. She collected scarves in all shapes and sizes and fabric materials. She kept them meticulously folded and layered according to hue; with pinks and corals creating the highest piles.

Garbo's customary ensemble would include a little chiffon silk scarf tied around her neck with a tidy knot; a simple touch of elegance as well as a bit of calculated softness near her face.

Garbo returned from her scarf drawers with a large scarf. It was red and gold with equestrian-themed images. She and I knotted and folded and figured out how to do many things with that one scarf. Garbo found it tremendously amusing to be inventive. Just that square piece of silk could keep her imagination engaged for quite some time. Not only did I take away a bag full of fabulous clothing on that morning. I took away an important lesson.

"You see, a square piece of cloth is not merely a scarf," Garbo announced. "It is a possibility."

Garbo always saw the possibilities. I believe that was the essence of her beauty; inside and out. Then, Garbo gave me another gift; the scarf. To this day, it reminds me that every little thing is filled with possibility, and it reminds me of my beautiful and elegant great aunt, Greta Garbo.

STEFANIA RICCI
GRETA GARBO: THE MYSTERY OF STYLE

"I promise to continue shining over everything in the future as well." Greta Garbo

n film history, Greta Garbo is a legend. Hers is one of the most famous faces of the twenti-eth century. Her sensuality, her voice, her style and her class disturbed the sleep of an entire generation of men and women, who would have wanted to seduce her or be just like her. A few years after Greta Garbo had arrived in Hollywood in the mid-1920s, many cinema and theatre actresses changed their make-up, hairstyle, wardrobe and ways of posing in front of the camera in order to attempt to appear like the Swedish actress; one of these was Marlene Dietrich, who initiated a true rivalry. Even the independent Katharine Hepburn, some years later, would confess to having been infected by the Garbo myth and having tried to resemble her.

But actresses were not the only ones subject to Greta Garbo's influence; there were also or-dinary women and the models in shops who attempted to emulate her way of walking, her pale face with big eyes veiled behind long eyelashes and marked eyelids, her enigmatic — barely im-perceptible — smile, straight pageboy hairstyle, the refined and never vulgar eroticism, her nat-ural elegance. Even the mannequins in shop windows in New York, London and Paris had her features. Immediately after her films were released, her scene outfits caused quite a stir, even among Parisian *couturiers*, from Chanel to Balenciaga. The inspirations sold like hot cakes in the commercial versions found in American department stores, including those in period films, such as *Queen Christina* and *Camille*; the former ushered in the fashion of heavy velvet jackets with ala-mar eyelets and broad white linen collars; the latter, romantic hats and wide hoop skirts. It was-n't the outfit in itself that drew attention but rather the illusion that every woman, by wearing it, could transform herself into a copy of the "Divine".[1]

Hollywood understood that this Swedish actress represented a new type of beauty able to in-terpret the modern woman, more evolved with respect to the feminine model it had previously presented upon the silver screen – an emancipated woman who in the art of seduction could stand on equal footing with men. In Greta Garbo, the outside appearance — so intriguing and perfectly in line with this new feminine model — was the result of an uncommon combination of a perfect, innocent, almost angelical and rather photogenic face above an athletic, tomboyish body with broad shoulders and a long stride, like an animal.

Mauritz Stiller, the brilliant Swedish director, was the first to intuit the potentials of the very young and still awkward Greta Louise Gustafsson, when he encountered her in 1923 in Stockholm. At that time Greta was only eighteen (she was born on 18 September 1905). She

A portrait of Greta Garbo taken by Arthur Genthe in the summer of 1925

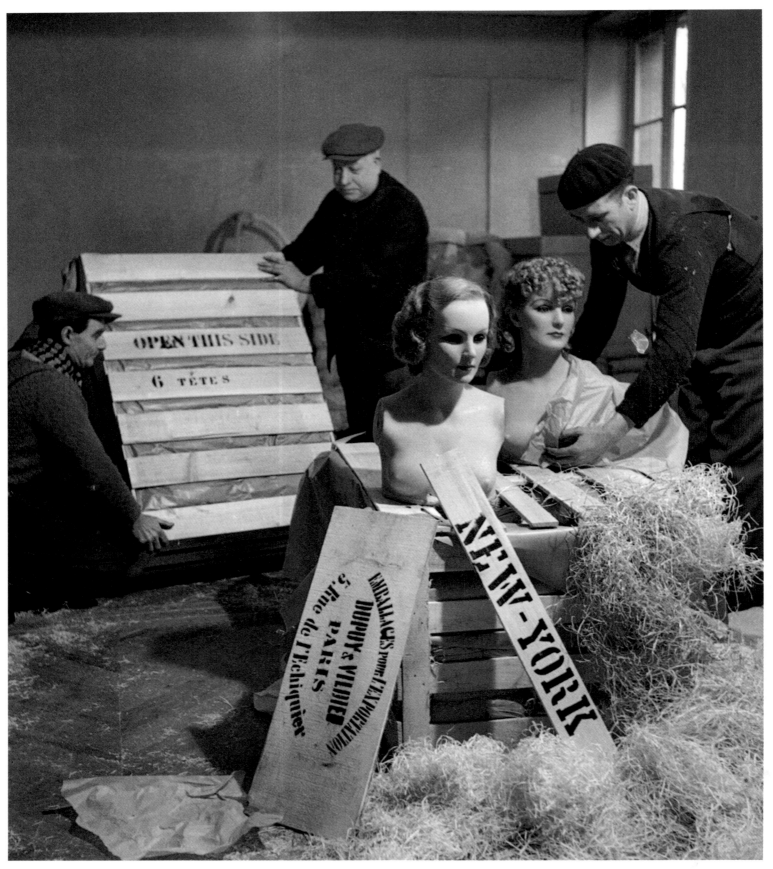

Wax mannequins shipped in 1936 from France to the United States reproducing the faces of Marlene Dietrich and Greta Garbo. Towards the late 1920s, all the Hollywood studios were searching for their own Greta Garbo. Upon her arrival from Berlin in 1930, Marlene Dietrich was proposed by Paramount as the Swedish actress's rival. Photo Gaston Paris/Roger-Viollet, 1936 circa

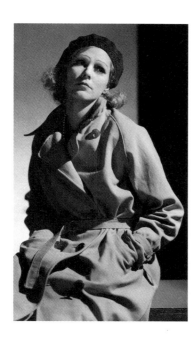

had little schooling and did not know how to act, even though since she had been a child she had shown a great passion for theatre and cinema. Born into a very poor family, the youngest of three siblings, at fourteen she was forced to leave school, and in 1920, after the death of her father, she had to find an occupation, first as an assistant in various barber shops and then as a clerk in the hat section of Stockholm's PUB department stores. For this task, she lent her face to advertising the seasonal hat collection, and had her first experiences on the set of some short films commissioned by the department store to publicize their products.

In the summer of 1922 the director Erik Petschler entered the hat department to purchase accessories for his upcoming film. The encounter allowed Greta to obtain a small part in the director's new film and the opportunity to pass the entrance exam for acting classes at the Royal Dramatic Theatre Academy. After a few months of study, the great opportunity arrived. Greta was sent to try-out for the two leading roles in Stiller's new film, *The Saga of Gösta Berling*, based upon a text by Selma Lagerlöf, the writer and pride of Sweden.[2]

The debutante was chosen by the director, who loved using amateur actors, taken from the street. Greta would play the Countess Elisabeth Dohna, and from that moment on she would take the stage name Garbo, which Stiller chose for her. "Technically," Stiller seems to have said, "she's still not mature, but the screen reflects a face like hers once every hundred years."[3]

Fascinated by the young woman, Stiller embarked upon a veritable transformation. He imposed a diet, taught her how to walk, to talk, to move, to act. He purchased elegant clothes and accessories for her. His goal was to make her become the greatest actress of all time.

From 1923 to 1928 the lives of Greta and Stiller were inextricably bound, so much so there was talk of a relationship between them. Greta Garbo would later admit, in one of her rare interviews, that her relationship with Stiller was much more than a simple relationship, since she had placed her fate into his hands. Stiller was her Pygmalion; he even negotiated the actress's cachet in the film by the director Georg Wilhelm Pabst, who, having seen Greta Garbo in the German version of *The Saga of Gösta Berling*, wanted her at all costs to interpret his new film, *Die freudlose Gasse*.

When Louis B. Mayer, the absolute ruler of Metro Goldwyn Mayer, the famous American film production house, arrived in Europe in search of new talent for American cinema, he proposed to Stiller to go to Hollywood; the director imposed his protégé as well, with a contract of 400 dollars a week, which was an enormous amount at that time. In fact, earning 75 dollars a week for an actress like Joan Crawford seemed like a considerable sum.

In the summer of 1925, upon her arrival in New York, Greta Garbo was photographed, as

Mrs Robert L. Stevens dressed like Greta Garbo at the masked ball in the Ritz Crystal Room, Paris, 9 December 1929

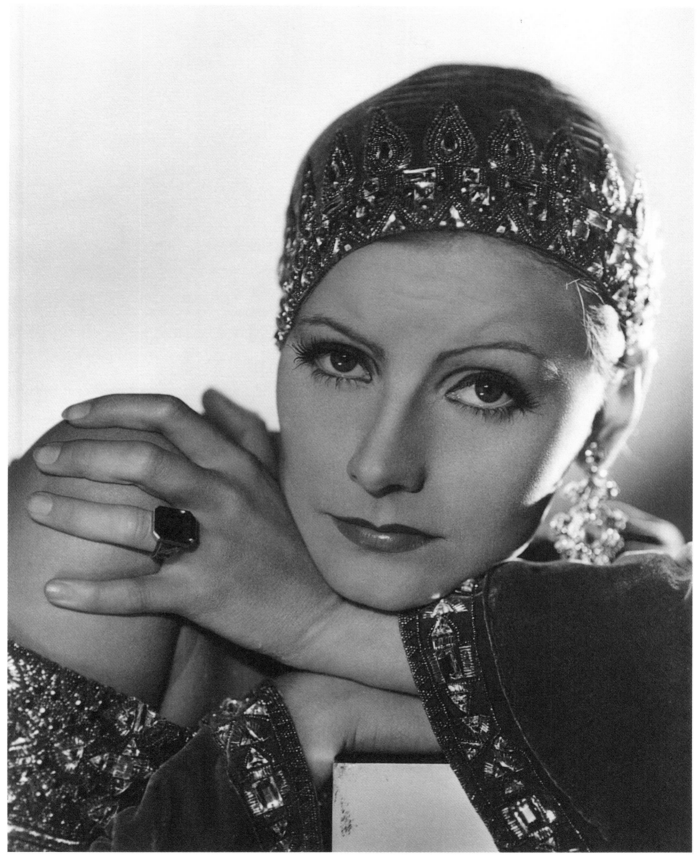

Greta Garbo in *Mata Hari*, 1931, and, on the left, Marlene Dietrich in *Shanghai Express*, 1932. Photo by Clarence Sinclair Bull and R. R. Richee, where the attempt of the German actress to imitate Garbo is evident

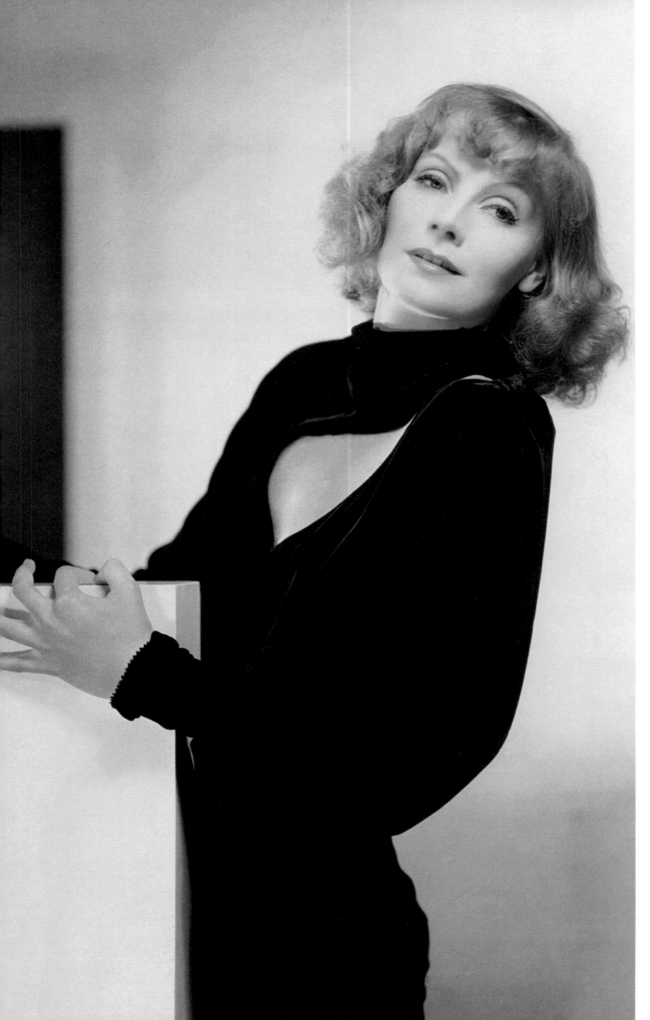

The debutante Whitney Bourne in a Hamlet-style high-necked outfit inspired by Greta Garbo's style in *Susan Lenox Her Fall and Rise* in *Vogue* (*USA*), 15 October 1933

Greta Garbo portrayed by Clarence Sinclair Bull, 1931

Greta Garbo in *As You Desire Me*.
Photo Clarence Sinclair Bull, 1932

Inspirations of collars and sleeves from
the clothes Greta Garbo wore in the film
As You Desire Me, 1932. In *Vogue's
Advance Trade Edition* (USA), 15 December
1933

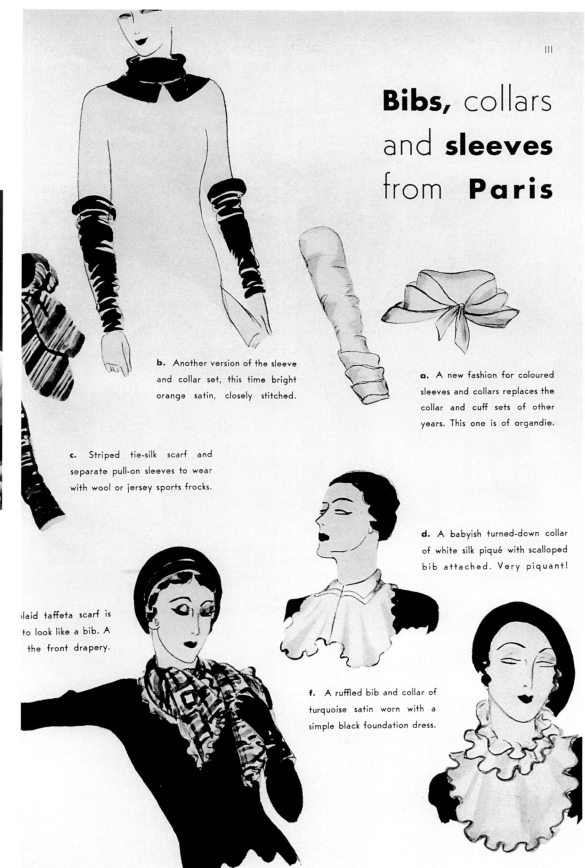

III

Bibs, collars and **sleeves** from **Paris**

b. Another version of the sleeve and collar set, this time bright orange satin, closely stitched.

a. A new fashion for coloured sleeves and collars replaces the collar and cuff sets of other years. This one is of organdie.

c. Striped tie-silk scarf and separate pull-on sleeves to wear with wool or jersey sports frocks.

d. A babyish turned-down collar of white silk piqué with scalloped bib attached. Very piquant!

plaid taffeta scarf is to look like a bib. A the front drapery.

f. A ruffled bib and collar of turquoise satin worn with a simple black foundation dress.

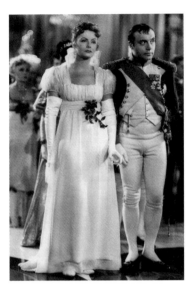

was the procedure, by Russell Ball, the photographer of MGM, and by the freelance Arthur Genthe. In fact, Genthe's photos, published in *Vanity Fair*, focussing only on close-ups of the actress with the almost absolute absence of a background and minimal reference to clothes, portray Garbo in an intense, very dramatic way, which placed the Swedish actress on a par with Eleonora Duse and Sarah Bernhardt. This convinced Mayer he had spent his money wisely.[4]

From that moment, Metro Goldwyn Mayer, which produced Greta Garbo's twenty-two American films and created the first two on behalf of Cosmopolitan, William Randolph Hearst's production house, used every means available to establish the Garbo myth. The ad photos entrusted to great photographers and distributed to fans and magazines of the age, the movie scripts where Greta Garbo had to, unwillingly, interpret almost always the *femme fatale* or heroine destined to an unhappy ending, with clothes created by legendary costume designers, heightened the personality of the character and cancelled out all actresses who had come before, thus putting into motion a complex mechanism that determined not only box office success but also influenced the fashion and behaviour of the period.[5]

Greta Garbo was not however an ad stunt on the part of the film industry; in the same way, she was not completely a creation of Adrian in her style. There is no doubt that Greta Garbo's charm was in part determined by the striking clothes she wore on the set. When in 1929 Adolph Greenberg (Adrian) became the costume designer for her films, he began a collaboration that was not only professional and based on trust, but also on friendship. Having abandoned all frills, Garbo's style became simpler as well as more sober and linear. Adrian greatly simplified the cut of the clothing, in such a way as to avoid distracting attention from the actress and to heighten the drama of the character she interpreted or the exotic charm. It is clear, however, that Greta Garbo acted upon the costume designer's choices. Unlike the majority of Hollywood actresses, her way of dressing off screen was not an extension of the model she represented on screen. Greta Garbo adored clothing that was minimal, comfortable and practical, very sporty, which borrowed items and accessories from men's fashion. She purchased her clothes at the military emporium in Los Angeles; she ordered pants suits from the tailor Watson, who had been suggested to her by her friend Mercedes de Acosta, the dramaturge famous for her elegance and anti-conformism. Her shoes were made to measure in the Hollywood Boot Shop, by Salvatore Ferragamo, the famous Italian shoemaker, who united the model's aesthetics with a great comfort fit.

Seeing Ferragamo was celebrated for his woman's high-heeled shoes, for Garbo he created models inspired by men's footwear, laced and flat.[6]

The Empire-style in *Conquest* influences fashion. Photo William Grimes, 1937 | In *Vogue (USA)*, 1 September 1938

In films like *The Single Standard* or *Anna Christie* and in historical subjects like *Queen Christina*, Adrian's costumes reflected the everyday clothing she wore and established the fashion of the lined tweed trench coat, cloche style hat which hid the face, men's classic white shirt, flat shoes, men's trousers, thus influencing her female public more than *couturiers* like Chanel and Patou who had created the style.

It has often been said about her that she was not an elegant woman, since, after her encounter in 1939 with Valentina, the legendary New York *couturière*, favoured by the health guru and dietician Gaylor Hauser, her way of dressing grew more selective and colourful. She was not a fashion victim, and she did not follow the conventional rules of fashion. She did not even follow them after she retired in 1941. "She could allow herself this," Irene Brin wrote in 1944, the

Greta Garbo (second from the left) at the start of her career in the film by Erik A. Petschler, *Luffar-Petter* (*Peter The Tramp*), 1922

fashion and social mores expert, "she was the only one authorized to wear cable shoes, short hair, inexpensive shirts . . . as Balzac once said, simplicity is a luxury reserved to persons very rich in money or sentiment."[7]

"Greta Garbo has the instinct of what suits her," added Cecil Beaton, the photographer of the royal families and her close acquaintance during the 1950s, "and she possesses an innate confidence of taste that makes her able to assess a lovely dress and also appreciate it."[8] The proof lies in her wardrobe, which is a combination of ordinary and designer clothes by Christian Dior, Givenchy, Emilio Pucci and especially Valentina, her friend in the 1940s and later enemy when her husband George Schlee began to accompany Garbo during her travels, on holiday, around the New York scene.

Thanks to her personality, Greta Garbo was able to set a tone for the period. And this is the personality that makes her contemporary. It was the personality she displayed on the screen and reflected in her characters. It is she — Greta Garbo — who had the upper hand by remaining loyal to herself. It is her anti-conformism shown in her open dissent concerning the Hollywood system, contesting the demands of the production house to impose a lifestyle in line with the characters portrayed, as was the case with the majority of film stars, totally absorbed in the role of the diva at every moment of the day. Greta Garbo, professional and ready to give all of herself on screen — she was the first to arrive every day on the set — separated the actress from the woman. She began avoiding ad photos that were not aimed at the release of her films; she turned down posing for fashion shoots. She released few interviews and was amazed that people were interested in the story of her life. "We all do the same things," she said, "we are born, we go to school, we learn, we walk."

She showed great ability in being an excellent manager for herself, threatening to break her contract with MGM, after the success of *Flesh and the Devil* in 1927. The contestation initially derived from the fact that she was tired with being assigned frivolous roles that degraded women; subsequently, she demanded attention for her own acting requests which she wanted similar to her male colleagues. And the outcome of negotiations that went on for months: she became the highest-paid diva in Hollywood, a millionaire at only twenty-six.

She led a solitary, very healthy lifestyle. Off screen, she slept, swam a great deal, loved to walk, associated with few people and did not attend parties, protecting at all costs her privacy even though she could not avoid gossip born from her relationship with Gilbert, who fell in love with her during the shooting of *Flesh and the Devil* and wanted to marry her, and subsequently with her ambiguous relationship with the scriptwriter Mercedes de Acosta, who became obsessed with her.

Greta Garbo playing Elisabeth Dohna in Mauritz Stiller's film, *The Saga of Gösta Berling*, 1924

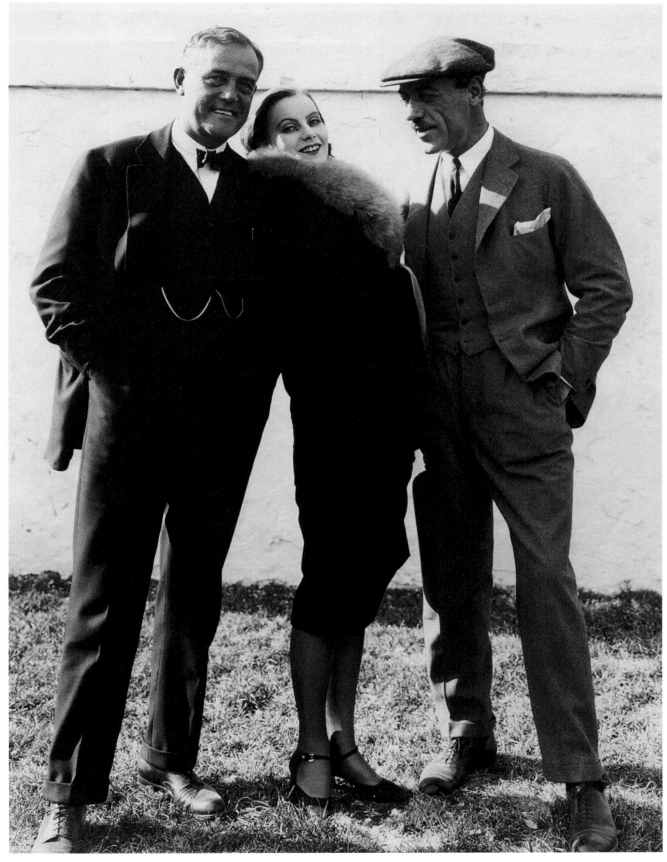

From left to right: Victor Sjöström, Greta Garbo and Mauritz Stiller in December 1925 photographed in Los Angeles by Ruth Harriet Louise

Under many aspects, Greta Garbo was a modern, twentieth-century woman. She refused to give in to the female stereotypes imposed by the most important film studios and by society. She lived her life exactly the way she felt like. She was a feminist even before feminism.

Her denying others — even her public — anything about herself, if not onscreen, nurtured around her an aura of mystery, which eluded and obsessed. A mystery that intensified at the moment she decided to leave the screen at only thirty-six after lukewarm reactions to the film *Two-faced Woman*. The film's minimal success, however, does not seem to justify such a drastic withdrawal, even though on other occasions the actress had shown, for her intolerance towards the world of Hollywood, her desire to leave the film industry. She could allow herself this, having earned what no other woman before her had even dreamed of.

The epoch change, the outlining of a new type of more domestic woman, may be another reason that explains her decision to leave the cinema, just as the truth may have been her fear of not measuring up to her legend anymore. Therefore her decision to leave the silver screen became a convenient solution for a happy ending and for keeping intact in the collective imaginary that which would have necessarily been destined to fall apart.

The ad photos intended to spread the image of Greta Garbo in Hollywood portrayed her as sporty or a fashion model. Photo Don Gillum

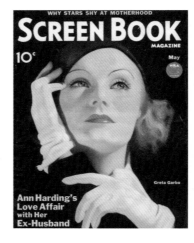

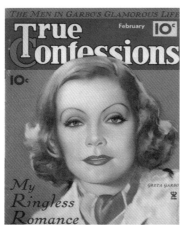

Not even today, despite writings and biographies about her, do we know the actual reason behind certain choices or who the real Greta Garbo was. What for some might have seemed haughtiness, an inability to relate to people or eccentricity, for others this was interpreted as shyness, typically Nordic discretion, determination in being left alone, desire to stay by herself, refusal to pose for the camera.

Greta Garbo — the mysterious — demanded to live a normal life, as if the Hollywood years had never existed. But the audience and the press still wanted the diva, and so they followed her. Paparazzi from around the world attempted to capture an image of hers – alone, with friends, with a new lover – upon which to build a story. The media announced her comeback at various times

The magazine covers of the period dedicated to Greta Garbo

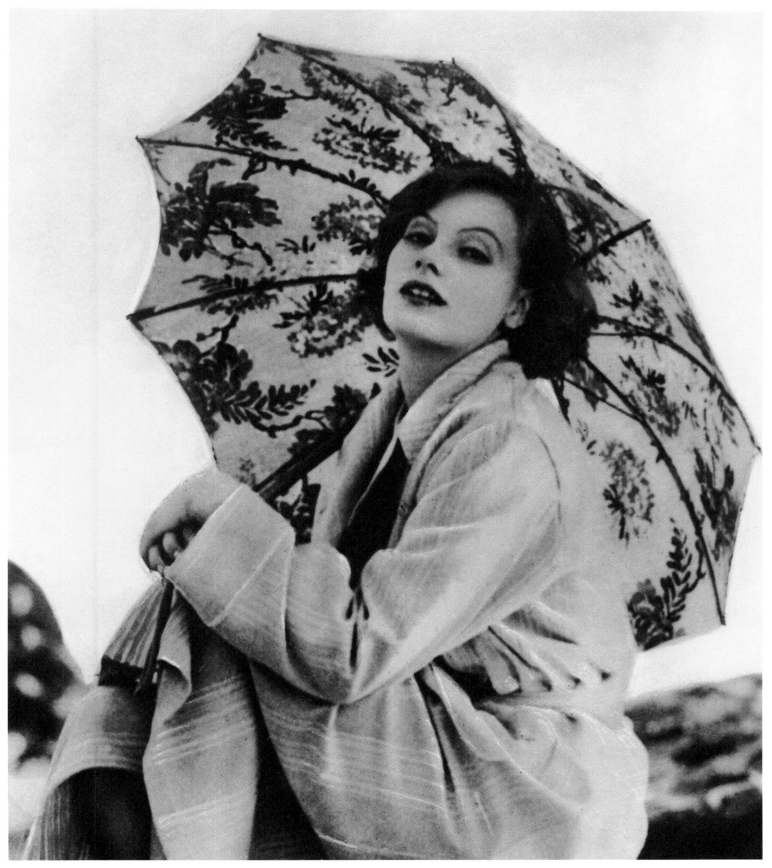

Even in fashion photos the combination between the femininity of the pose and the masculine style of her clothing is stressed. Here she is on the beach in Los Angeles with a parasol, coat and shirt with tie

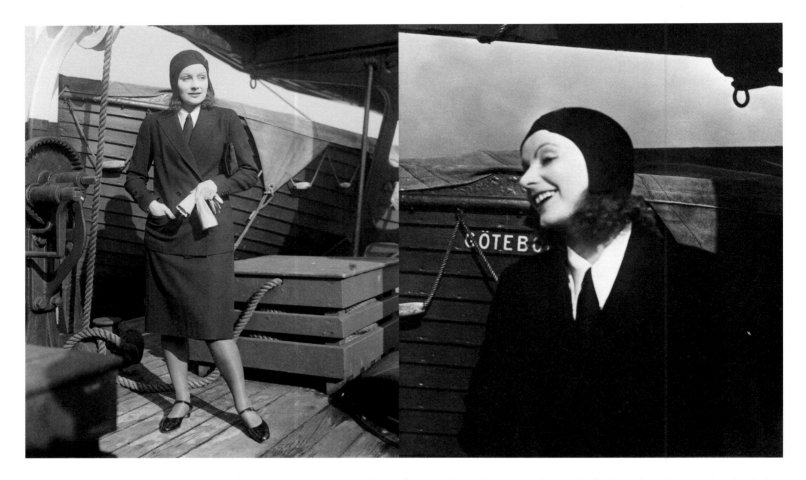

without however an actual confirmation on her part. Greta eluded, took refuge under the brim of her hats, concealed her gaze behind her ever-present sunglasses.

Today, the mystery has not been revealed, and it takes on new meaning. The woman's contemporaneity lies precisely in her living apart, in her understatement, in the absence of presence, in her desire to say nothing if nothing needed to be said, in having remained herself, unadulterated by success. Upon the screen she appeared enigmatic, aloof, almost unearthly, but in her private life, according to her life-long friends and her family, she was a person open to others, affable, with a sense of humour, amusing.

In 1949, Salvatore Ferragamo, who had encountered her during her Hollywood days, met her once again, when on a trip to Italy Greta Garbo came to Florence and ordered seventy pairs

Greta Garbo photographed on the ship *Drottingholm* returning to the United States in 1929 from holidays in Sweden and wearing decidedly masculine clothing which also inspired Adrian's style for costumes in some films | Greta Garbo in *Wild Orchids*, 1929. Photo James Manatt

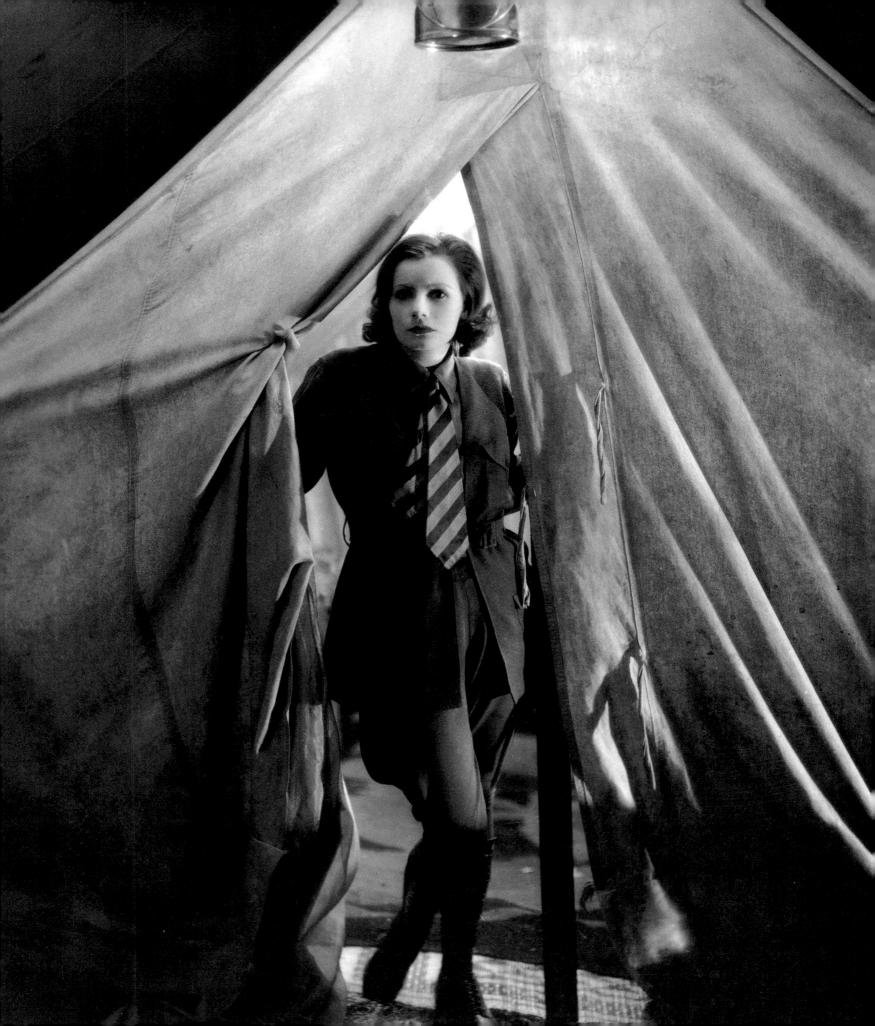

of shoes from her trusted shoemaker. They were summer and winter models, united by their simplicity and comfortable fit. Ferragamo narrates this moment in his autobiography, issued a few years later, and lingers not upon the great actress of Hollywood, but rather on the woman herself, thus painting a picture of Garbo that was quite similar to her everyday life and not the one created by the press of those years.

"I cannot pass Greta Garbo with only a sidelong glance. She is incomparable, the greatest actress the screen has ever seen. She ranks in my estimation with Cecil B. de Mille as a director and Charles Chaplin as a clown.

Greta Garbo arrived in Hollywood not long before I left it for Florence, but I made her first shoes in the film city. Later she bought my shoes as long as the Hollywood Boot Shop remained in my ownership and afterwards from wherever she could obtain them, including Saks Fifth Avenue in New York.

Then one day in August 1949 I saw her again. She walked into my salon in Florence, looking not a day older than when I first met her, wearing a pair of worn, rope soled sandals. 'I have no shoes', she said. 'I want to walk.' In five sessions I created for her a series of low-heeled, closed-toe styles which included 'Zita', a black afternoon suede pump with a grated vamp; 'Greta', also suede, with seamless uppers, a discreet buckle, and a soft dimple toe; and an ankle-strap sandal in wine-red calf that she particularly adored. As she paced the floor of the salon in the first pair she smiled at me as she smiled in *Ninotchka*, and her exclamations of pleasure were more than I expected. Altogether she ordered seventy pairs, mostly differing only in colour.

As a woman Greta Garbo is charming, affable, intelligent — and knows exactly what she wants. In fact, our only difference of opinion occurred when I wanted to give her a heel, following up her arch in my own style, and she refused. She is the only person who has ever opposed my ideas. She has beautiful feet, and I imagine that her preference for low-heeled shoes reflects an intense desire to preserve her feet against any possible damage. In my shoes she does not need to worry. I did manage to give her a little heel — not as much as I would have liked but more than she wanted — and later, when I saw moving pictures of her, they convinced me that I was right. She walks beautifully on a small heel, and it shows off her ankles to perfection. Her temperament is truly aristocratic. I have never seen her in a bad temper and never expect to. I can tell from the reaction in her feet. There is none at all: the sure sign of an equable, assured personality. For instance, as we left the salon at the conclusion of her visit crowds surged forward around her car and cameramen rushed to take pictures. I was annoyed at the intrusion, but not

Seamstresses at work at MGM as they create the outfits for *Camille*, designed by Adrian, 1 January 1936

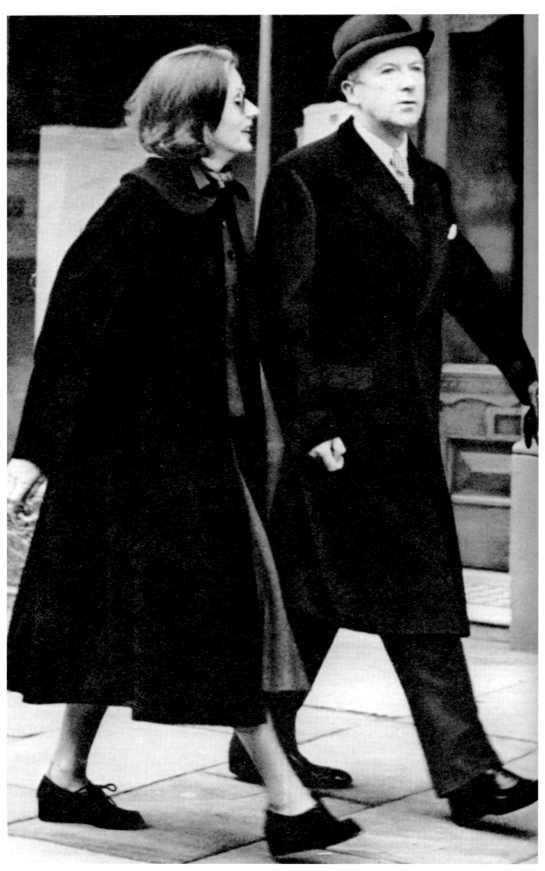

Greta Garbo strolling with Cecil Beaton on 17 November 1951 in London. She is wearing her favourite Ferragamo shoes. Photo Harold Clements

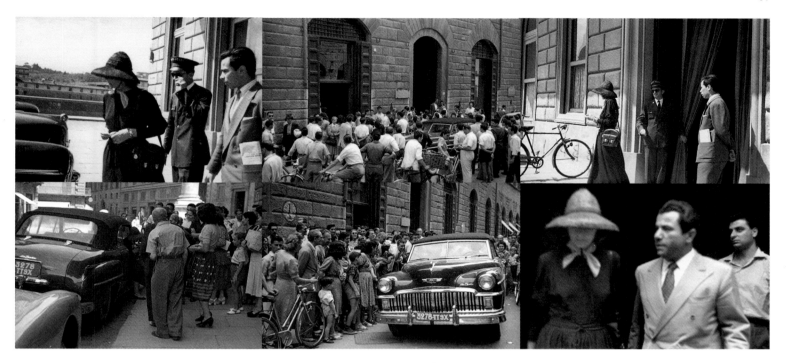

Miss Garbo. She is a princess at heart. She merely bent her head to indicate that she did not desire to be photographed and climbed into her car.

As an artist she is consummate. She has been endowed by Nature with a degree of acting quality which others do not possess, and she worked without cessation to transform it into a medium which satisfied her own standards. When she is acting she possesses the film through and through; the film is her, her life, her personality. I know little about her preparation for the camera, but I believe that whereas others spend days and perhaps weeks on it she spends all her free time for months beforehand.

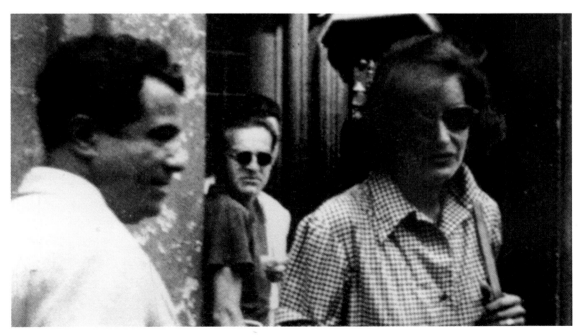

Greta Garbo in the summer of 1949 in Florence as she orders shoes from Salvatore Ferragamo | Greta Garbo in 1949 at Ferragamo during her stay in Florence. Photo Locchi

Why has she apparently abandoned the screen? I do not know. It is certainly not for lack of offers. While she was in Italy I was approached by an Italian film company which authorized me to offer her £150,000 for one film, plus all the rights a star of her magnitude can command. Later, through the same source, I learned that in Paris she had turned down a similar offer which went up to £200,000 for one picture. If I have to essay an opinion on her long screen absence it is this: whatever Greta Garbo accepts to do she must do it with all her might. She is incapable of walking before the cameras for a fabulous sum and giving only a part of herself. I read once that she sits through her pictures again and again and her passionate desire for perfection in her art causes her physical anguish at every mistake she can detect; such agony that it is easier not to endure it all again. It may be right; it fits into the character of Greta Garbo as I have seen her.

I know this too: if ever again she consents to appear on the screen," Ferragamo concludes, "she will draw the greatest audiences the cinema has ever known and she will draw them irrespective of the picture. She will draw them by the power and strength of her own personality."[9]

As is also the case today.

[1] Sofia Gnoli, *Moda e cinema. La magia dell'abito sul grande schermo*, Città di Castello: Edimond, 2002, p. 32.

[2] John Bainbridge, *Garbo*, New York, Chicago, San Francisco: Holt, Rinehart and Winston, 1955, pp. 32–34.

[3] Jean Lacouture, *Divina. Il racconto della vita di Greta Garbo*, Rome: e/o, 2005, p. 19.

[4] Robert Dance, Bruce Robertson, *Ruth Harriet Louise and Hollywood Glamour Photography*, Berkeley, Los Angeles, London: University of California Press, 2002, pp. 161–162.

[5] Karen Swenson, *Greta Garbo. A life apart*, New York: Scribner, 1997.

[6] Deborah Nadoolman Landis, *Dressed. A century of Hollywood Costume Design*, New York: Collins, 2007, p. 33.

[7] Irene Brin, *Usi e costumi 1920-1940*, Palermo: Sellerio, 1989, p. 94.

[8] Cecil Beaton, *Lo specchio della moda*, Milan: Garzanti, 1955, pp. 231–232

[9] Salvatore Ferragamo, *Shoemaker of Dreams*, London: George G. Harrap & Co., 1957, pp. 206–208.

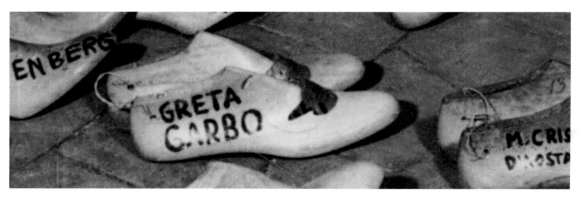

A drawing of Greta Garbo's foot — she wore a 9AA — and the wooden mould conserved in Palazzo Spini Feroni, the Ferragamo headquarters. Photo Locchi

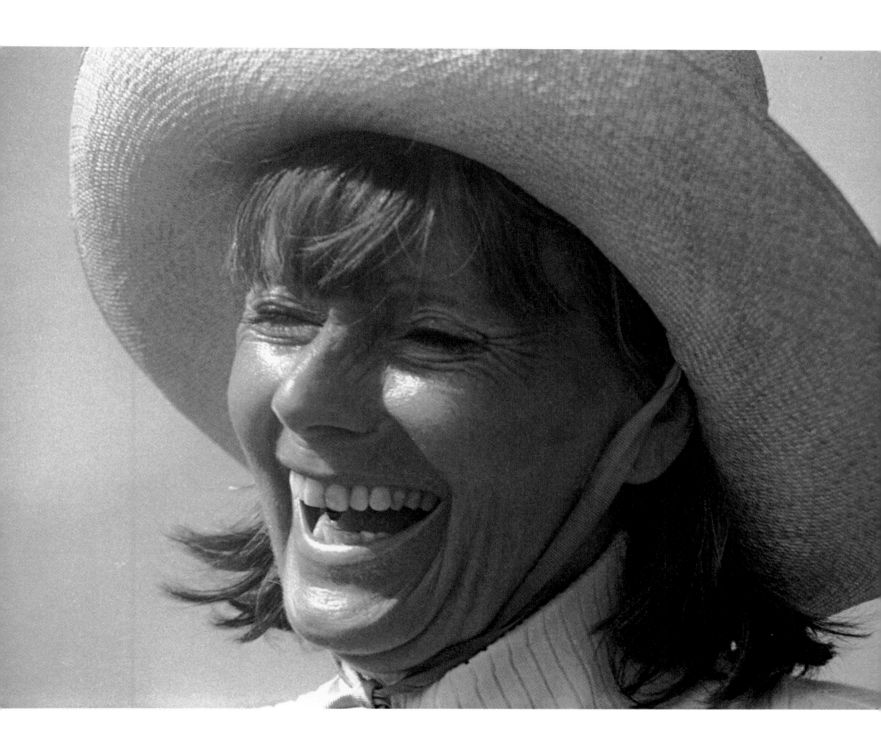

Greta Garbo on a cruise in Greece, 1965. Photo Cecil Beaton

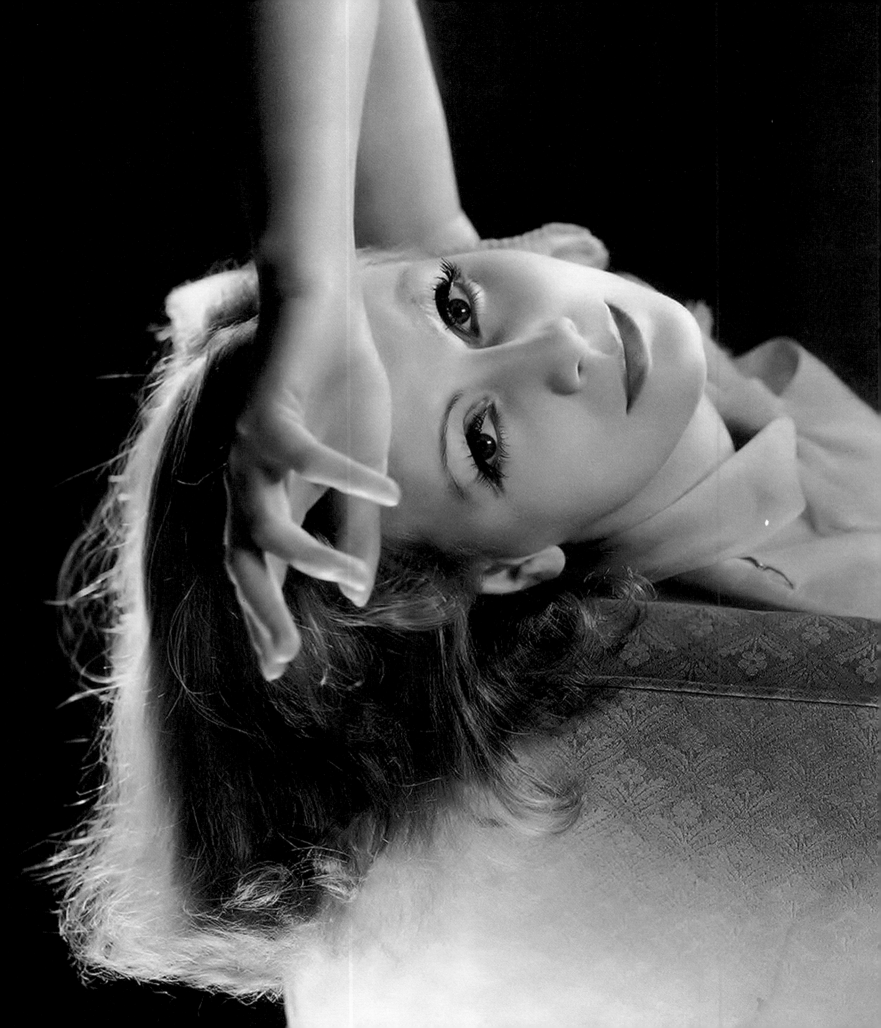

GIANNI CANOVA
OF FLESH AND OF SNOW. GRETA GARBO, CINEMA AND FILMS

Are you truly real or were you born from a blizzard? (question asked by the actor interpreting Napoleon to the Countess played by Greta Garbo in the film *Conquest*, 1937, by Clarence Brown)

In the last frame of what is almost certainly one of her most beautiful and intense films (*Queen Christina,* 1933), Greta Garbo stands on the prow of the ship carrying her away from Sweden, after the death of her lover. The wind ruffles her hair, while she seems to peer into the distant horizon. Resignation, resolution, melancholy: one can read many things — in that face — and many things have been read by scholars, critics and mere spectators. Actually, the news of the times narrates that the director Rouben Mamoulian supposedly advised Garbo to do absolutely nothing in that scene, and it seems that for once the "Divine" did exactly what had been suggested to her.[1] That is to say: a totally relaxed face with no expression whatsoever becomes, paradoxically, polysemous and anxious, laden with multiple meanings, varied and even unpredictable, embracing the emotions that the story or the viewer decide to deposit upon that surface. All in all, Greta Garbo's acting secret is entirely enclosed within this extraordinary and paradigmatic frame: subtracting, erasing, taking away, in order to reach — in emptiness — the maximum expressivity.

Her face is a blank page, as Mamoulian described her.[2] Her whiteness is also referred to by Roland Barthes, in one of the most beautiful texts ever dedicated to her,[3] when he speaks of "a face of snow and solitude," or when he makes snow the metaphor-key to express the essence of the actress's face: "In all this snow — both fragile and compact — only the eyes, black like strange soft flesh, but not in the least expressive, are two faintly tremulous wounds."[4] Garbo is white, of course: one could not imagine her any other way. But why does Barthes "feel" Garbo as *snowy*? Instead of a "face of snow", he might have spoken about a face of porcelain, or a face of light. He would have saved the colour and light substance of that extraordinary face, and perhaps he might have brought to the forefront its *smoothness*. Instead no: Barthes prefers to underline — with the choice of his metaphors — that this face has to do with coldness rather than warmth. And that Greta Garbo's face — just like snow — marks a (physical) change of state: no longer the actress's liquidity, but the icon's immobility. Snow is rain that solidifies, and then becomes flakes and ice and layers. Garbo's face is similar to this process: it is flesh that dematerializes, grows cold and deposits itself upon the image. Well beyond the "photogenic quality" theorized in the 1920s by Louis Delluc, Greta Garbo incarnates that unique moment in the history of cinema and "divaism" in which a body and an instrument penetrate one another and give life to a form: the *close-up*.

An intense close up of Greta Garbo during the filming of *As You Desire Me*, directed by George Fitzmaurice in 1932. Photo Clarence Sinclair Bull

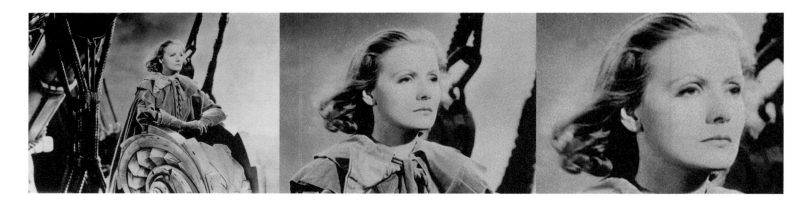

The *close-up* would not exist without Greta Garbo's close-ups. The close-up does not belong to Marlene Dietrich (who instead is perfectly suited to the thigh shot, moreover the statistically most frequent shot in the staging or representation practices in classic Hollywood cinema[5]) nor — in later years — to a diva like Marilyn Monroe (who seems condemned to the full-figure shot). Instead, Greta Garbo, even when she is framed in full, when she walks, when she runs, when she crosses the hall of a Grand Hotel, is always and only in close-up. She does not need thigh shots that capture at the same time the body's posture and the face's message, because in her, body and face are one. As if her body transubstantiates into her face and there lets off the light taken in from the world. Because Greta Garbo is a star that shines by her own light: a permanent centre of radiation of charm and the mystery of beauty.

But this extraordinary effect is not in Greta Garbo the fruit of a natural "gift", but rather the result of a long and complex work on her face's "cultural" construction. Garbo is born — paradoxically — from a process that liberates the body from the flesh: initially, her Swedish Pygmalion Mauritz Stiller — who discovered her while she was a clerk in one of Stockholm's department stores and brought her with him to Hollywood, turning her into a "diva" — makes her lose 10 kilos, then in America MGM gives her a contract and demands she loses another 10 kilos. Her cheeks and profile sink in, becoming smooth, minimal, essential. Long before the era of morphing and plastic surgery, Greta Garbo is the emblematic and very modern example of a face that becomes a sign, and is totally redesigned, stripped bare, replanned. "Don't treat her like a human creature, because she isn't. Treat her like plasticine," Stiller says about her. And concerning this "malleability", this plasticity and adaptability, the star system made its masterpiece. Thus she places herself in the collective imaginary first through her face: in the great metonymies of the star

Greta Garbo in the final scene of the film by Rouben Mamoulian, *Queen Christina*, 1933. Photo Milton Brown

system, Greta Garbo is her face, just like Marlene Dietrich is her legs, like Jane Russell would be her breasts and Audrey Hepburn would be her eyes. Platonic and discarnate, purged from all carnal residue, Greta Garbo is ready to incarnate the quintessence of a seduction that may allow itself to do without the flesh. In her fourth film, *Flesh and the Devil* (December 1926, directed by Clarence Brown), a magnetic melodrama with a misogynous ending, Garbo dares the undareable: approaching the Eucharist, she chooses to drink from her own chalice in the exact place where her lover had just put his mouth, there where she still feels the wetness of his lips upon the cold metal. Blasphemy? Perhaps. But Garbo is forgiven every offence. Why? Maybe because in Keatons's immovability of her face we glimpse what a scholar like Béla Balázs defines as the essence of *sadness*: "Greta Garbo is sad. Not only in certain situations, but for certain precise reasons. Greta Garbo's beauty is a suffering beauty, which envelopes all life and the entire world that surrounds us. This sadness is an exactly determinable expression: it is the sadness of solitude and of *extraneousness*, a sadness that knows not of communion with other men."[6] In short, Greta Garbo, according to Balázs, feels like an outcast in a foreign land, and she lets those who look upon her grasp in her face the awareness and pain of this extraneousness. Whatever character she is playing, Garbo's beauty is never solely due to a harmony of lines or the effect of particular slants

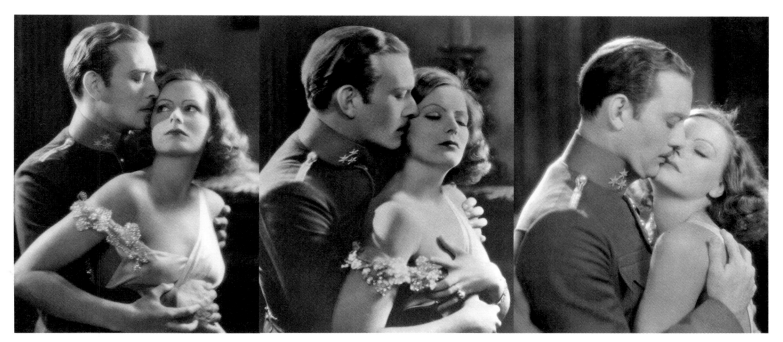

A few passionate scenes with Greta Garbo and Conrad Nagel in the film *The Mysterious Lady*, directed by Fred Niblo in 1928. Photo James Manatt | Following pages: photo taken by Milton Brown during the shooting of *The Kiss*, directed in 1929 by Jacques Feyder

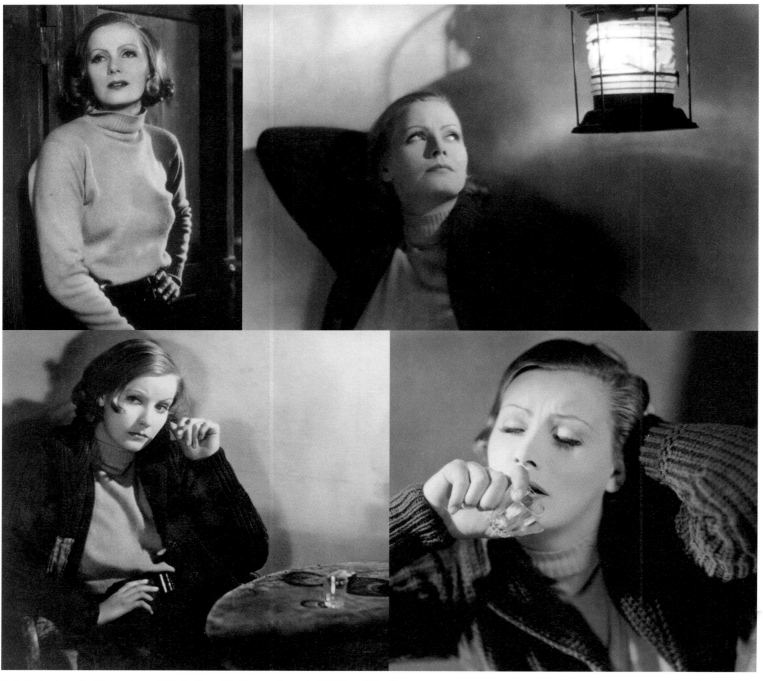

Greta Garbo during the filming of *Anna Christie*, directed by Clarence Brown in 1930. Photo Milton Brown

of light, but rather it is tied to the expression of a state of mind the audience feels it shares. Balázs also writes: "In Greta Garbo's physiognomy, millions of people catch sight of a painful and passive protest. Millions of people who perhaps have not yet become aware of their own protest. But precisely for this reason they love Greta Garbo's beauty, and they place it above the loveliest of all other beauties."[7] The analysis is evocative and sharable, but on one condition: that of not forgetting the constitutional "duplicity" not only of her face but of the entire Garbo character. Cristina Jandelli astutely writes: "Garbo's face is double and changes depending on the profile she shows: the romantic heroine face corresponds to the cold manipulator one."[8] For example, a film like *The Mysterious Lady* (1928) by Fred Niblo: there, Greta's face appears in an extreme close-up of striking beauty, framed in profile, immersed in a soft light that highlights the perfect shape of her nose, her forehead and left cheekbone. An Austrian officer is looking at her, visibly unsettled. She slowly lowers her eyelashes, then raises them, but not completely, leaving her eyes half-open. He is definitively seduced and enraptured. In this close-up, there is surely the *sadness* Balázs speaks about, but — as the story unfolds — there is also the manipulation of the professional seductress who wants to steal some military plans from the officer (the "mysterious lady" is in fact a Russian spy, quite able in playing with seduction and simulation). Greta Garbo is this way, both on and off screen: a double, ambiguous, androgynous, mysterious. *Body Double*: in a hoop dress and trousers, masculine and feminine, in silent films or talkies.

Of course, in Hollywood Garbo is mainly a foreigner passing through, so much so that the "dream factory" makes her encounter only occasionally a few of the great directors of the age (George Cukor and Ernst Lubitsch). Besides, Garbo must content herself — so to speak — with honest artisans, oftentimes at grips with mediocre scripts, like Clarence Brown (who directs her in seven films) or Fred Niblo, Edmund Goulding and George Fitzmaurice, each in two films a piece. Even her partners, at her side, risk looking like drones in front of the queen bee, or at the most eunuchs or prince consorts. And yet she, the "sphinx from the North", or the "torch of ice", as Hollywood's proto-marketing strategists called her, is able to redeem the scarcity of the films she finds herself interpreting. "Each film of hers is a jumble," writes Giuseppe Marotta, "but she shines, untouched, healthy, unrepeatable. Greta has truly stopped time."[9]

The women she interprets are almost always beings wounded by life and in love with love. Greta Garbo is Anna Karenina (twice: the first time, in a silent film, in 1927 for the director Edmund Goulding; the second, in a talkie, eight years later, in 1935, for Clarence Brown) and Marguerite Gauthier — Dumas's *Camille* — in the film by the same title by George Cukor in 1936, perhaps her most touching interpretation; but then she is a prostitute for sailors (*Anna Christie,*

1930, by Clarence Brown), an Italian opera singer (*Romance*, 1930, also by Brown), an adulteress in 1920s China (*The Painted Veil*, 1934, by Richard Boleslawsky), a Polish countess in love with Napoleon (*Conquest*, 1937, by Clarence Brown), a spy (*Mata Hari*, 1931, by George Fitzmaurice), a dancer (*Grand Hotel*, 1932, by Edmund Goulding), haughty ruler (*Queen Christina*, 1933, by Rouben Mamoulian) and charming courtesan (*Susan Lenox Her Fall and Rise*, 1931, by Robert Z. Leonard), up to the superb role of *Ninotchka* (1939, by Ernst Lubitsch), where she is a Soviet political commissioner, bewitched by the sweet capitalist life of Paris. To each of these films, Greta Garbo gives a femininity of the soul, an absolute ability for passion and sacrifice and an unforgettable and magnetic mystery. "Garbo," writes Giacomo Debenedetti, "defends first of all the modesty of her own sentiments."[10] She works with nuances and dreaminess, she lets herself go without conceding, she keeps under control the mask she imposes upon her characters, and she acts with absolute economy of expression, avoiding hyperbole, redundancy and exaggeration.[11] She doesn't need any exercise in disguising — Garbo: all she has to do is be herself in order to interpret — in the same film, *Queen Christina* — both the ruler-protagonist and a young knight.[12] Her almost asexual face ends up being absolutely all-purpose, adaptable, available: she expresses an almost Platonic idea of the character to which the actress always gives an ethereal, impenetrable, unreal aura that is nevertheless very concrete and carnal. Her smile is for film history the equivalent of what in the history of painting Leonardo's smile on the Monna Lisa was: an untouched and immortal mystery. But with a difference: under the mask of snow on Greta Garbo's face, there is always the flesh of a real woman. And flesh decays, becomes corrupt, is destined to disappear. Even though she did everything she could to make herself immortal and to exit the scene while she was still young so as to remain on scene forever, in a decided and rigorous self-imposed eclipse she knew how to say no to the many who in vain sought her out and courted her (from Luchino Visconti to Ingmar Bergman, Jacques Cocteau to Tennessee Williams), Greta Garbo as well had truly started to disappear. Behind the snow the flesh appeared once again, and under the whiteness the grey began to emerge.

I know this – and I write – because I have, unfortunately, a small but significant direct confirmation: in fact, for the past ten years now I have started my History of Cinema course at university by showing a picture of Greta Garbo to my students. In the dark classroom, I turn on the screen and show one of her close-ups. At times from *Queen Christina*, at others from *The Mysterious Lady*. I don't say a word, at first. The course begins with the appearance of that image in the dark. Then, still in the dark, I walk among the desks and randomly ask my students to express

Greta Garbo playing an opera singer in the film *Romance*, directed by Clarence Brown in 1930. Photo Clarence Sinclair Bull

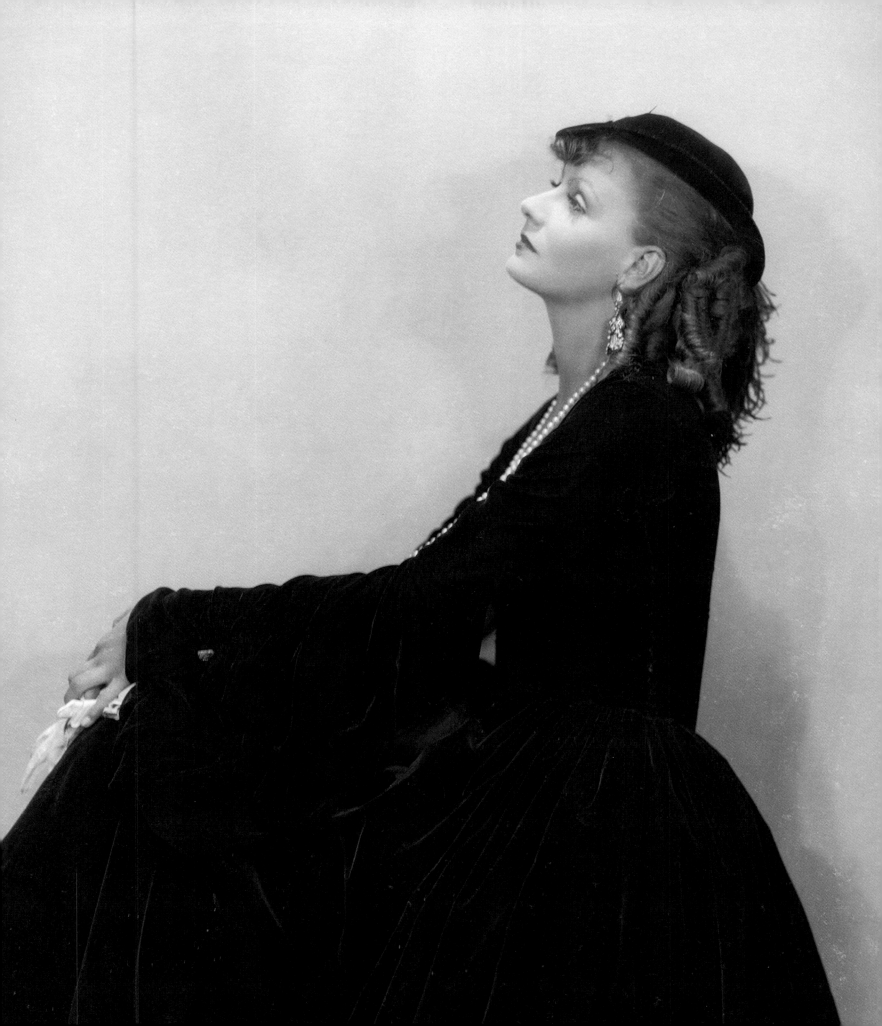

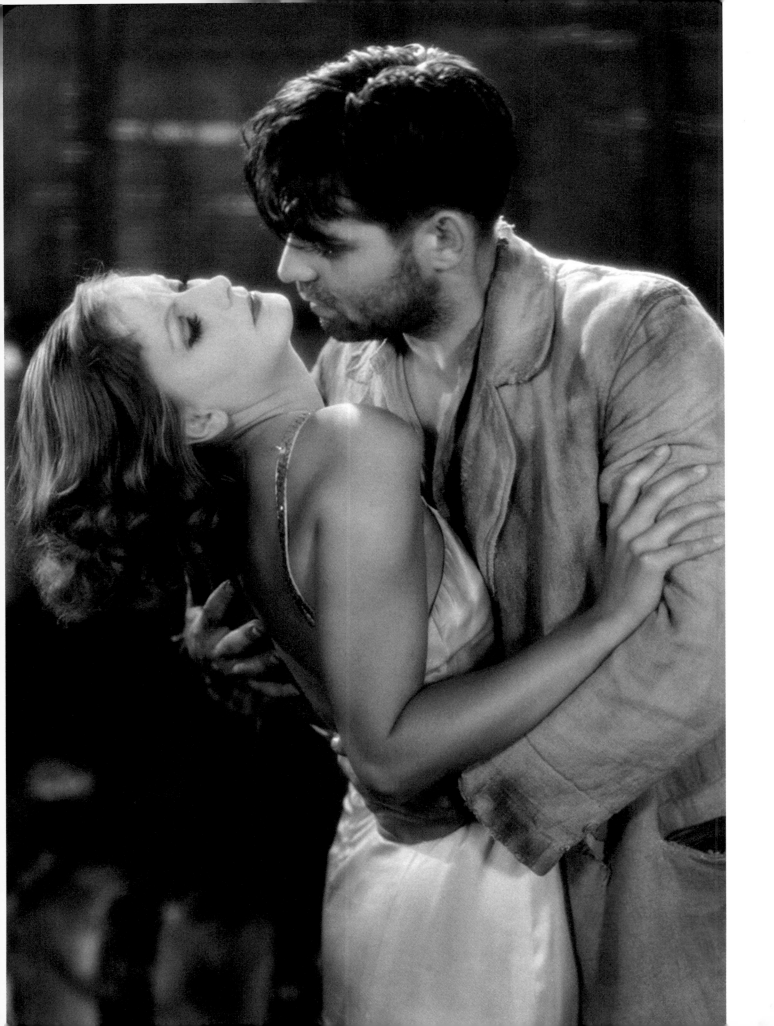

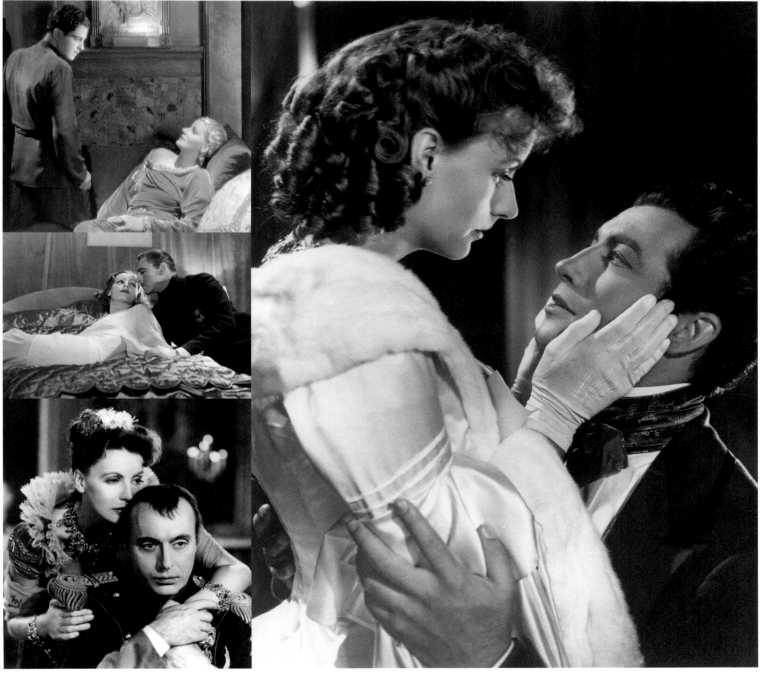

Facing page: Greta Garbo with Clark Gable in *Susan Lenox Her Fall and Rise*, 1931. Photo Milton Brown | Above, on the left: with Ramon Novarro in *Mata Hari*, 1931; with John Barrymore in *Grand Hotel*, 1932 (photo by Milton Brown); with Charles Boyer in *Conquest*, 1937 (photo William Grimes); on the right: with Robert Taylor in *Camille*, 1937 (photo William Grimes)

out loud what they are seeing. Ten years ago one out of three still said, almost touched: Greta Garbo. Today, for the new generations, even the Divine is slipping into oblivion. They don't recognize her anymore. At the question: "What do you see?," they respond in the simplest and perhaps most disarming way: "A woman . . .". At first, it was a response that made me melancholic. But today I think that all in all Greta Garbo would have liked this. No recollection, no memory. Even the faces on the totem poles Barthes discusses are destined to disappear, and Greta Garbo cannot subtract herself from this shared fate. The woman remains. Actually: the Woman. Because even in oblivion, Greta Garbo continues to be quintessential. And in this, perhaps, lies her modernity. But also — and above all — her necessity.

[1] Richard Dyer, *Star* (1979), Turin: Edizioni Kaplan, 2003, p. 178.

[2] Jacqueline Nacache*, L'acteur de cinéma*, Paris: Armand Colin, 2005, p. 109.

[3] Roland Barthes, "Il viso della Garbo", in *Miti d'oggi* (1957), Turin: Einaudi, 1974, pp. 63–64.

[4] *Ibid.*, p. 63.

[5] Concerning the representation rules of classic Hollywood cinema stars and the relationship between this anthropocentric organization system of space and pictorial precepts of the Renaissance, see David Bordwell, Janet Staiger and Kristin Thompson, *The Classical Hollywood Cinema. Film Style &Mode of Production 1917–1960*, New York: Columbia University Press, 1985.

[6] Béla Balázs, *Il film. Evoluzione ed essenza di un'arte nuova,* Turin: Einaudi, 1955, p. 335.

[7] *Ibid.*

[8] Cristina Jandelli, *Breve storia del divismo cinematografico*, Venice: Marsilio, 2007, pp. 68–69.

[9] Giuseppe Marotta, *L'oro di Hollywood,* Milan: Bompiani, 1956.

[10] Giacomo Debenedetti, "Greta Garbo"*,* in *Cinema*, 25 October 1936.

[11] A negative exception may be *Grand Hotel,* where Garbo is evidently not at ease with the transition to talkies, using emphatic and redundant gestures which the French scholar Alain Masson defines "unbearable". Cfr Alain Masson, *L'image et la parole. L'avénement du cinéma parlant,* Paris: La Différence, 1989, p. 225.

[12] In confirmation of her nonchalant androgynous vocation, it may be helpful to keep in mind that after her retirement, in 1941, she supposedly encouraged Aldous Huxley to write a script on the life of Francis of Assisi and to give her the part as the saint.

An intense portrait of Greta Garbo during the filming of *Ninotchka*, directed by Ernst Lubitsch in 1938. Photo Clarence Sinclair Bull

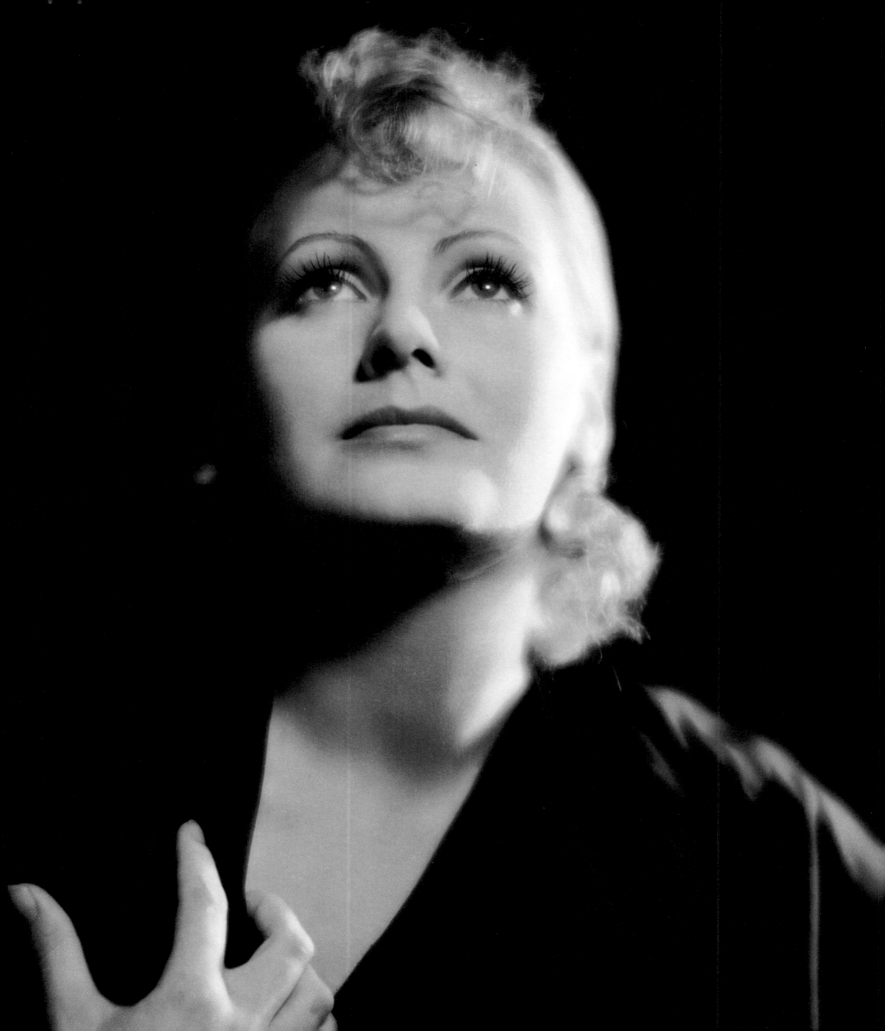

GIUSI FERRÉ
GRETA GARBO. THE ETHICS OF MINIMAL

"I love colour. With me it's inborn. I just know. I didn't have to learn it." Greta Garbo

Who's surprised today at the news that the famous model or queen of gossip wears a size 10 or 11 shoe? They're tall girls, so it's only normal that they rest upon suitable bases. But regarding Greta Garbo, who was 1 meter 70 and wore a size 9 narrow shoe, and therefore a delicate shape, word got around — thanks to a few women reporters and the deceitful Helda Hopper — that her feet were so big they were embarrassing. Maybe because, when shooting on the set did not consist in full-figure shots, she wore slippers to feel comfortable and would continuously ask the cameraman: "Can you see my feet?". Of course, when the Divine arrived in Hollywood in 1925, all the rage was the dolly-type, like Norma Shearer and Mary Pickford, whose feet, as Salvatore Ferragamo narrates in his autobiography, "were the smallest of the all divas I had the opportunity to fit . . . tiny even in proportion to her height."

Of this marvellous woman there remains the false legend of a defect that wasn't actually there, with so much gossip and insinuation that grew with each success. As Irene Brin, society journalist genius, narrates: "To react to the photomontage where Greta's head was placed above the vastness of the Sphinx, they would say that Garbo ate vigorously, that she preferred tinned anchovies, that her bedroom was full of additional food for midnight snacks. She loathed — and it would seem with good reason — crowds. Those few who got next to her describe her as an attentive, devote woman, very severe with herself. All of us keep loving her." And it was as early as 1944 when the author published for the first time her book *Usi e costumi 1920-1940* [*Customs and Usages 1920–1940*] which gathers comments, annotations, stories: a kind of dictionary of pertinent ideas, commonplaces and fashion between the two wars.

With her skill for observation, Brin had intuited an aspect in Greta Garbo's personality that dominated her life: "Very severe with herself". Because the most beloved diva in the world was obsessed with the imperfections she attributed to herself, so unlike the petite actresses that reigned in the Studios. She felt too big, awkward. Klaus Mann in *The Turning Point* describes her as "her long legs and broad shoulders of the young ancients figure had heavy joints". And the directors complained that Louis B. Mayer, the boss of MGM, had imported a foreign actress with a flat chest and a look that was not too feminine. The truth is that she was a woman with an elegant line, slender but strong, so contemporary with her vaguely boyish allure to rewrite the rules of glamour and charm. Accustomed to a healthy, strict diet, to very long walks even under the rain,

A dramatic and minimal portrait of Greta Garbo by Clarence Sinclair Bull, 27 August 1929 | Greta Garbo was often called the "Swedish Sphinx". Photo Clarence Sinclair Bull, 1931

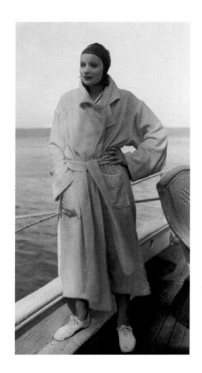

to a life that, off the set, was the most natural possible, she had such freshness and presence to impose herself with great, surprising intensity — or should I say, truth.

Everything about her was splendid, smooth and different from all other models. Far from the screen, her face only needed light make-up: a dusting of blush, a touch of pencil on her eyebrows, and very rarely soft lipstick. For Klaus Mann she was the most beautiful face he had ever seen: "Her forehead was like the marble of a pained Goddess, and large eyes full of golden darkness. Her long arched eyebrows were carefully shaven and drawn, the black shadows of her eyelids were artfully deepened; otherwise, she did not use rouge, not even lipstick, so her mouth appeared quite pale: a large, pale mouth contemptuous of incomparable form, set in an arduously sculpted large, pale face, with a sadly proud expression". This magical Viking associated with a motley group of intellectuals who had left Europe, though following her own rhythms and rules. She would usually arrive late in the night, without being announced, crossing Emile Jannings' dark and scented garden to reach them on the terrace where they would get together and drink whisky. "She wore no hat, with an open rain coat and flat sandals".

We can already see, in this description, quick like a Polaroid, Garbo's entire character right from her debut. With a style that today seems contemporary, but which in the mid-1920s must have been scandalous. "It was as if she couldn't stand looking beautiful," commented Joe Ruttenberg, a photographer of the period very active in the capital of cinema. "But she felt at ease only if she attracted attention." That's exactly what the superdiva wanted. "I'm not interested in clothes . . . When I'm off the set, I don't want to think about them anymore . . . I like living simply and dressing simply" (reported by Patty Fox in *Star Style)*. Her priority, in short, was comfort, and this, in no way interfering with her image, as some critics sustain, contributed to creating her and establishing her style. With the precise intention of hiding what she believed were her defects, without giving in to the trends of the times, she wore trousers and long dresses, which made her seem taller, with low neck-lines, and hats that covered her hair and revealed only her face.

She was the one who made turtleneck sweaters popular (before her, jockeys wore them), because she found them practical and they focussed the gaze only on the face, without highlighting the neck, which for some unknown reason she felt was too big. Having discovered the advantages, there were a few variations in style: laced collars tied on top; scarves wrapped or tied at the neckline; hoods. For day or for evening, she avoided being seen in public with low-cut clothes.

Polo-necked sweaters became a classic, with her typical trench coats that, depending on the season, could be long, grazing the calf or ankle, and in different fabrics. There were even very light

Garbo's sporty look is also reflected in the clothes for the films she interpreted. Scene photo by James Manatt during the filming of *The Single Standard,* 1929

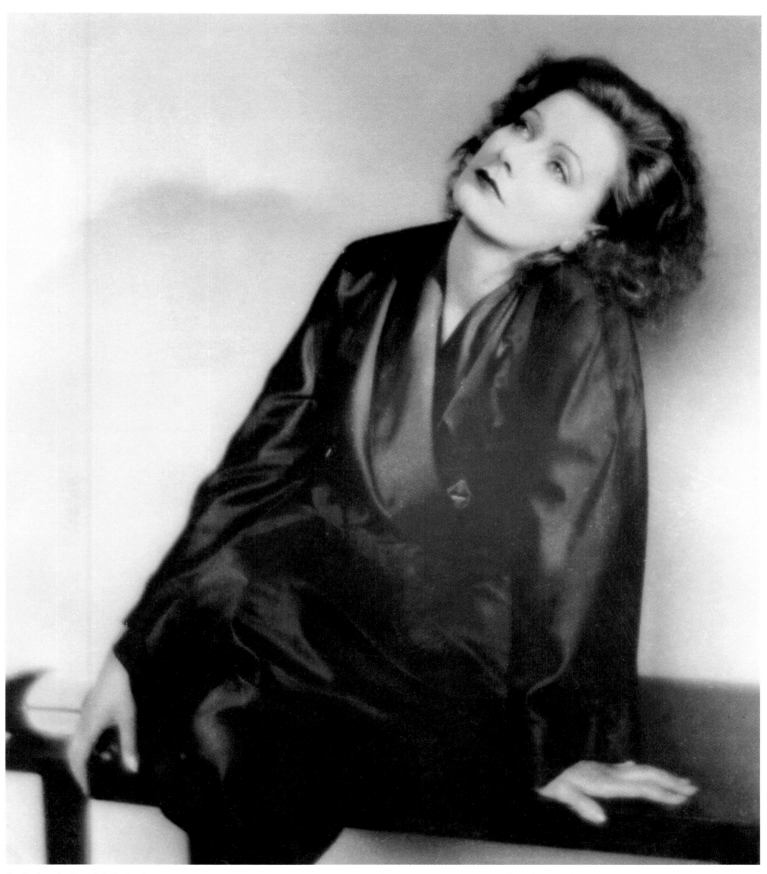

Studio photo by Russell Ball taken in 1927 during the filming of *Love* and *The Divine Woman* | Following pages: two images of Greta Garbo by Clarence Sinclair Bull shot in the studio to advertise the film *Mata Hari*, 1931

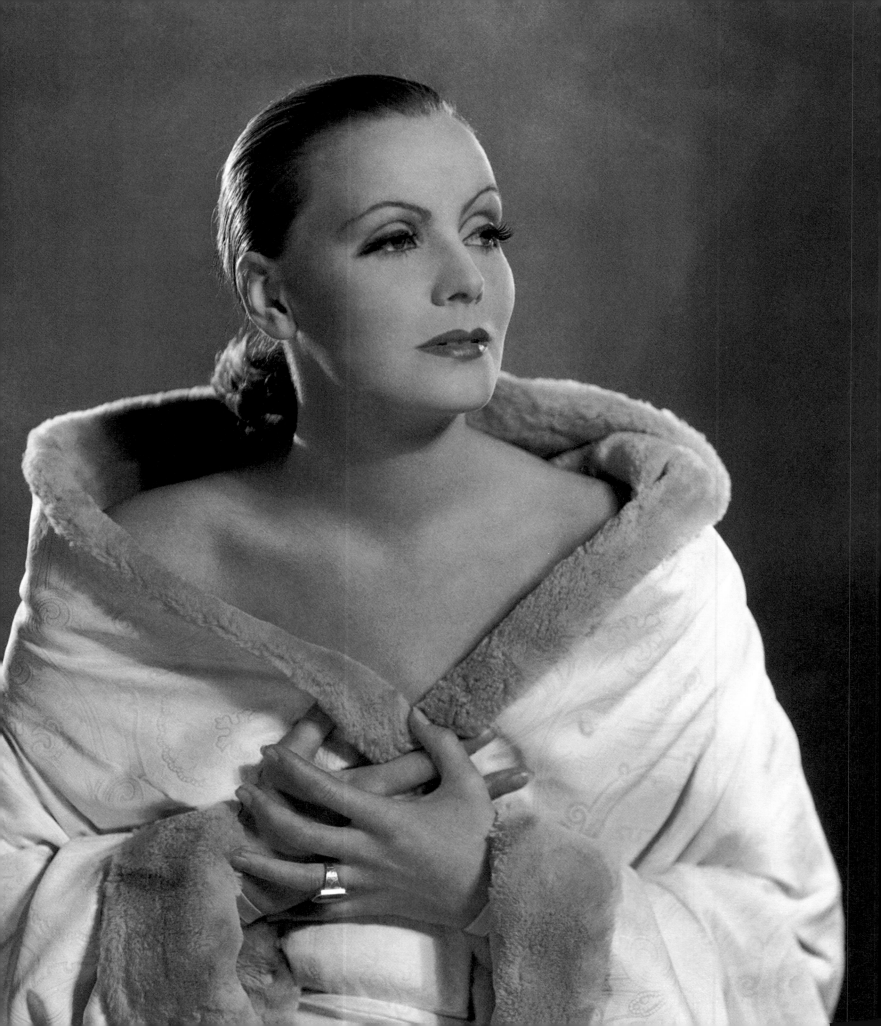

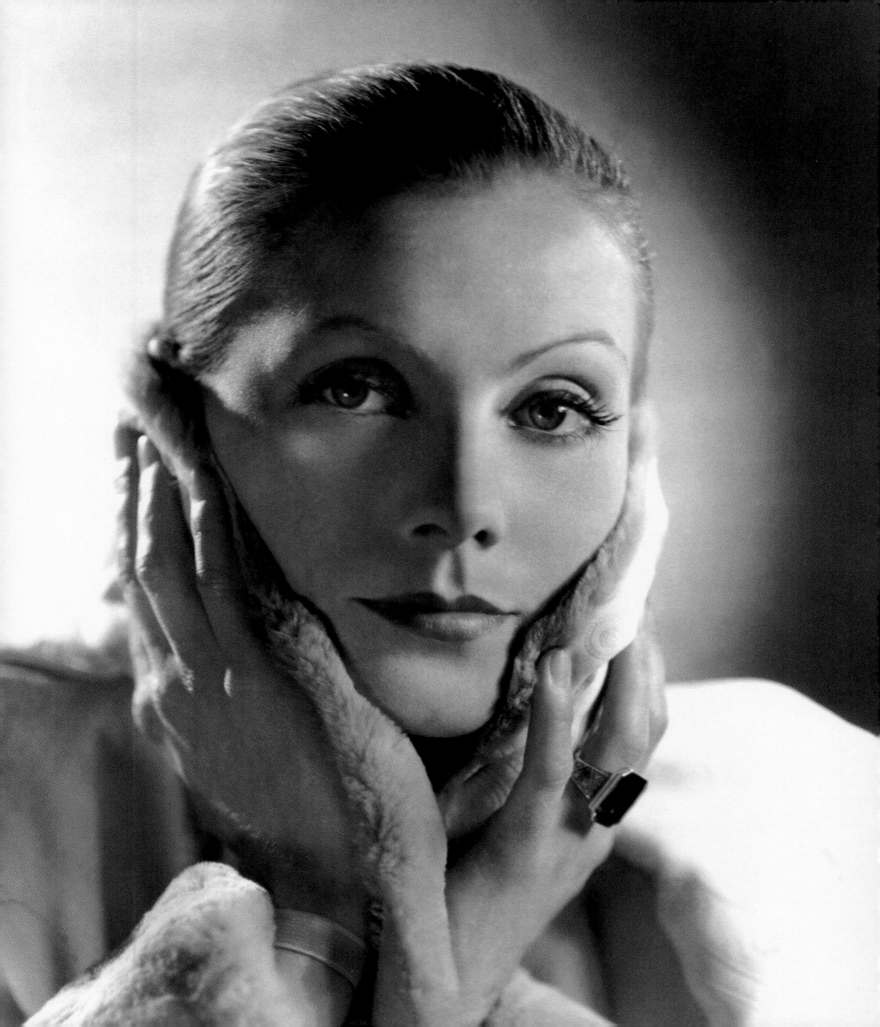

ones for the summer. She wore them on top of enormous sweaters and jackets, and when she tied the belt around her waist, she showed a figure rich in curves. There were her allies: all-purpose raincoats, because they gave her a practical use and allowed strangers to see only what she was willing to offer. Moreover, they helped her get out of any inconvenience, like the evening when she went to dinner at Chasen, a Los Angeles restaurant that did not allow entry to women in trousers. All she needed to do was roll them up and hide them under the trench coat, which she never took off, and take her place at the table with all the honours.

It was Greta Garbo who launched the trousers suit which she had custom-made by the tailor Watson, and which later became the trademark also of Marlene Dietrich. Always with that hint of ambiguity, that sweet-sour taste of intriguing relations, of sensuality that strives to approach all confines. But the perhaps unintentional masterpiece were the hats — cloche, berets, with rolled-up brims, made with felt — she always wore and which ended up becoming an extension of her face. Ever since she arrived in Hollywood she was wearing one, with all the nonchalance of she who had learned to wear them for work, when she used to present the new models in a department store in Stockholm. And, metaphorically speaking, she never took them off again.

Greta Garbo returning to the United States after one of her trips to Sweden in June 1946 and in a snapshot by a paparazzo in 1946. With the ever-present trench coat, hat, classic shirt and scarf around her neck

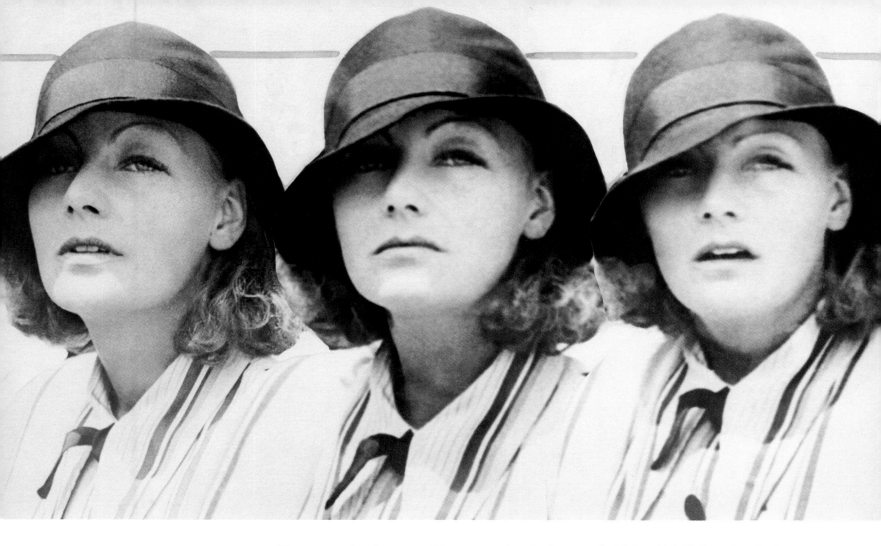

These were the elements of her personal style that struck Adrian (Adolf Greenberg), the refined designer MGM placed at her side starting with her film, *The Mysterious Lady*. With intelligence and subtlety, Adrian realized that her personal style could offer much more than that mishmash of clothes that up to then the star had worn on the screen. Therefore, he made costumes for her that displayed, even in different time periods, the strong points of her wardrobe. For the film *A Woman of Affairs* he prepared for her a wide wool coat, to be worn above a turtleneck, finishing it off with a soft felt hat and flat shoes. He adapted the trench coat to match it with evening gowns with a neckline higher than the ones in fashion at the time.

Greta Garbo thus became, without aiming to do so, "the lasting distracted arbiter of countless women," wrote Irene Brin. "First victory, she was the one to resolve the hair problem. Our childhood, surrounded by mothers with shaven napes, by bigger sisters with Eton-style clothes, resounded at length with clever questions and fearful rulings: does hair look good very long, or very short, what will we do, once it grows? Garçonne style, or braids, nothing worse than shoulder-length . . .". Instead, the triumph belonged totally to shoulder-length hair, and Greta's pageboy hairstyle resists, after twelve years, still today. And the beret, and dark cloth coat, sporty, dishevelled pants to alternate however with fabulously sparkling evening wear: *Flesh and the Devil*, *The Temptress*, *The Torrent*, Greta was always radiant and delicate, ingenuous and wicked. Then, with *The Painted Veil* there appeared the turbans, like in *A Woman of Affairs* there were the small felt hats with the inside-out brim: since Anna Christie wore a sweater, oilcloth and the

Greta Garbo launched the fashion of the cloche hat, 1929

south-west, she dreamed of nothing more. Pages upon pages in *Harper's Bazaar* and *Vogue* during those years offered photos and drawings of this infinite variety of headwear.

There was such a perfect blend between Greta Garbo and her characters that the (imposed) variations were not forgiven: décolleté and permanent wanted by the director George Cukor for *Two-Faced Woman* — and announced as a turning point — were dismissed by the public, to the extent where the *Times* wrote that "it was shocking, almost like seeing one's own mother drunk". The Divine retired, Adrian retired, and an epoch in the history of cinema ended. But the star began a life that was different from the one she had lived up to that moment. After twenty-five films shot in Los Angeles, she moved to New York, looking for new experiences and acquaintances. She also decided to leave Adrian, whose approach had grown predictable: a real capital sin in the eyes of the actress, whose need for privacy was such that she could not stand that anyone changed her into a living category.

Greta Garbo on the beach with one of her famous straw hats, circa 1940 | It was Garbo who made turtlenecks popular and which she used throughout her life. Here she appears in a photo of the 1950s

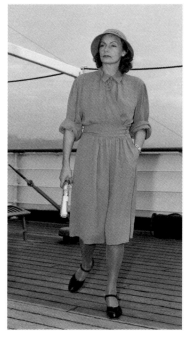

But then she was not too interested in fashion and clothes, as can be seen in an amusing episode narrated by the powerful and well-informed journalist of Hollywood news, Elsa Maxwell. The wicked deed had been mentioned to her by Elsie de Wolfe, the queen of interior decorating, who had insisted with her famous friend so that she would clean up and glamorize her wardrobe: "OK," Greta agreed. "Would you be so kind as to send me something that you think suits me?". "Naturally," replied Elsie, and the following day she had delivered a box full of "rough" clothes in untreated muslin that the great tailors used to show the look the finished product would have . . . and to establish the cut. For weeks, Elsie didn't hear anything. Then one day she decided to stop by for a visit, and Greta Garbo, who was wearing one of those muslin outfits, welcomed her, exclaiming: "Ah, the clothes you sent me are lovely. I always wear them."

If it's true, we may think that she was attracted by the neutral colour, the lack of decorations and frills, which is a characteristic of her taste and which accompanied her in every stage of her life. Even when, presented by her friend Gaylord Hauser, the millionaire nutritionist who was one of her many homosexual lovers, she made her encounter with Valentina, the most authoritative fashion designer in New York, and she entrusted herself to her magic hands. The encounter was total, professional and amicable, which also involved Valentina's husband, George Schlee, in what seemed like a ménage à trois, unleashing endless gossip for over twenty years. Also because the actress had purchased a flat in the same building as the Schlee family at 450 East 52nd Street.

There has never been such tantalizing news for the press, who surely didn't respect the request of the lovely hermit to be left in peace. Also because both women, who looked alike (Valentina would say about herself: "I'm the gothic version of Greta Garbo") or behaved alike in such a way as to frustrate and confuse even the people closest to them, carrying out practical jokes. During events in the city, they would wear identical outfits made by the same designer and they would cling on to George. It seems these weren't exceptional situations, according to those who knew them well. For example, Eleonor Lambert, a PR talent, remembers well the identical transparent navy organza shirts and the same skirts cut on the bias that the two jokers wore one evening for a party in her flat in Manhattan. They knew all too well what they were doing and they had fun playing with the attention they attracted. Because G.G., the nickname her closest friends would use, wanted to keep her private life to herself — of course — but she would go out every day in New York and almost every evening, with what had become a kind of family for her. In the meantime, they shared their overseas origins: both Valentina Nikolayevna Sanina and Georgii Matveyevich Schlee were Russian, and both from that generation who in the fire of the October

Greta Garbo photographed with her trademark eyeglasses, 1957 | Greta Garbo on the ship *Gripshom* carrying her off to Sweden, 8 July 1946. She is wearing a dress by Valentina

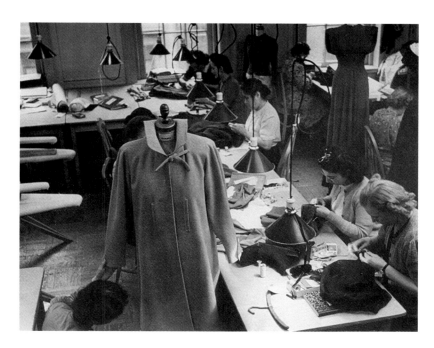

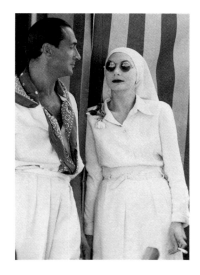

Revolution changed their destinies. They met by chance in a station in Ukraine (Valentina was born in Kiev) and they married in 1921. Together, across Constantinople and Greece, they arrived in Italy, where Valentina found work in the cinema, in a silent film. Then they moved to Paris, invaded by Russian refugees, and for two seasons the aspiring actress performed in a cabaret, which had become the aristocratic place because everyone, as Brin melancholically commented, "wore crowns, from the doorman to the bathroom cleaner". Then the move to New York, where in 1928 on the Upper East Side they established the *Valentina House of Fashion*. It was there that Garbo arirved: at the "fashion designer of the stars" who dedicated time also to Pola Negri, Claudette Colbert, Marlene Dietrich, so much so that the exhibition dedicated to her last year by the Metropolitan Museum and Museum of the City of New York was called *Valentina: American Couture and the Cult of Celebrity*. And who was more famous than the beautiful Greta Garbo? This special client was given a piece of advice by the *couturière*: "to adapt to the century, forgetting the current year".

There never has been a more brilliant piece of advice, because it freed her — if ever she had felt like a prisoner — from the seasonal narrowness of fashion, unbinding her from any reference that was too tied to itches and tics of the moment. With energy and a brilliant sense of colour,

Valentina's atelier in 1943. In close-up a coat created for Greta Garbo | Greta Garbo and Valentina together in 1949 | Valentina photographed at the Lido in Venice, 12 June 1935. Her resemblance to Garbo is evident

Valentina convinced her friend to eliminate pale brown — that light dull brown that seemed to silence the sweet colours of Greta — and to choose cornflower blue, lime, ice blue-grey and a touch of regal purple. Though sharing Greta Garbo's severe rules of design, the fashion designer interpreted them in an uncommon way, highlighting a soft and sophisticated look with broader shapes. She was able to convince the Divine to wear even a dress with a cut-out diaphragm that showed her nude skin. Not to mention the coolie hats, personally designed by Valentina. As can be seen from the models displayed in the exhibition that sum up the immense private wardrobe of Greta Garbo, the actress also loved rosy shades in all their nuances, from the palest to the most vibrant, which must have marvellously illuminated her skin and which could also be found in her impeccable house overlooking the Hudson.

With the same autonomy of taste, she chose items of the legendary tailors: Givenchy, Emilio Pucci. By Dior there is a striking black dress, large but unusually simple.

She was truly original, too distant from the taste of the times not to be criticized and the subject of gossip. For those who look at her today, she appears instead like a forerunner, who gave her own aesthetics a strong epochal mark, making every piece of clothing rarefied, essential and, at the same time, powerfully expressive of her personality. She was minimal much before someone said "less is more" and waved it about like a revolutionary slogan. That's why she seems so contemporary.

Greta Garbo's home in New York, in shades of salmon pink | Greta Garbo in 1955

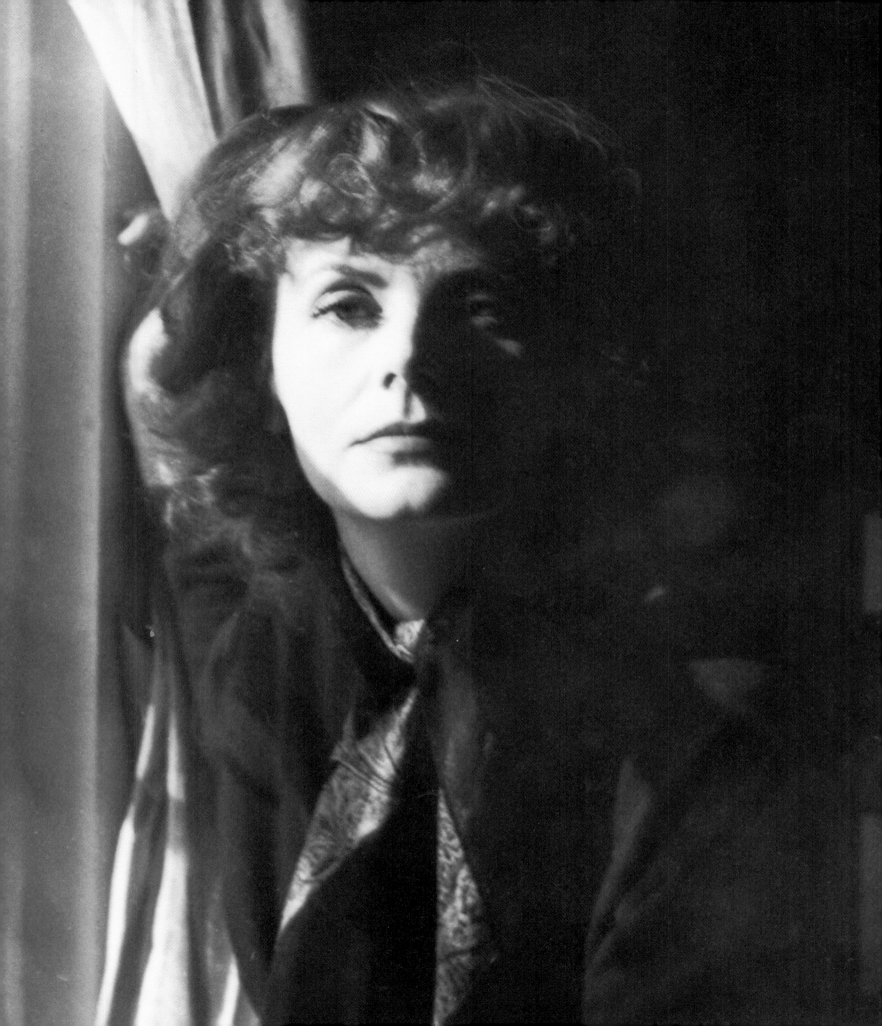

THE FACE OF

GARBO

Even before becoming an internationally recognized film star, admired and imitated as perhaps no one before or after, Greta Garbo was above all a face. Her power to seduce was based on certain apparent bodily incongruities: her small head, long body with broad, square shoulders like a young athlete, peculiar way of walking with long strides and a bit diagonally, velvety and hoarse voice, all at the same time.

Her charm was nevertheless determined by her particular face, in which the bone structure, skin compactness and depth of gaze veiled by long eyelashes not only represented traits of impressive photogenic quality but also gave her a natural innocence and candour: an almost sexless face, without any misunderstanding, as Roland Barthes would admirably say — a face that would contribute the image of a creature that is divine, perfect and unattainable but at the same time fragile, that eludes and obsesses.

She is the one who lends her unique face to characters, though always remaining herself, never renouncing — in her interpretations — her own physical and intellectual typicalness.

Greta Garbo photographed by Clarence Sinclair Bull during the filming of *Ninotchka*, 1939

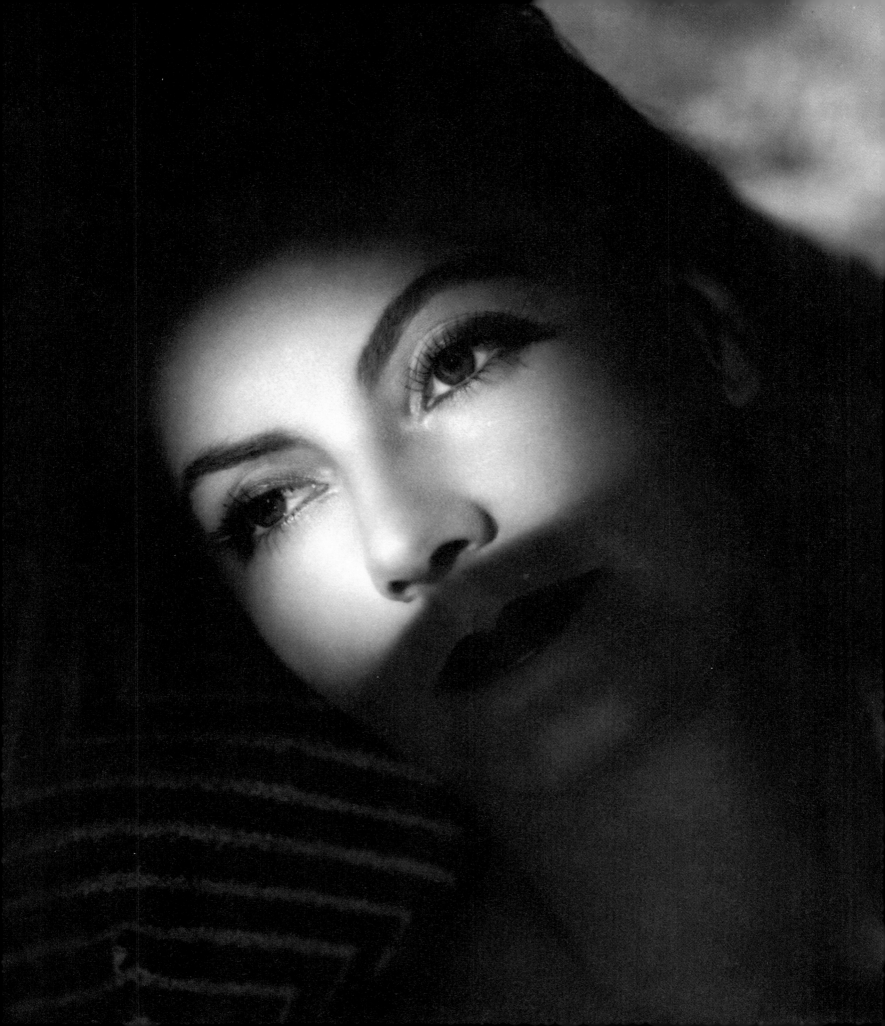

Greta Garbo photographed by Arnold Genthe in New York, August 1925

As early as the first photographs taken by Arnold Genthe and by Russell Ball in the summer of 1925 upon her arrival in New York, Garbo's face appears in all its beauty. Impenetrable and enigmatic, it displays itself as adaptable to the most imperceptible changes of expression, given by the beating of her eyelashes, her sidelong gaze and the light movement of her mouth.

However, both portraits are quite different. In the sensuality of the pose and the gaze, Ball aims to emphasize the woman's power to seduce; on the other hand, in Genthe's photo, the portrait of the actress is intense and dramatic. Greta Garbo is not presented as a Hollywood diva, but rather as the great actress, just like Eleonora Duse and Sarah Bernhardt.

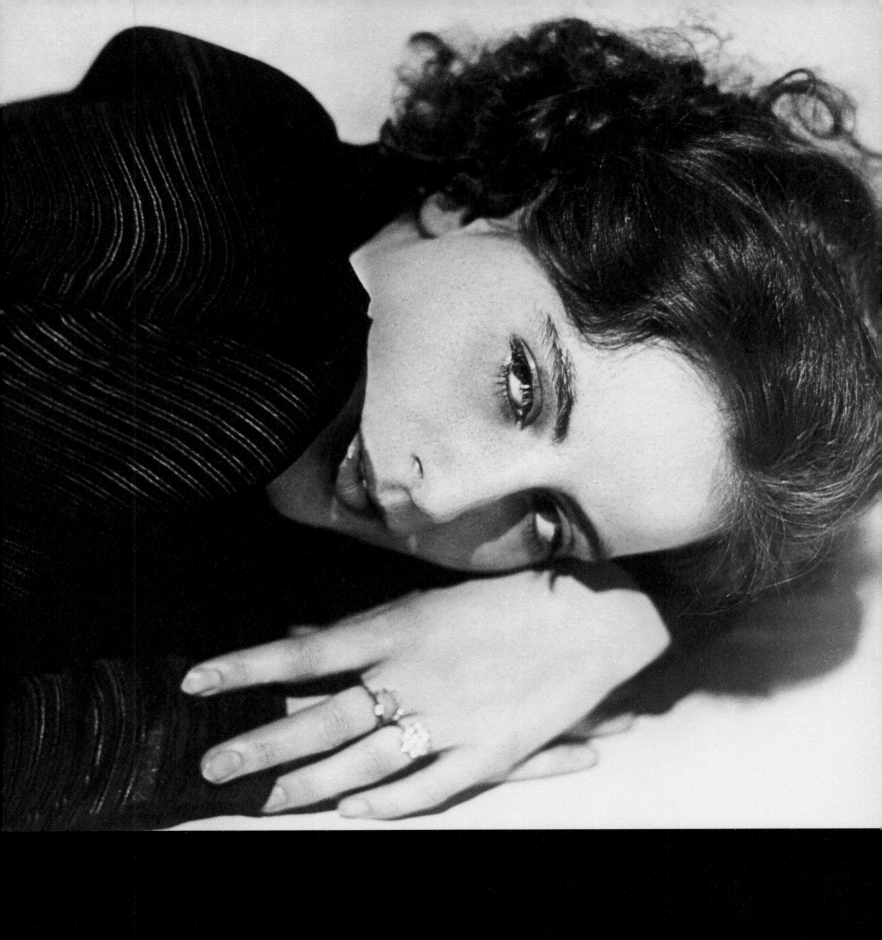

One of Greta Garbo's first photos upon her arrival in America, taken in 1925 by Russell Ball, at that time an MGM photographer.

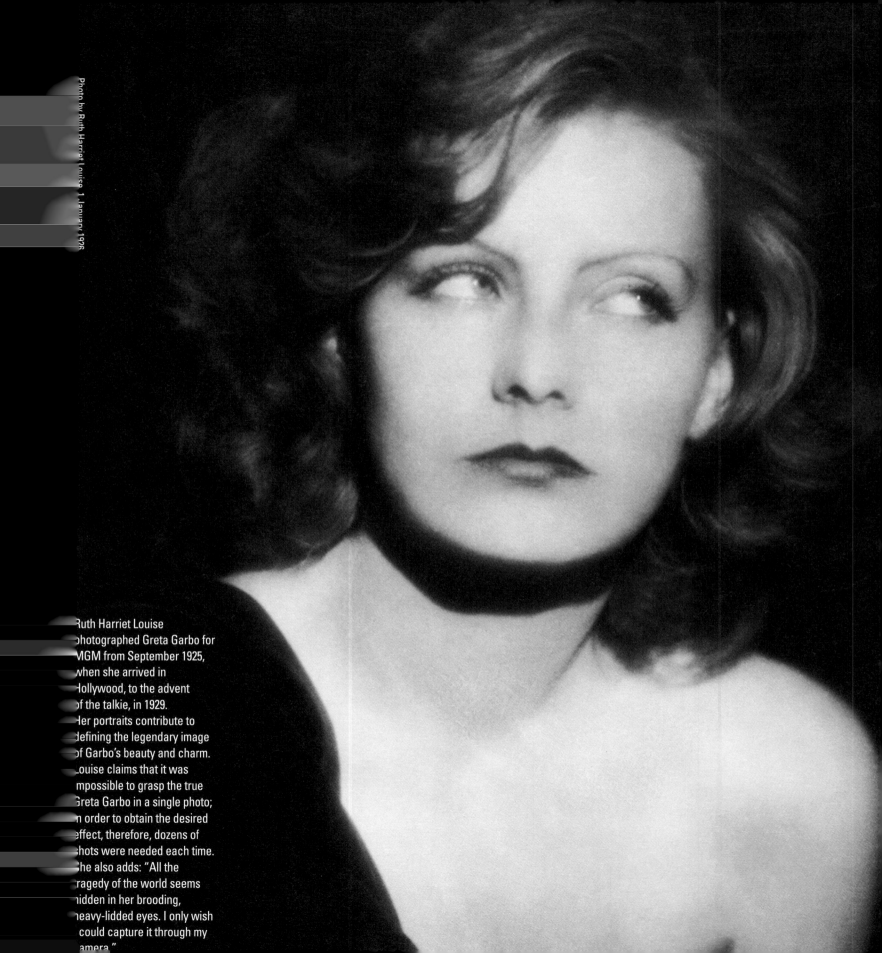

Ruth Harriet Louise photographed Greta Garbo for MGM from September 1925, when she arrived in Hollywood, to the advent of the talkie, in 1929. Her portraits contribute to defining the legendary image of Garbo's beauty and charm. Louise claims that it was impossible to grasp the true Greta Garbo in a single photo; in order to obtain the desired effect, therefore, dozens of shots were needed each time. She also adds: "All the tragedy of the world seems hidden in her brooding, heavy-lidded eyes. I only wish I could capture it through my camera."

As Nestor Almendros,
the celebrated photography
director, sustains, Greta
Garbo, though he never
worked directly with her, had
a particularly photogenic and
structured face, a prominent
nose, high cheekbones,
well shaped eyebrows and
a splendid jaw that favoured
contrasts of light and shade.
Above all, she had marvellous
eyes, with long, absolutely
natural eyelashes.

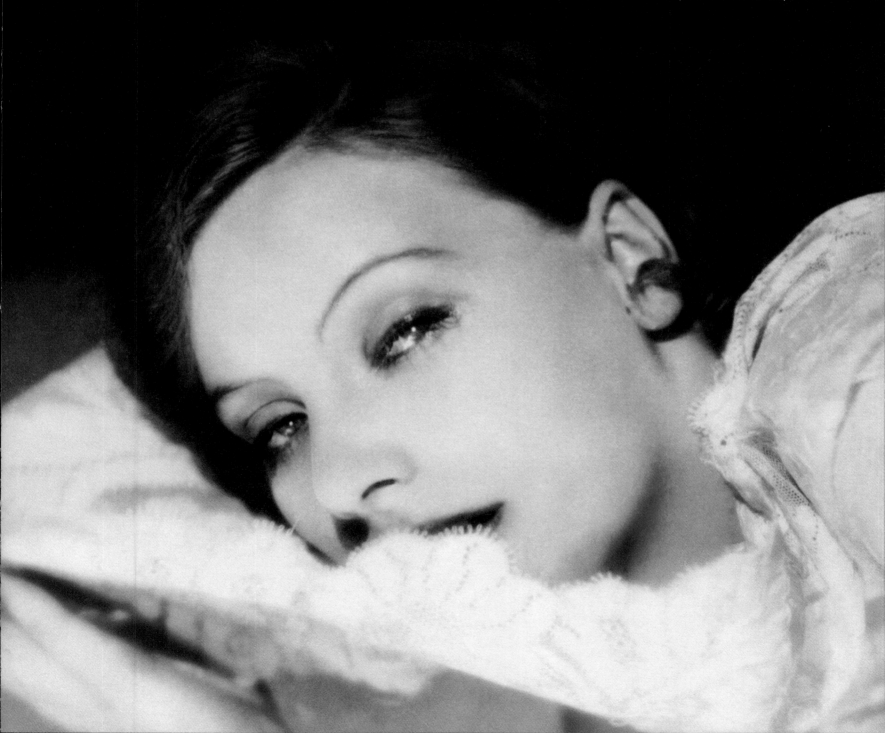

One of the ad photos taken by Ruth Harriet Louise on 14 July 1926 for the film *The Temptress*

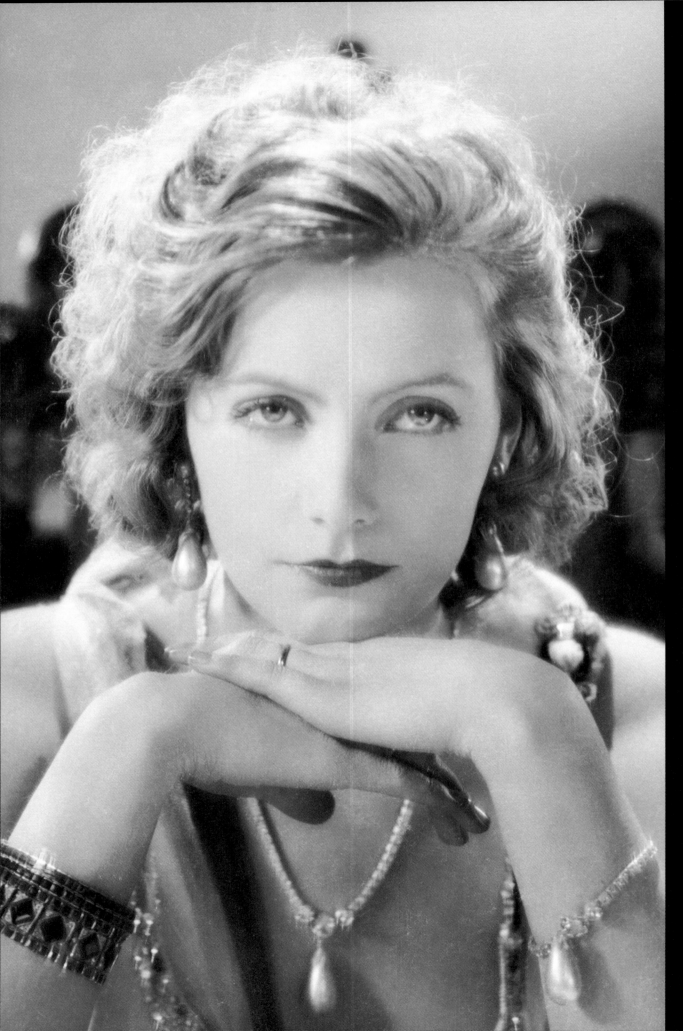

Just two years after arriving in New York, Greta Garbo exerted her power to seduce, as can be inferred from the lovely quote by Klaus Mann, the son of the celebrated writer, who met her in Hollywood during 1927–1928: "The face under that lion's mane was of striking beauty, it was the loveliest face I ever saw; actually, even today, I've never come across a more beautiful one. Her forehead was like the marble of a pained Goddess, and large eyes full of golden darkness. Her long arched eyebrows were carefully shaven and drawn, the black shadows of her eyelids were artfully deepened; otherwise, she did not use rouge, not even lipstick, so her mouth appeared quite pale: a large, pale mouth contemptuous of incomparable form, set in an arduously sculpted large, pale face, with a sadly proud expression."

An early photo of Greta Garbo during the shooting of the first film on Anna Karenina, 1927. Photo by Frank Grimes

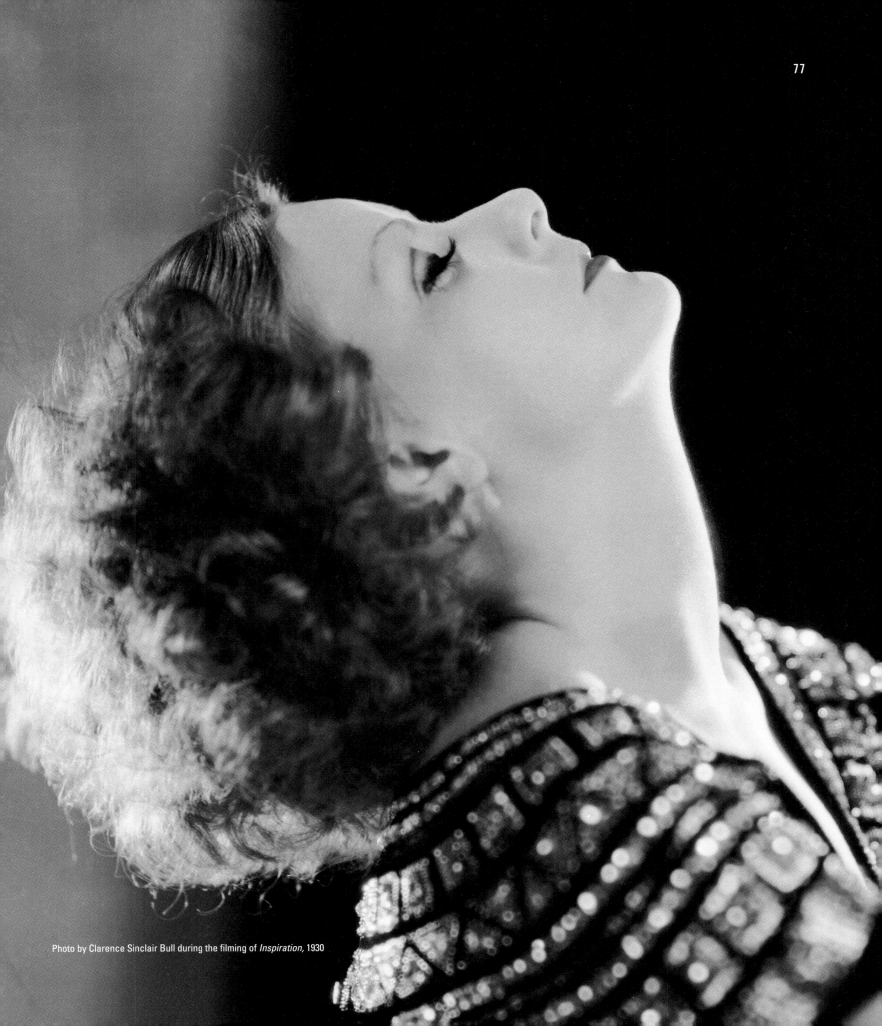

Photo by Clarence Sinclair Bull during the filming of *Inspiration*, 1930

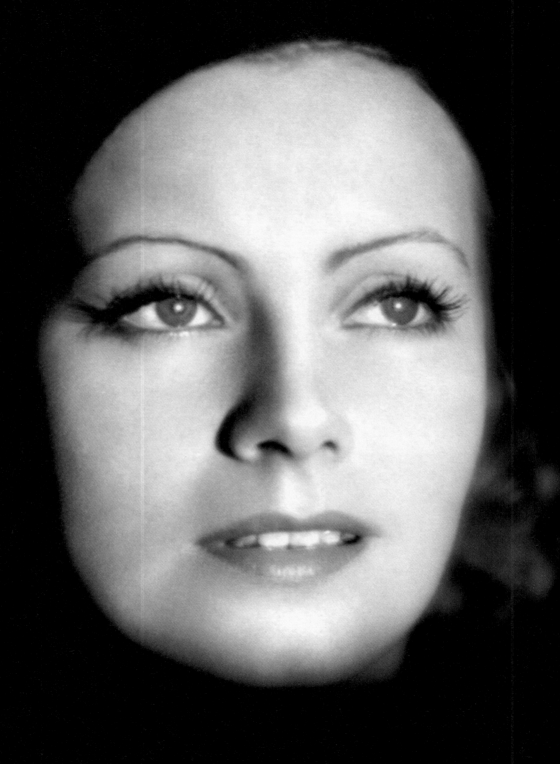

One of the 200 snapshots
taken by Clarence Sinclair
Bull of Greta Garbo's face
requested by MGM to
advertise the film *The Kiss*,
1929.
Clarence Sinclair Bull
succeeded Ruth Harriet
Louise as Greta Garbo's
photographer for MGM film
publicity. His vision is aimed
in giving of the actress
and her expression a more
abstract and ideal image.

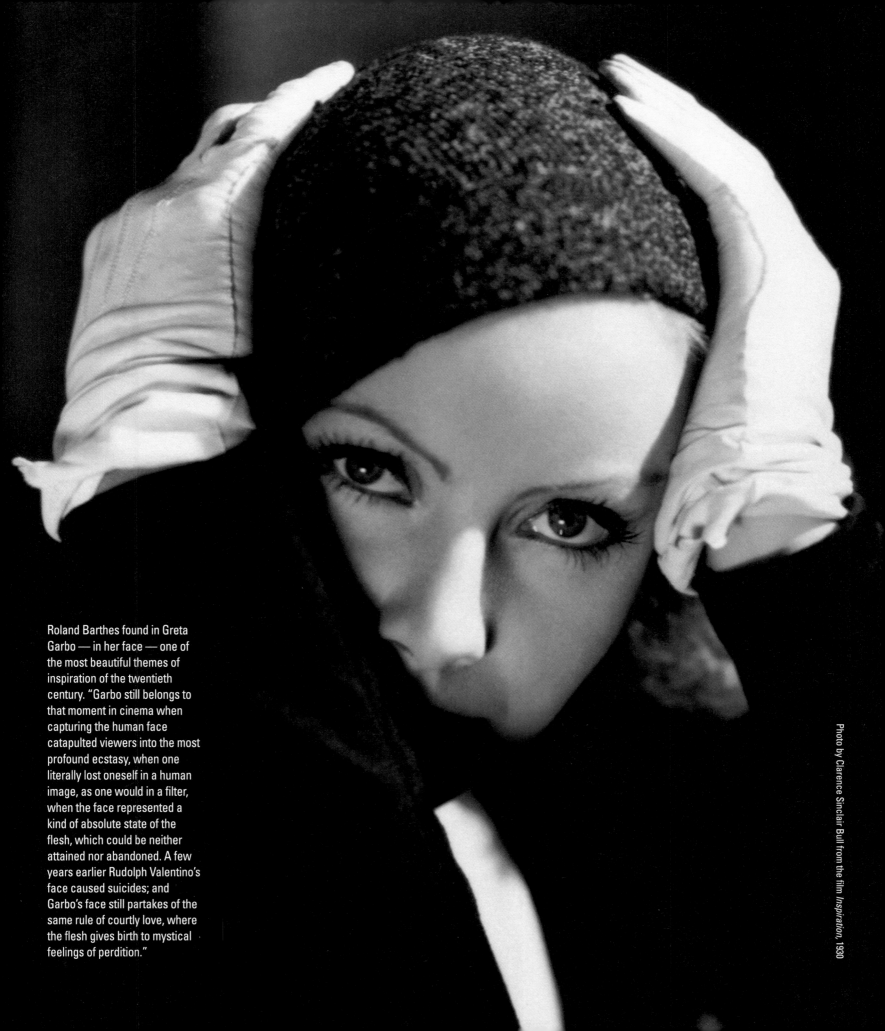

Roland Barthes found in Greta Garbo — in her face — one of the most beautiful themes of inspiration of the twentieth century. "Garbo still belongs to that moment in cinema when capturing the human face catapulted viewers into the most profound ecstasy, when one literally lost oneself in a human image, as one would in a filter, when the face represented a kind of absolute state of the flesh, which could be neither attained nor abandoned. A few years earlier Rudolph Valentino's face caused suicides; and Garbo's face still partakes of the same rule of courtly love, where the flesh gives birth to mystical feelings of perdition."

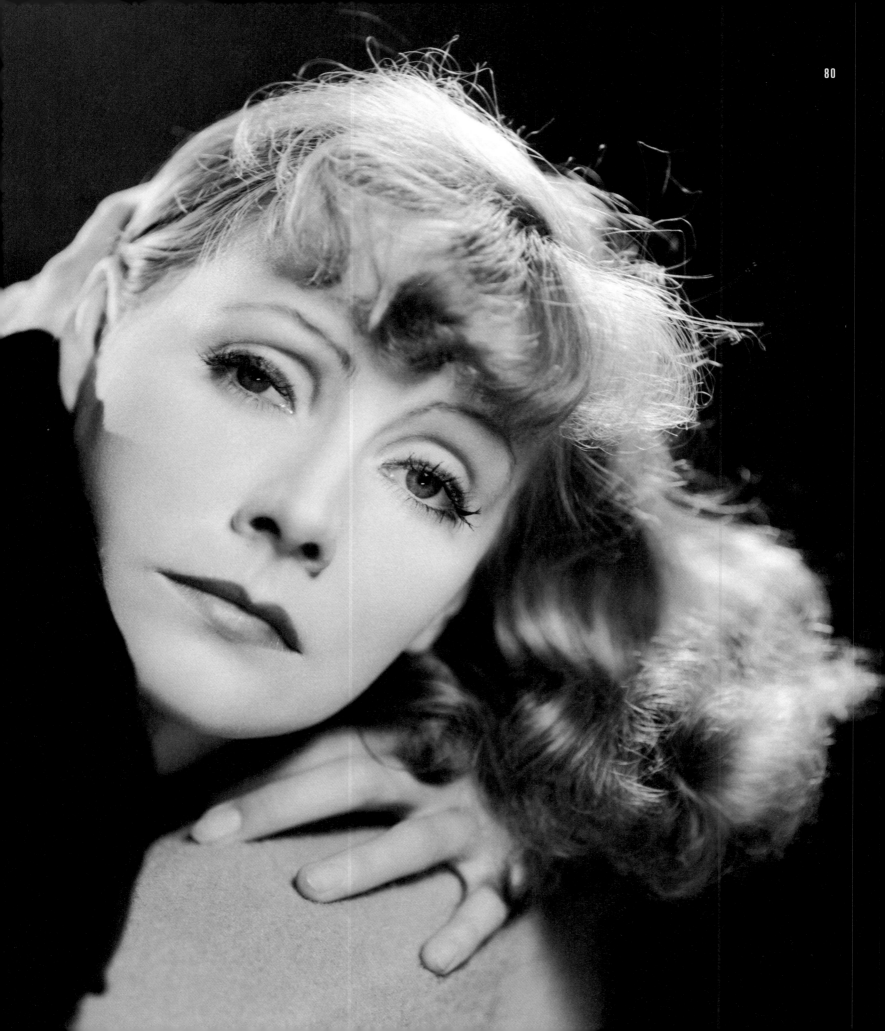

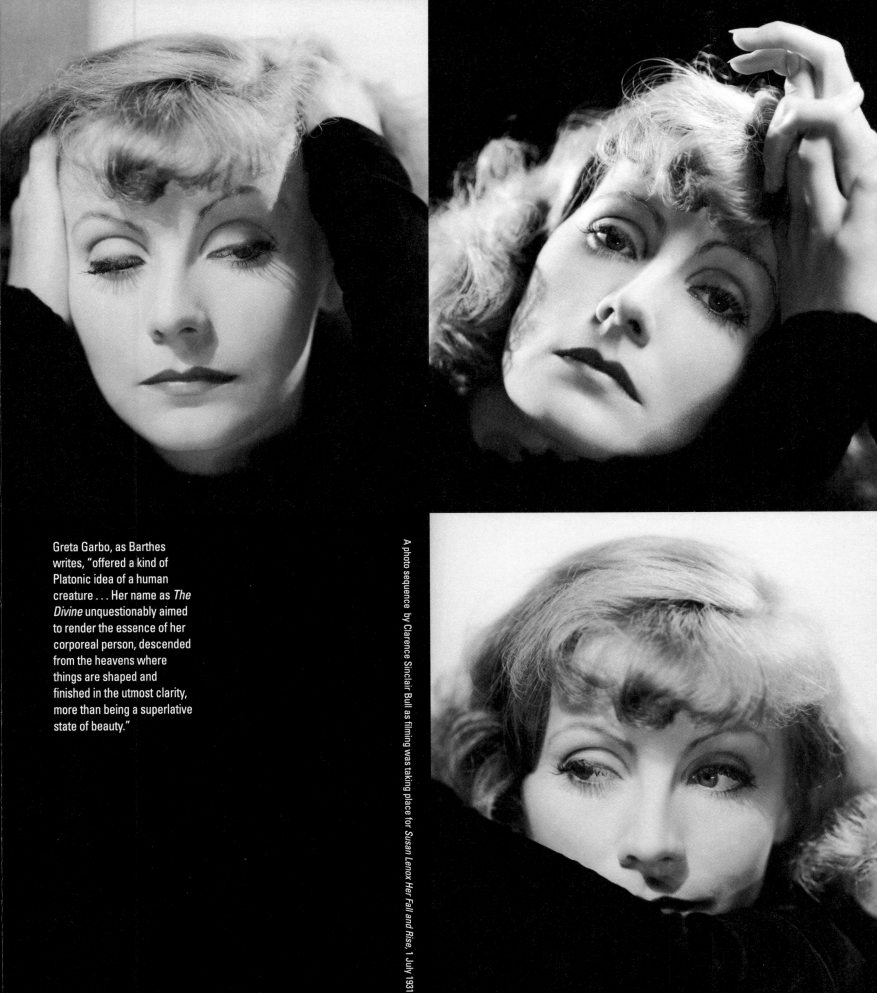

Greta Garbo, as Barthes writes, "offered a kind of Platonic idea of a human creature . . . Her name as *The Divine* unquestionably aimed to render the essence of her corporeal person, descended from the heavens where things are shaped and finished in the utmost clarity, more than being a superlative state of beauty."

A photo sequence by Clarence Sinclair Bull as filming was taking place for *Susan Lenox Her Fall and Rise,* 1 July 1931

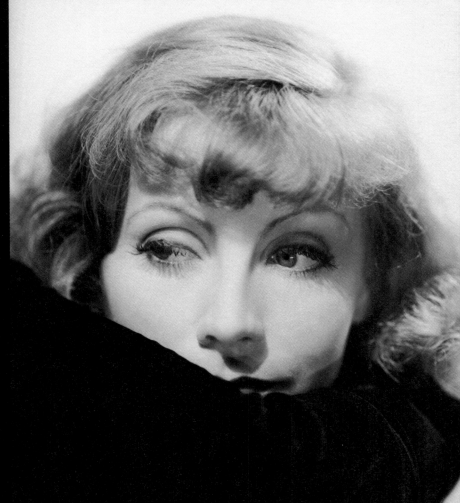

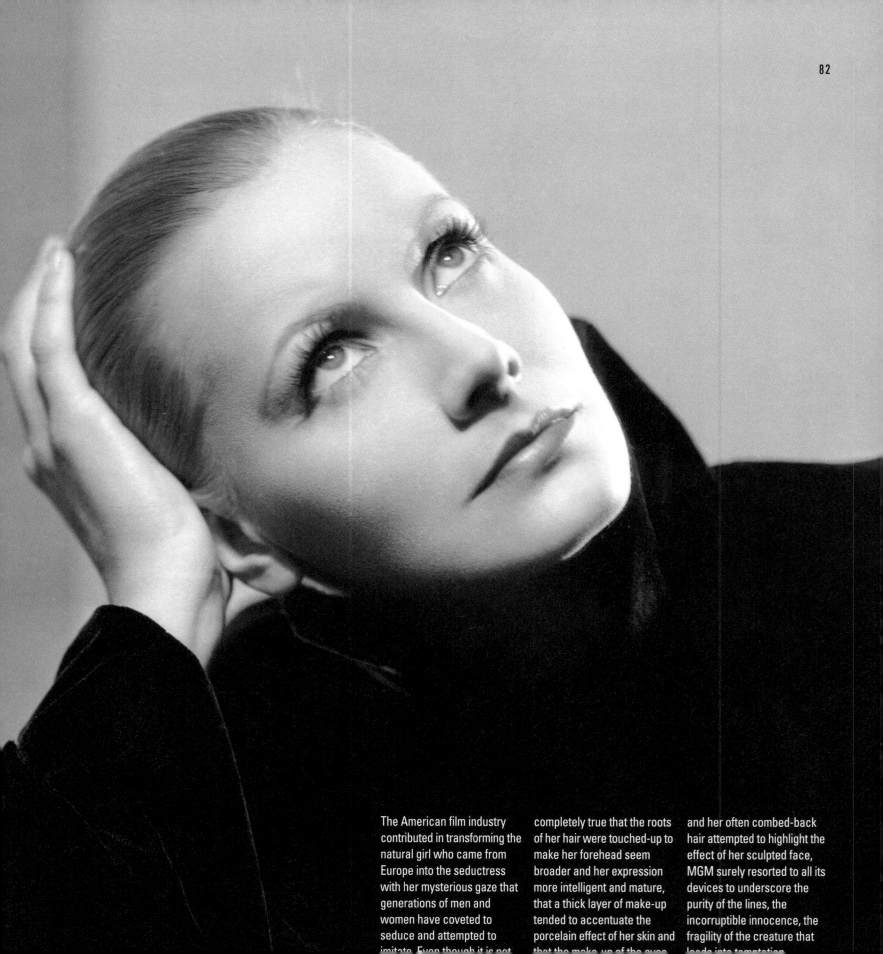

The American film industry contributed in transforming the natural girl who came from Europe into the seductress with her mysterious gaze that generations of men and women have coveted to seduce and attempted to imitate. Even though it is not completely true that the roots of her hair were touched-up to make her forehead seem broader and her expression more intelligent and mature, that a thick layer of make-up tended to accentuate the porcelain effect of her skin and that the make-up of the eyes and her often combed-back hair attempted to highlight the effect of her sculpted face, MGM surely resorted to all its devices to underscore the purity of the lines, the incorruptible innocence, the fragility of the creature that leads into temptation.

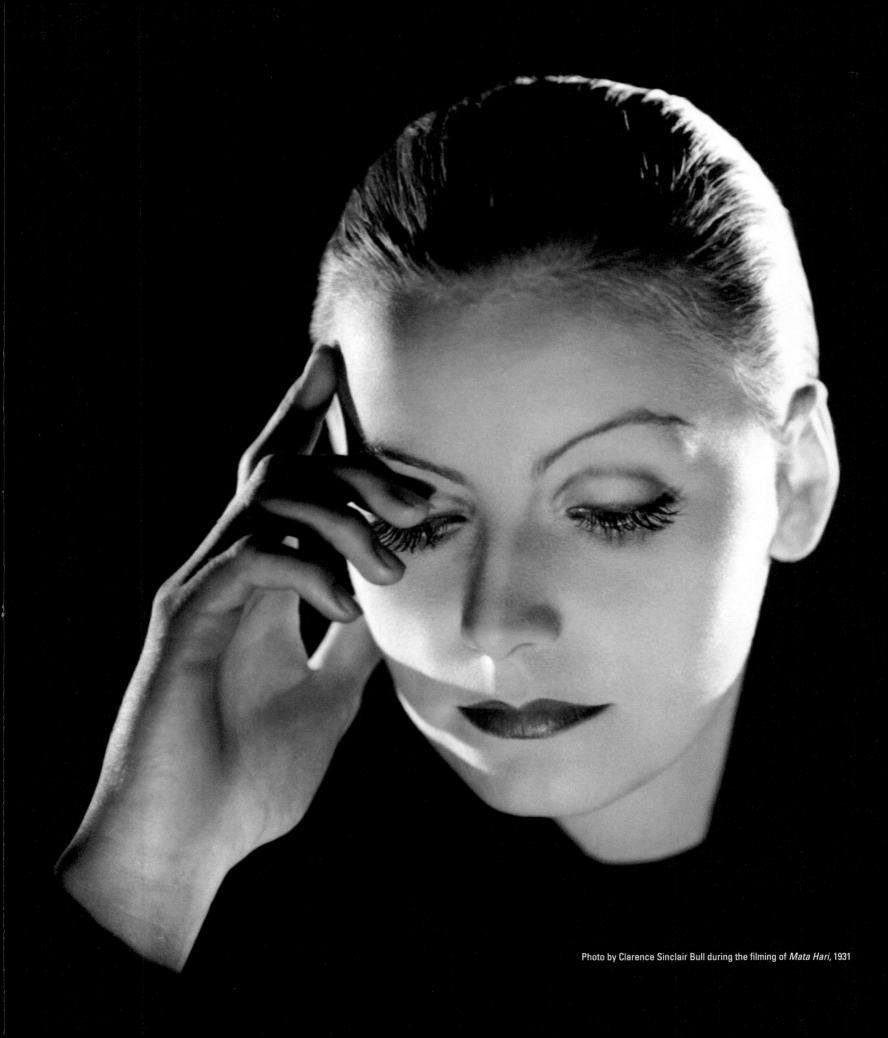

Photo by Clarence Sinclair Bull during the filming of *Mata Hari*, 1931

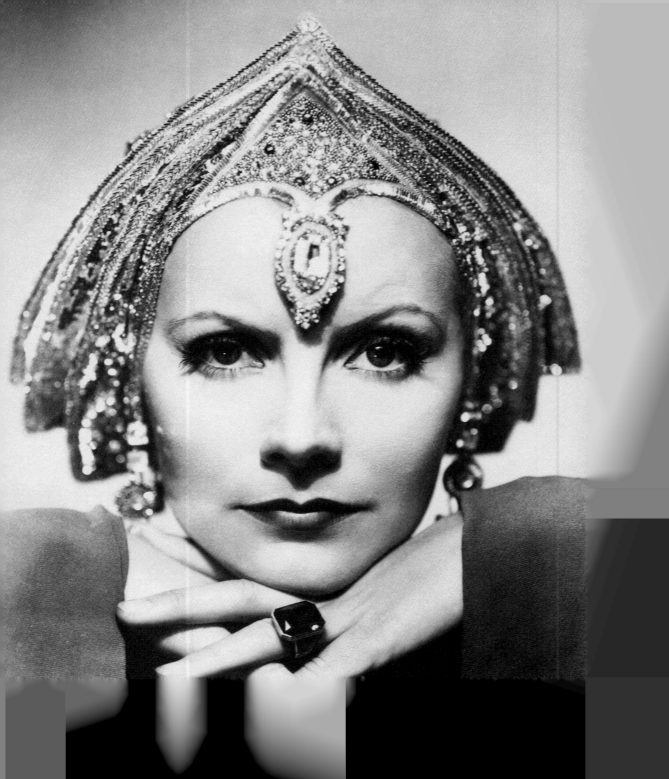

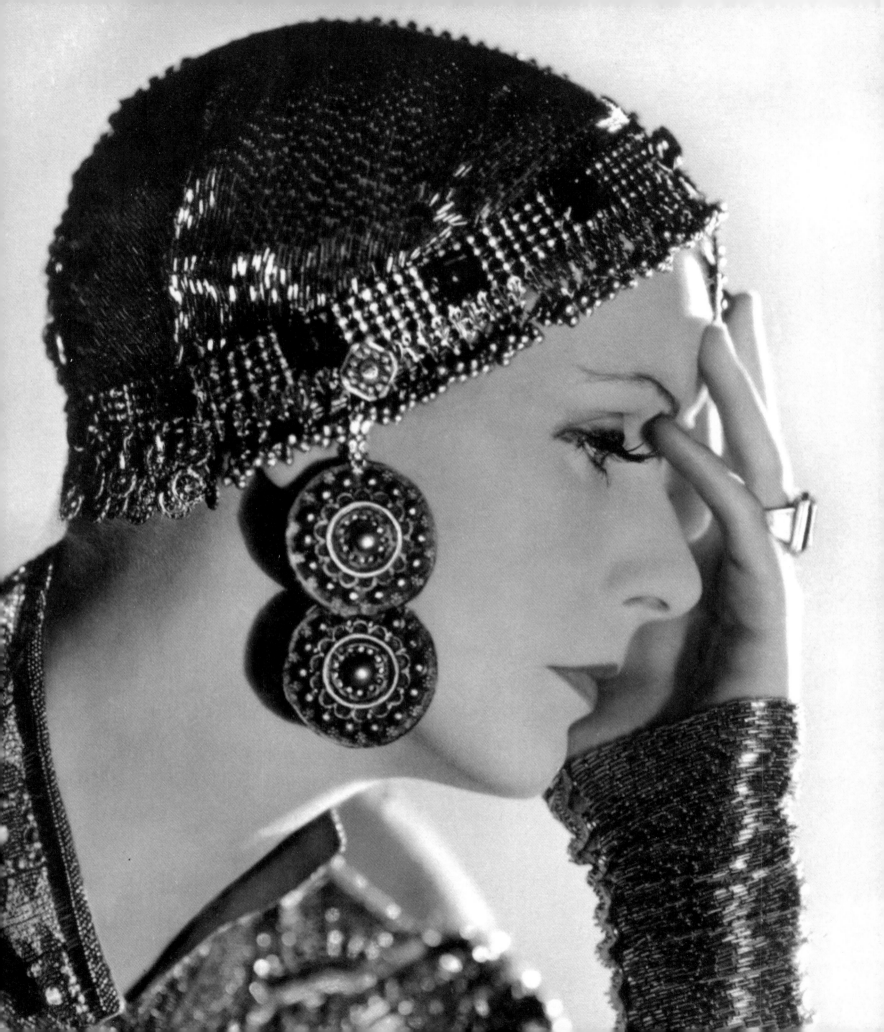

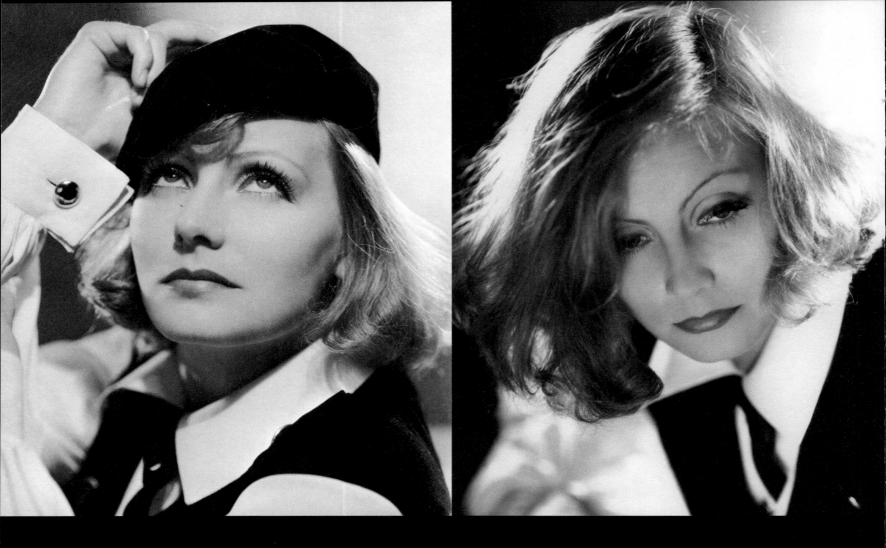

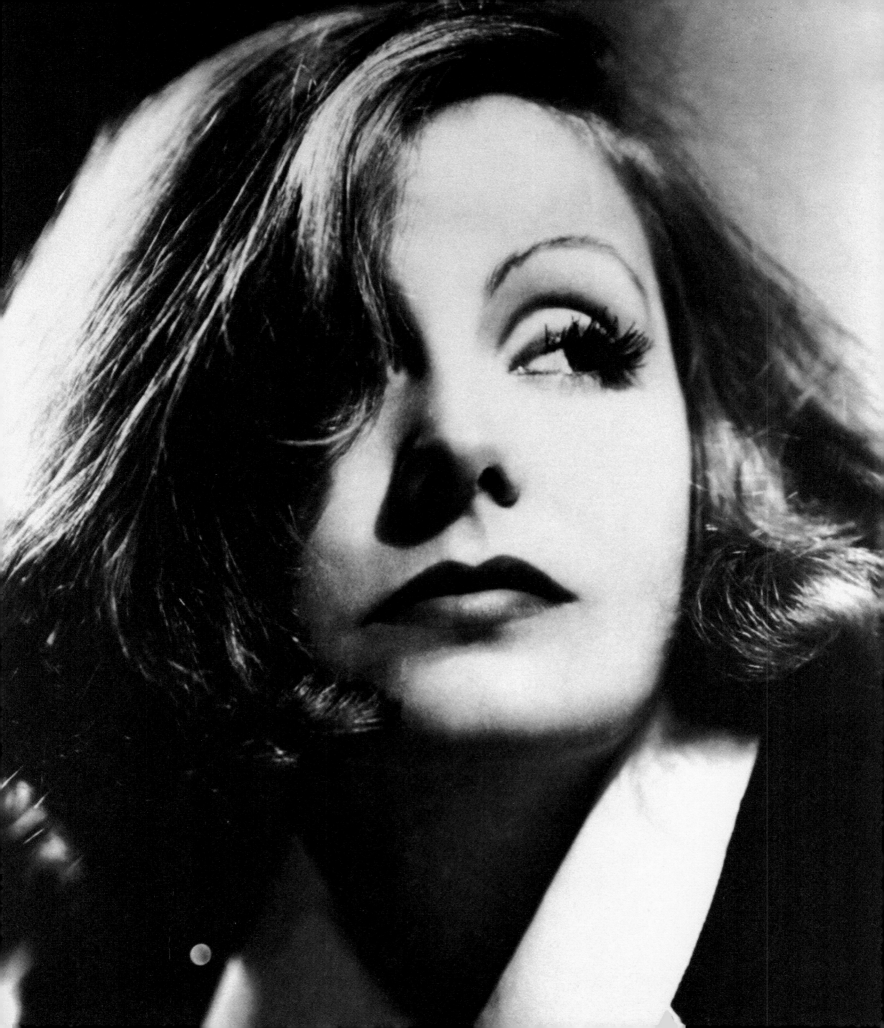

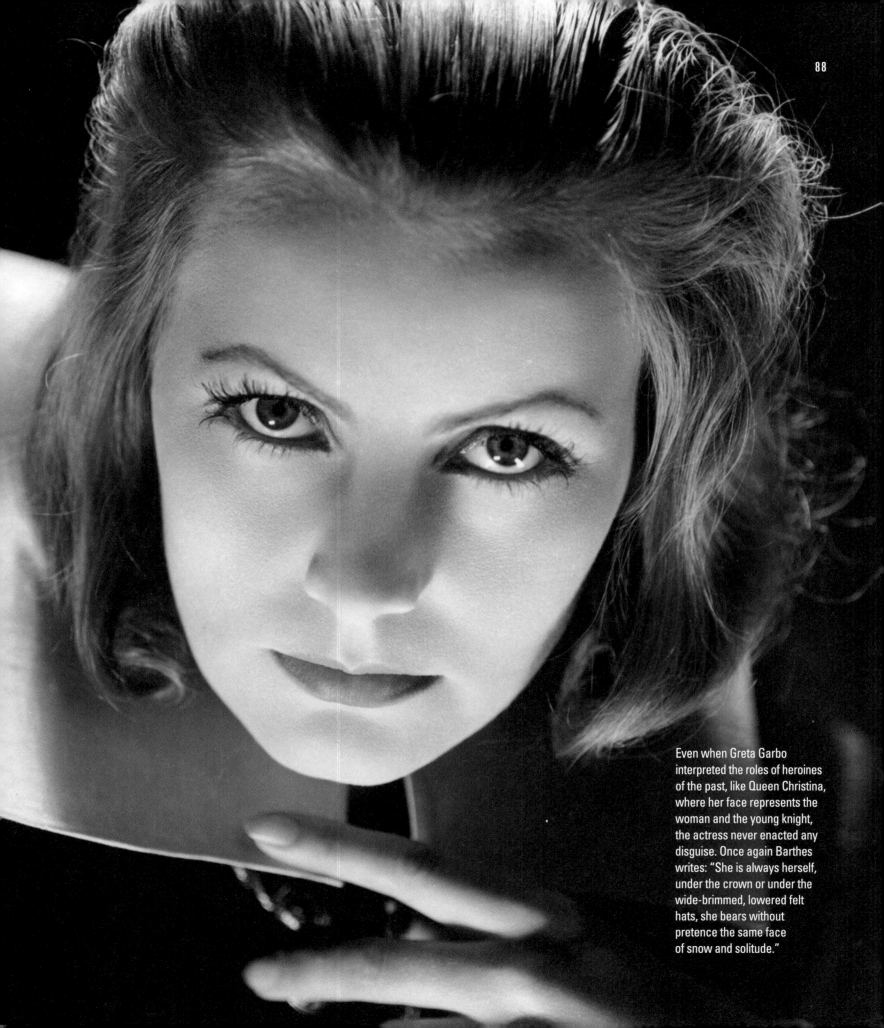

Even when Greta Garbo interpreted the roles of heroines of the past, like Queen Christina, where her face represents the woman and the young knight, the actress never enacted any disguise. Once again Barthes writes: "She is always herself, under the crown or under the wide-brimmed, lowered felt hats, she bears without pretence the same face of snow and solitude."

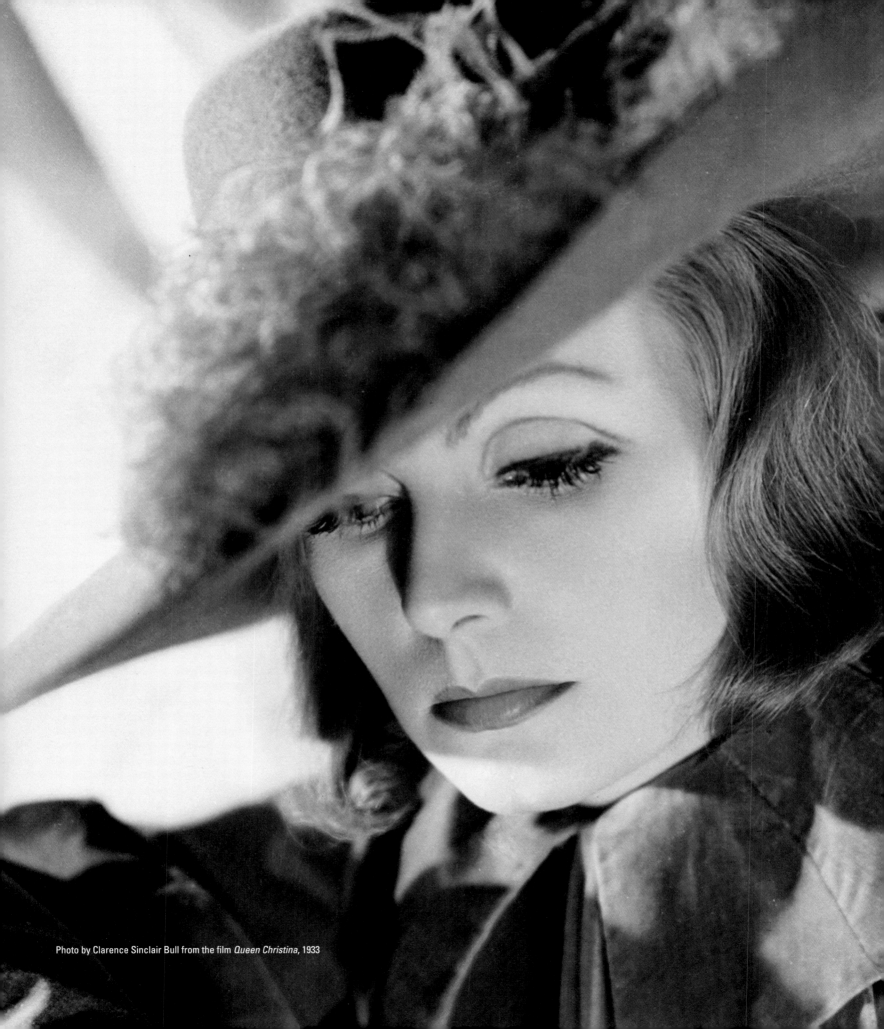

Photo by Clarence Sinclair Bull from the film *Queen Christina*, 1933

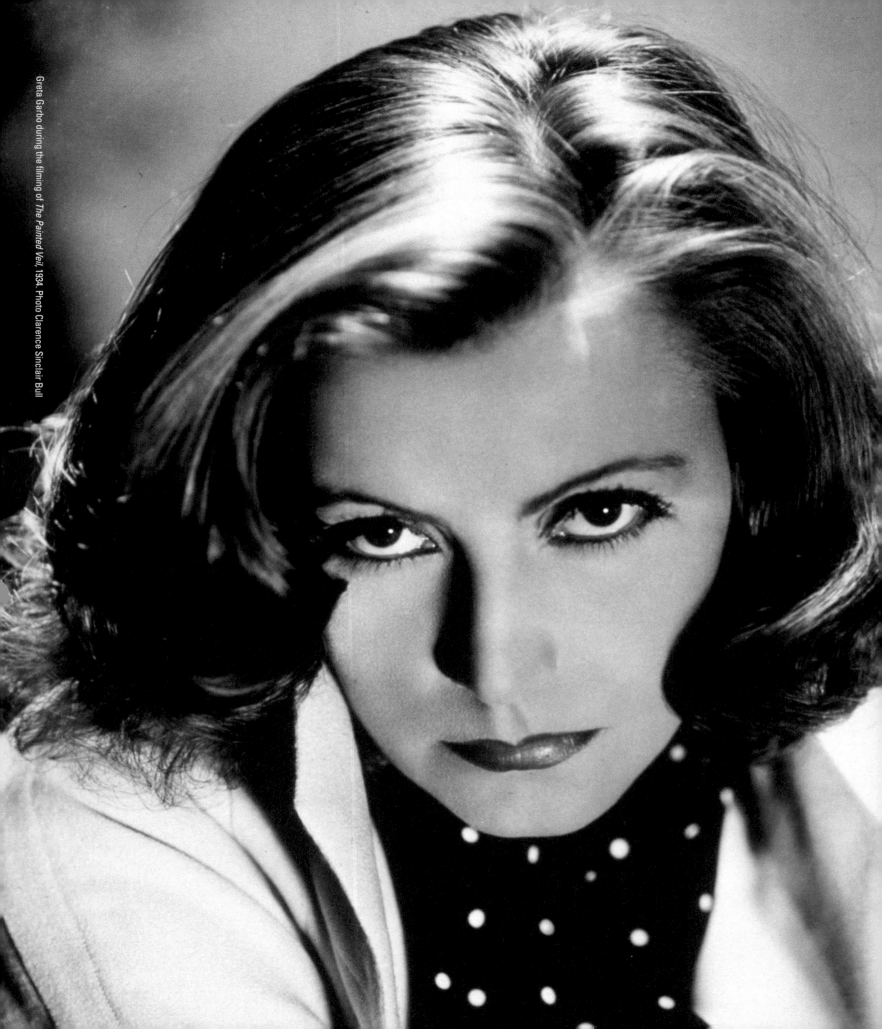

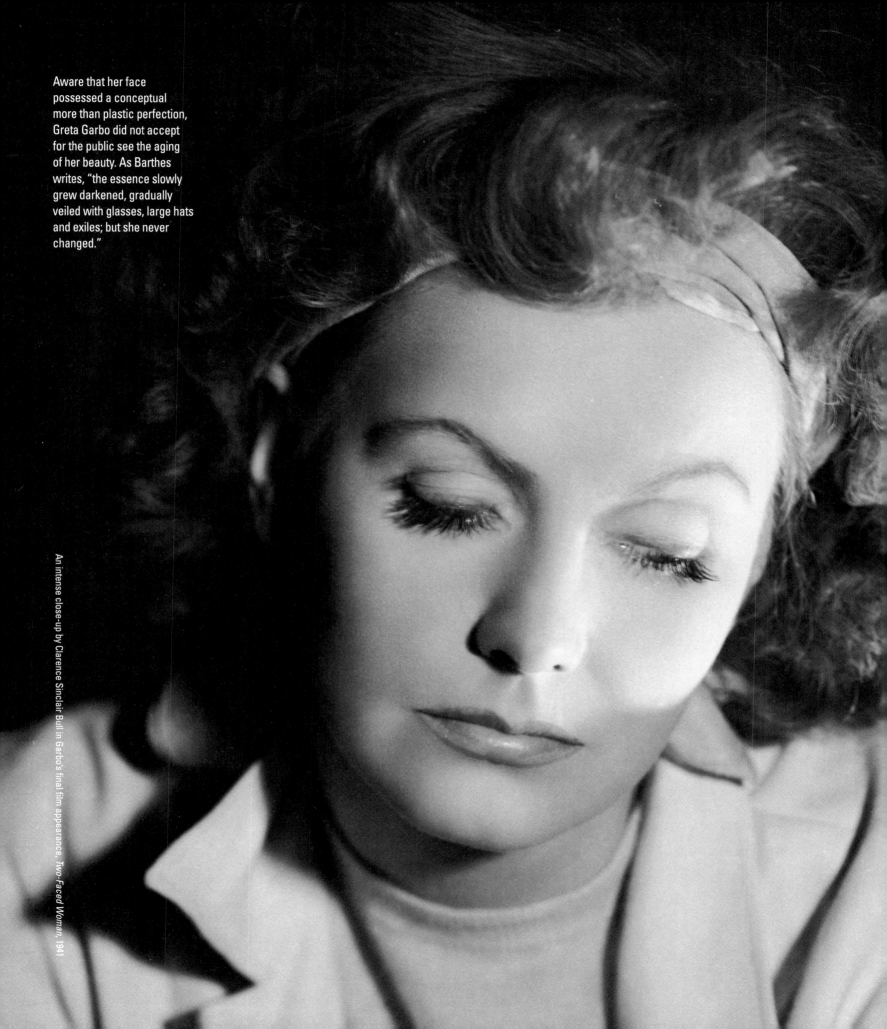

Aware that her face possessed a conceptual more than plastic perfection, Greta Garbo did not accept for the public see the aging of her beauty. As Barthes writes, "the essence slowly grew darkened, gradually veiled with glasses, large hats and exiles; but she never changed."

An intense close-up by Clarence Sinclair Bull in Garbo's final film appearance, *Two-Faced Woman*, 1941.

THE BIRTH OF

A STYLE

Charm and Seduction.

Back in the early days of Hollywood, it was already clear that cinema, through its protagonists, would have determined an unprecedented diffusion of fashion and of the implicit significance of clothing. But no actress has influenced fashion and lifestyle as much as Greta Garbo. As early as the release of her first two films, *The Torrent* and *The Temptress*, Greta Garbo had become a legend. A "Garboesque" style was born. Every woman wanted to have the same hairstyle, the same make-up, wanted to look like her — mysterious, seductive, unattainable. Even the mannequins for women's clothing in shop windows in America, in France and in England were made to resemble Greta Garbo.

Upon her arrival in the United States with the director Mauritz Stiller, the film industry immediately understood that this Swedish actress represented a new model of beauty, able to interpret a type of woman that surpassed the nineteenth-century model but which was also different even from the one cinema had been dressing for a decade: a figure so emancipated to be able to reclaim those weapons of seductions and sex appeal the previous decade had disdained. Greta Garbo, like Marlene Dietrich and Joan Crawford, shortly afterwards, no longer impersonated women involved in work but rather fascinating women — femmes fatales — who treated their lovers as equals.

The plots of the films in which Greta Garbo was the protagonist and the snapshots of the actress taken to advertise the release of the films at the box office were carefully selected to accentuate the image of the femme fatale. Her clothes had to contribute to creating the character of the great seductress. For this purpose, legendary designers were called, like Clement Andreani, known as André-Ani, and Gilbert Adrian Greenburg, Adrian, who created a series of models, such as the very elaborate ones in *Mata Hari,* which travelled the globe and became a source of inspiration for contemporary fashion.

Greta Garbo in a nude-look outfit in the first seduction scene in the film *Mata Hari*, released in 1931, in which the costumes by Adrian contributed to creating her character — an intriguing, romantic and seductive spy.

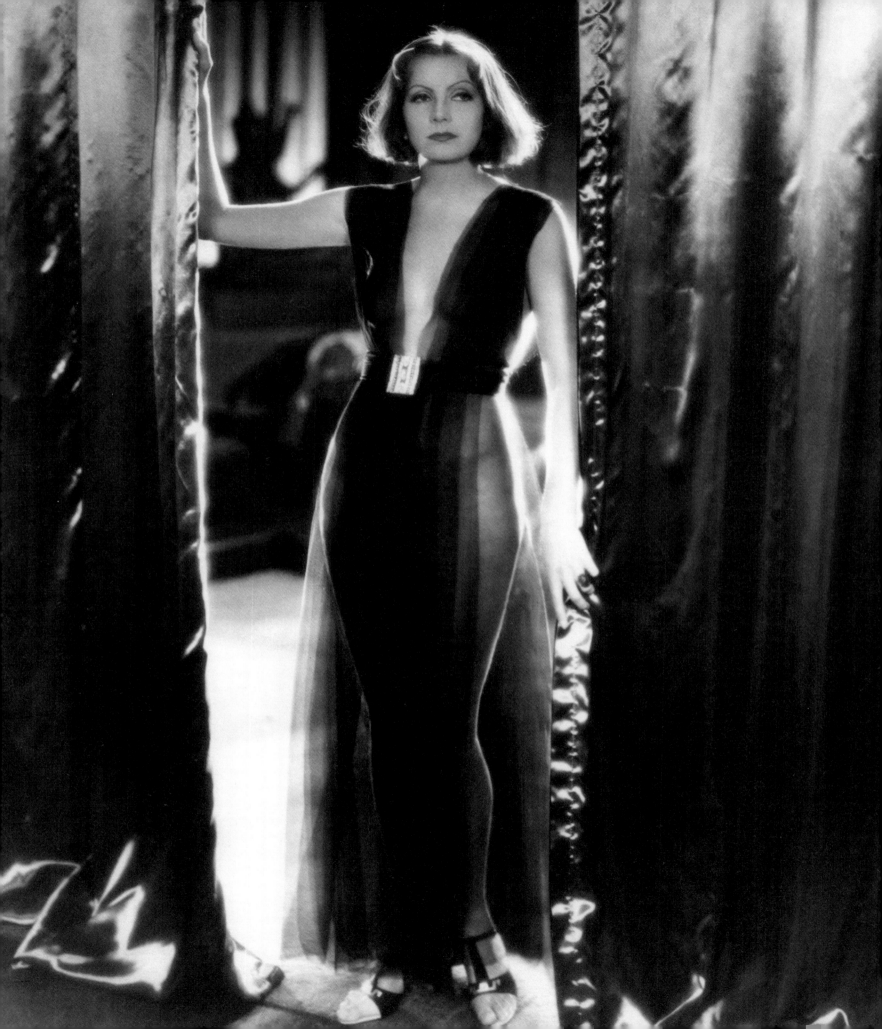

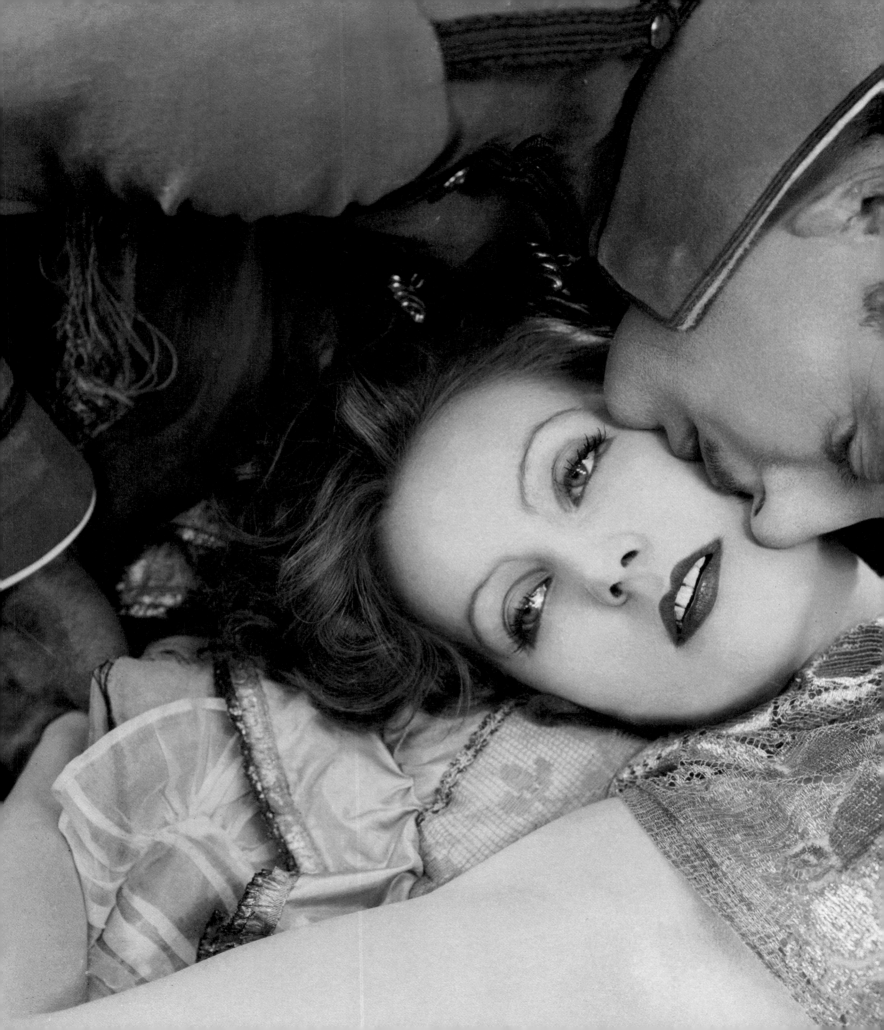

One of the scenes from the film *Flesh and the Devil*, 1926, with John Gilbert, who during the filming hopelessly fell in love with the Swedish actress.
Thanks to the passion of the characters, to Greta Garbo's beauty and its brilliance and to the photography of William Davies, the film consecrated the actress as the most seductive woman of the period, surpassing the charm of Theda Bara, Francesca Bertini and Gloria Swanson.

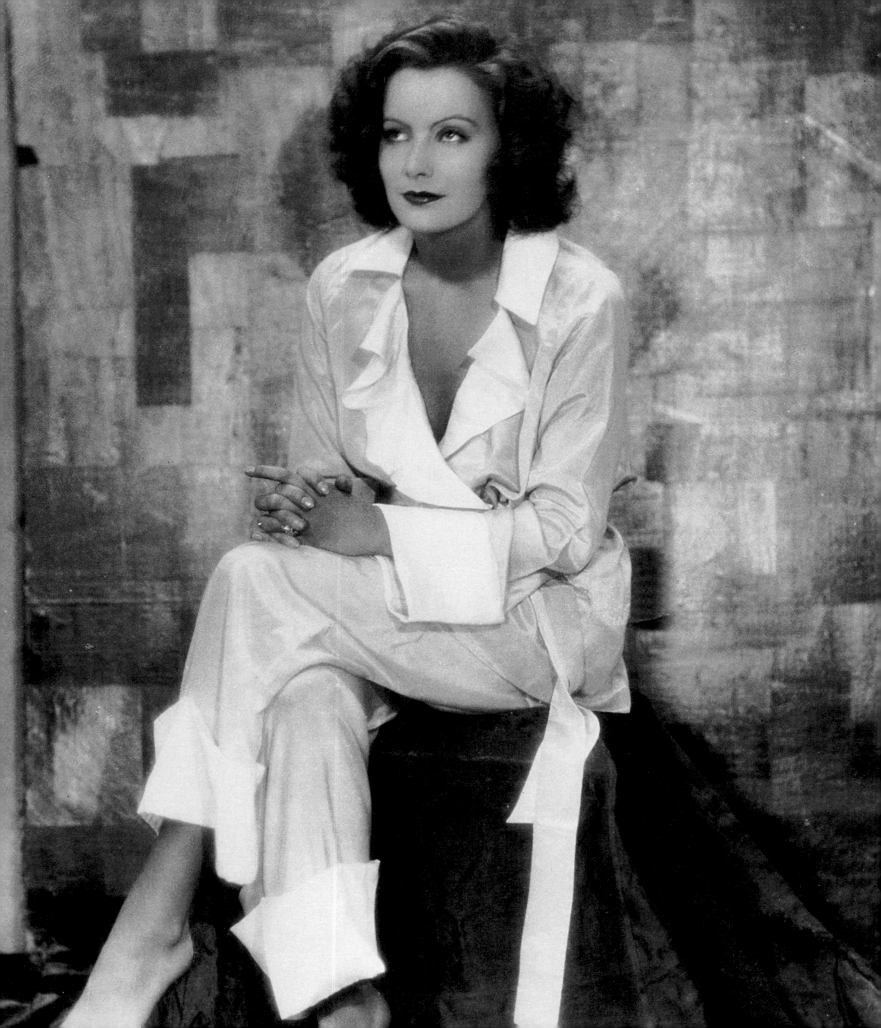

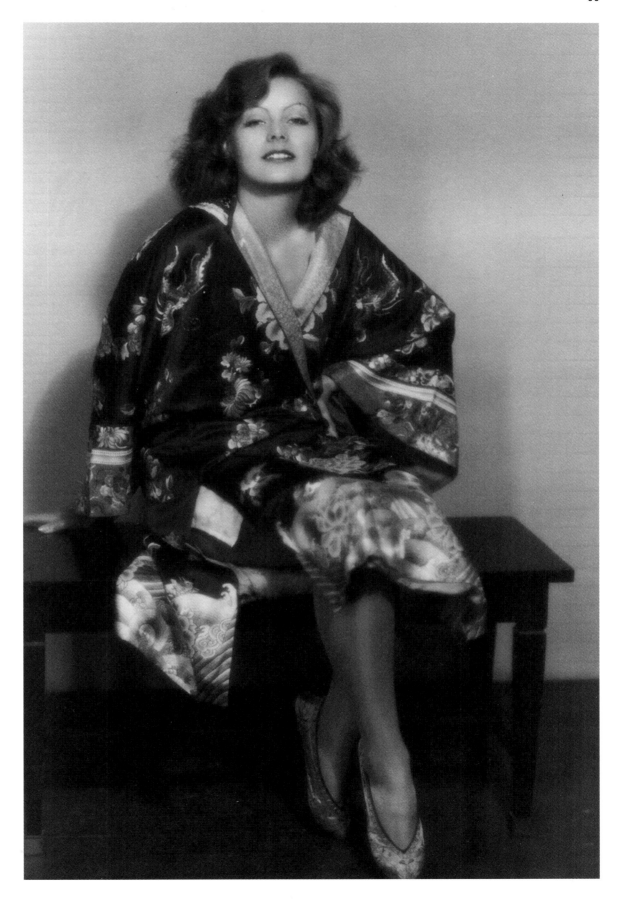

In Greta Garbo's photo
taken by Ruth Harriet Louise
between July 1927 to
advertise the first version of
Anna Karenina and November
of that same year during the
filming of *The Divine Woman*,
Garbo's style takes on more
precise features, thus
becoming simpler as well
as more elegant and sensual.
Even though Greta Garbo had
refused to pose for fashion
photos, it was impossible
for the studio shots not to
emphasize her particular
femininity even through
the clothing she wore.
In these photo shoots, Louise
alternates portraits which
thanks to costumes,
accessories and Oriental-style
themes accentuate the exotic
charm of the actress, with
poses that play on a positive
association between a model
of femininity and androgynous
fashion, which would also
take place subsequently
with Marlene Dietrich.
On the left, Louise portrays
Garbo against a geometric
backdrop while she wears
a lavish men's silk pyjama.

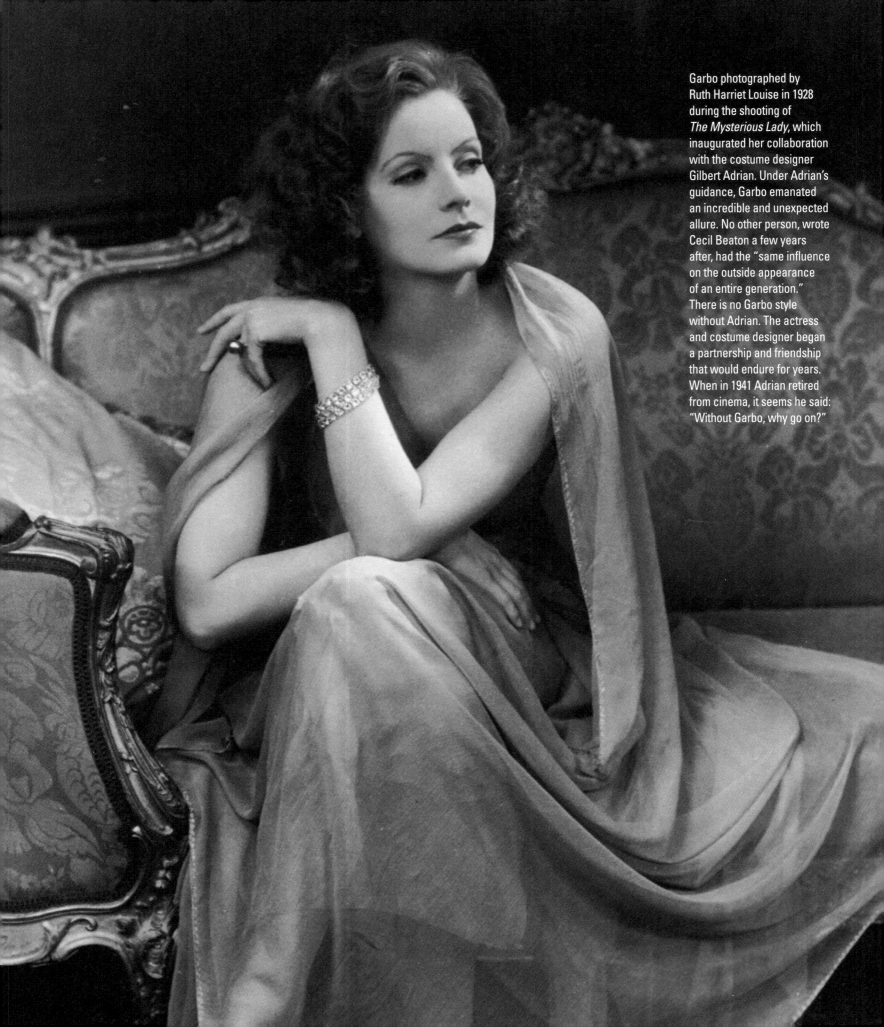

Garbo photographed by Ruth Harriet Louise in 1928 during the shooting of *The Mysterious Lady*, which inaugurated her collaboration with the costume designer Gilbert Adrian. Under Adrian's guidance, Garbo emanated an incredible and unexpected allure. No other person, wrote Cecil Beaton a few years after, had the "same influence on the outside appearance of an entire generation." There is no Garbo style without Adrian. The actress and costume designer began a partnership and friendship that would endure for years. When in 1941 Adrian retired from cinema, it seems he said: "Without Garbo, why go on?"

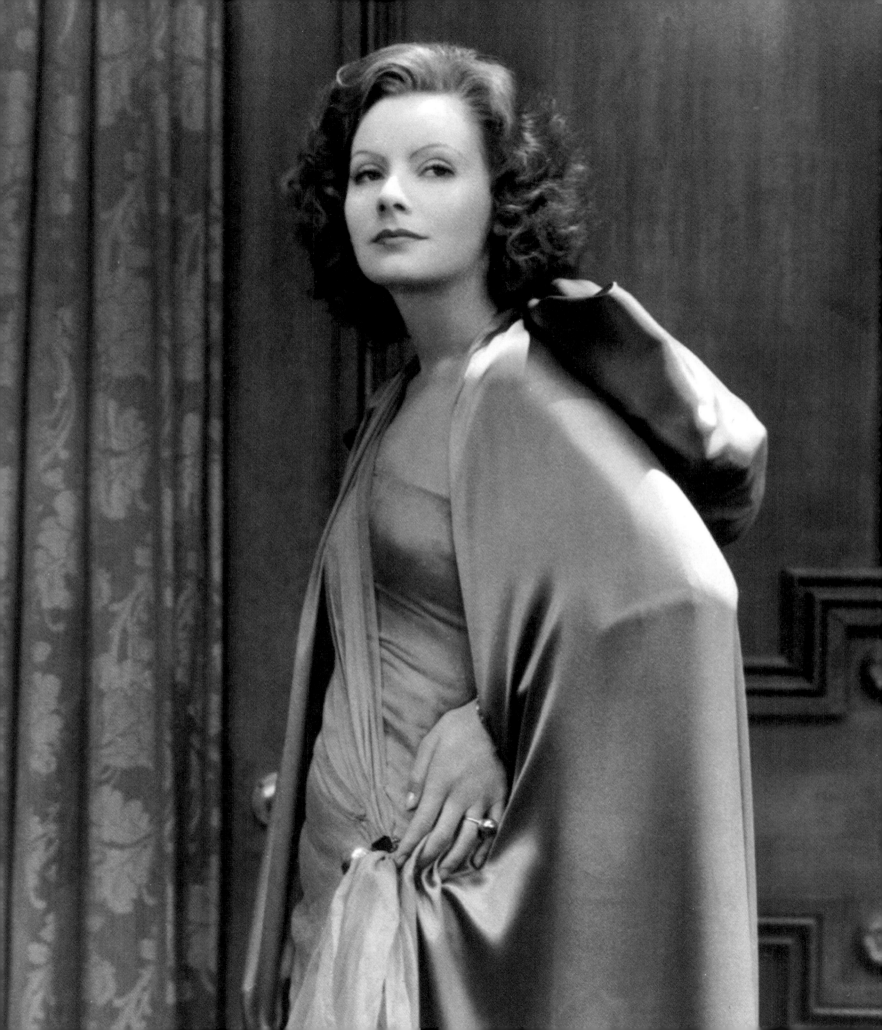

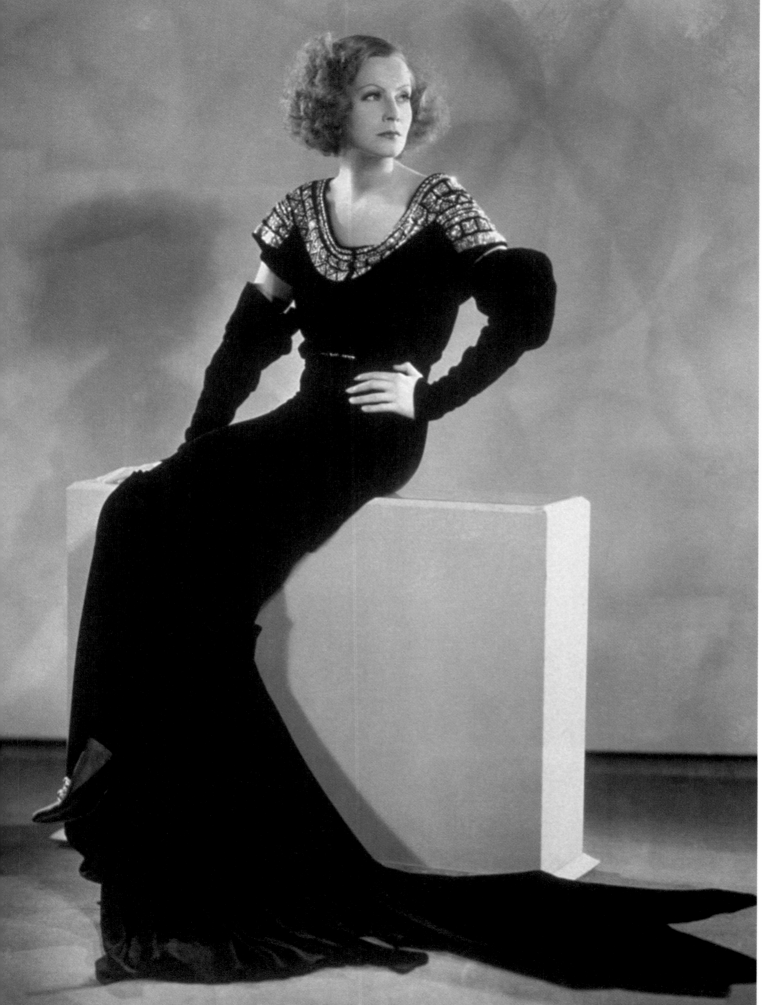

Photo by Clarence Sinclair Bull for the film *Inspiration*, 1931

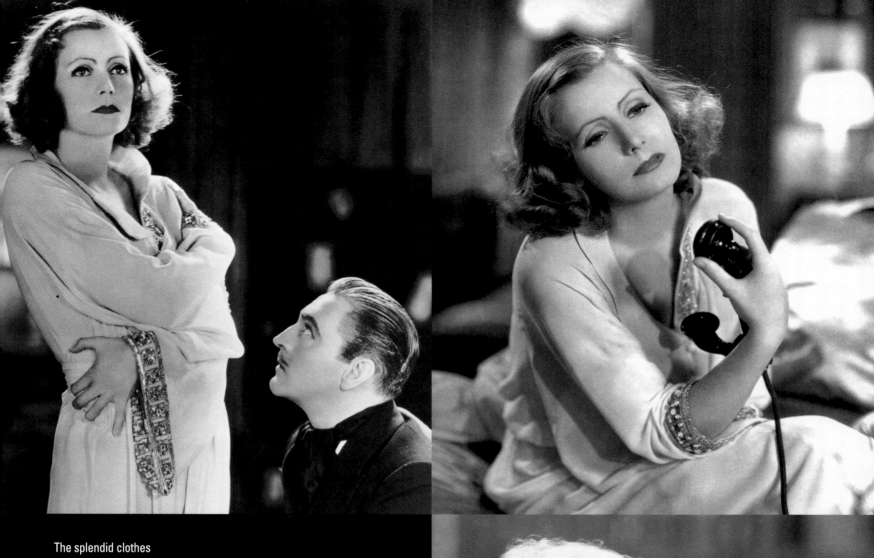

The splendid clothes designed by Adrian for Greta Garbo in the films *Inspiration*, *Grand Hotel* and *As You Desire Me*, released between 1931 and 1932, became a reference point for the fashion of those years. In America's department stores, like Macy's, Bloomingdale's and Saks, there were entire sections dedicated to cinema where customers could purchase at a low cost clothes copied from box office hits.

Photos by Clarence Sinclair Bull for the films *Grand Hotel* and *As You Desire Me*, 1932

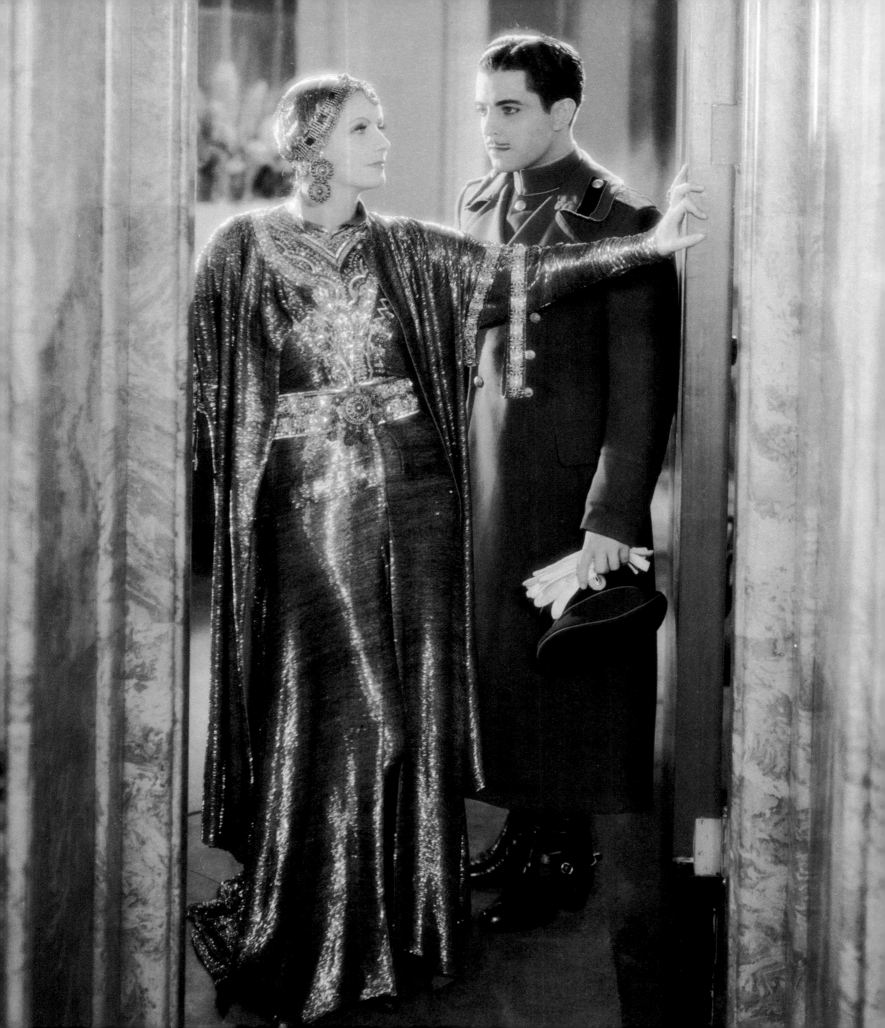

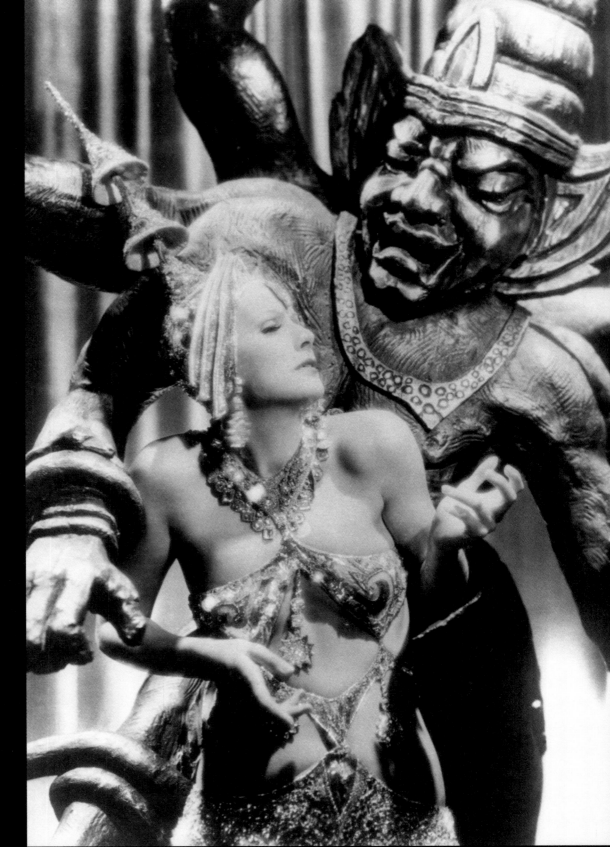

The costume designer Gilbert Adrian for the film *Mata Hari* was inspired by the Oriental creations of the French tailor Paul Poiret, who in turn had been influenced by Diaghilev's Ballets Russes, staged in Paris in 1909. This elaborate costume consisted in a gold lame draping dress with a jewel-bust embroidered by sequins, open upon leggings, entirely covered with glass beads, which gave Garbo's tomboy legs a new sex appeal. According to Hedda Hopper, in order to make the outfit and the headgear, eight embroiderers were employed for nine weeks. The cost was 2,000 dollars, a considerable sum for the period; the weight of the costume was also impressive: 50 pounds.

No less elaborate was the costume Greta Garbo and her double, June Knight, a Broadway dancer, wore in Mata Hari's celebrated dance to Shiva.

Photo Clarence Sinclair Bull, 1931

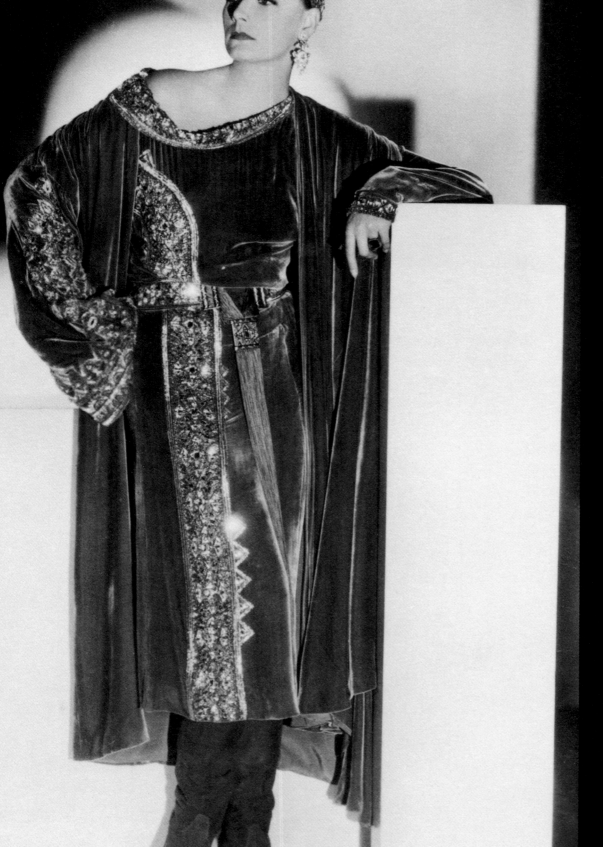

Garbo, who normally did not
love scene outfits, was struck
by the quite rich models
for *Mata Hari*.
Mercedes de Acosta,
who assiduously kept Greta
Garbo's company during
those years in Hollywood,
credited herself as having
suggested to Adrian the
costume in the final scene,
when Mata Hari was shot.
The long black velvet cape
worn by Garbo with her hair
combed behind magnified the
dramatic effect of the finale.

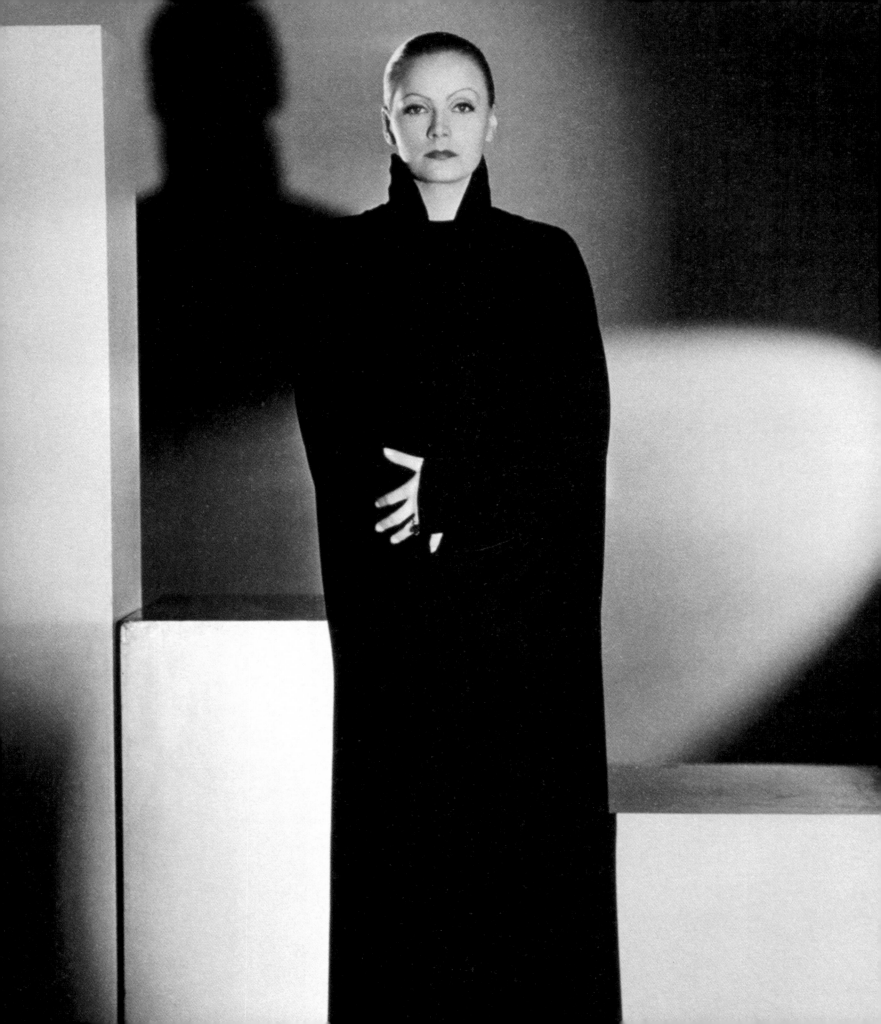

More than a film, *The Painted Veil*, based upon a novel by William Somerset Maugham, seems like an ad studied to extol Garbo's beauty and style. Even though certain appearances of the diva in white, almost nunnish clothing and intricate headgear did not avoid criticism from *The New York Times*, the knee-length jacket with alamar eyelets and the turban that extolled the diva's perfect face became quite fashionable, influencing the style of Parisian *couturiers* in subsequent years.

Photo Clarence Sinclair Bull, 1934

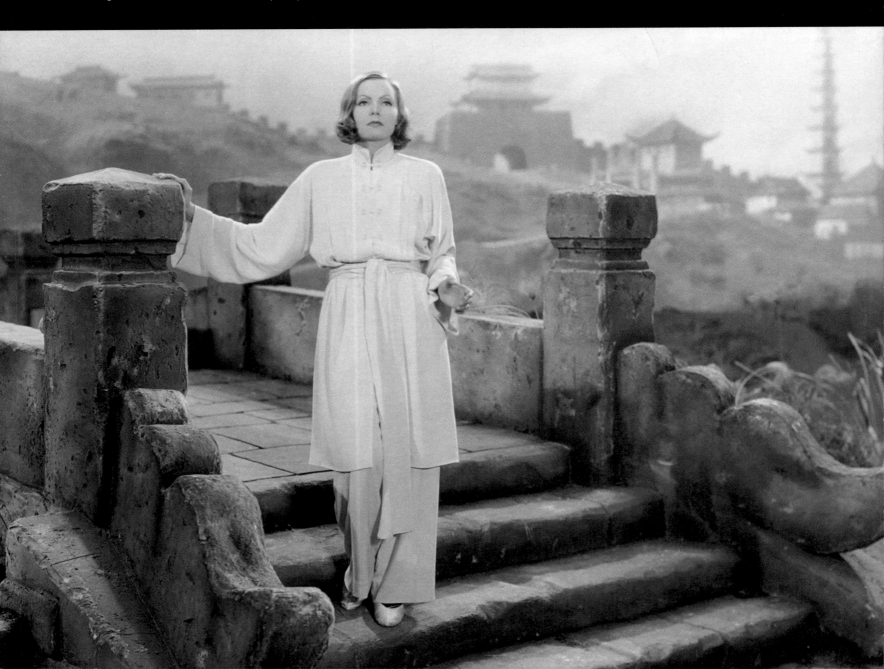

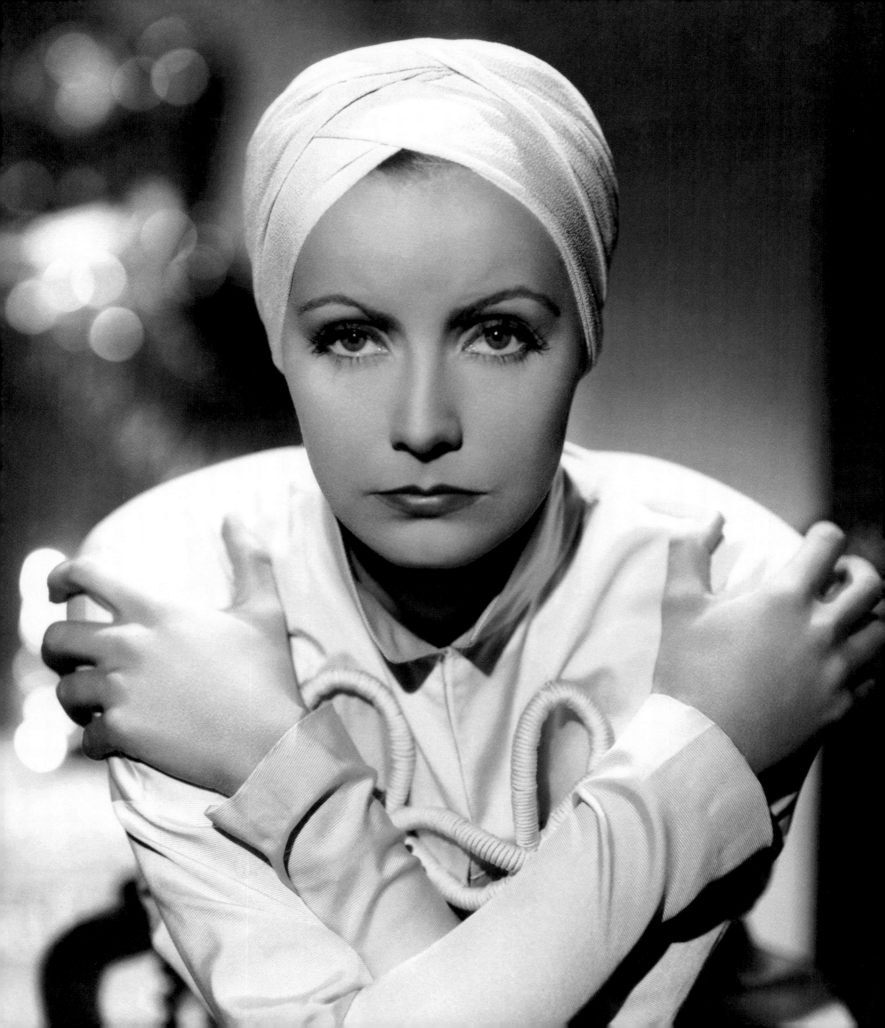

Costumes Setting Trends. "The most interesting thing about Greta," stated Adrian, "is her ability to wear an outfit and create a style straightaway. She dresses without pretence, with naturalness, and gives aristocratic charm to both the masculine outfits of Christina and the luxurious and feminine ones of Marguerite Gauthier."

Greta Garbo was able to exert an enormous influence on outside appearances, even when she wore period dresses in her movies. Adrian's historical outfits did not accurately recreate those actually worn during the period, nor did they resemble the models published by fashion magazines of the time. Precisely because the shooting of a film took place many months before the release in theatres, the costume designer, as Adrian sustained, had to be able to play in advance on the style that would take hold. Garbo's masculine clothes in *Queen Christina* immediately affected the fashion of the times. Following the release of the film, heavy velvet jackets, double-breasted coats and broad linen collars filled American department stores, from Macy's to Gimbel's and Saks Fifth Avenue, where the film outfits, recreated at an accessible price, soon became popular. The same phenomenon took place a few years earlier with the film *Romance*, and then afterwards with *Anna Karenina* and *Camille*, to which *Vogue* dedicated an issue.

Anna Karenina, 1935. Photo Clarence Sinclair Bull

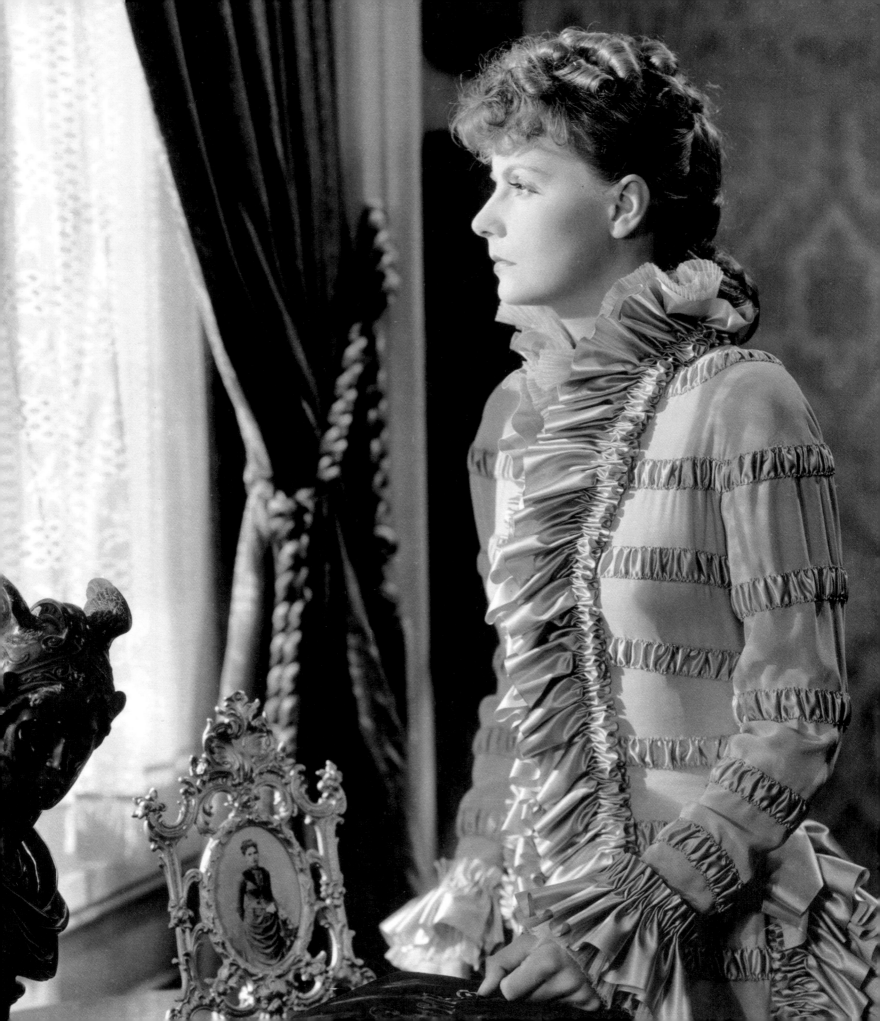

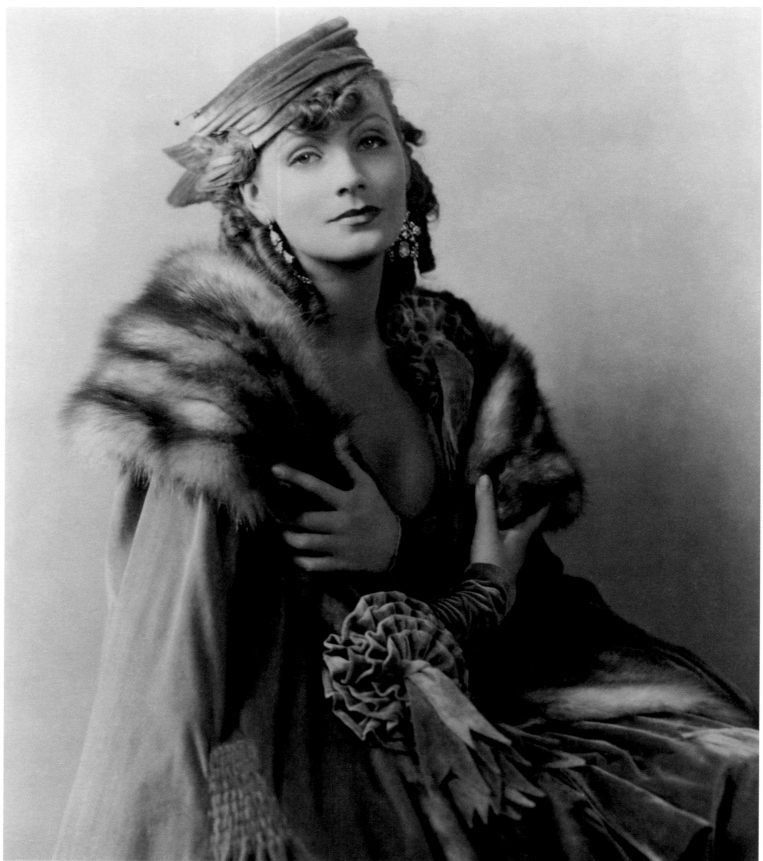

Photo George Hurrell, 1930

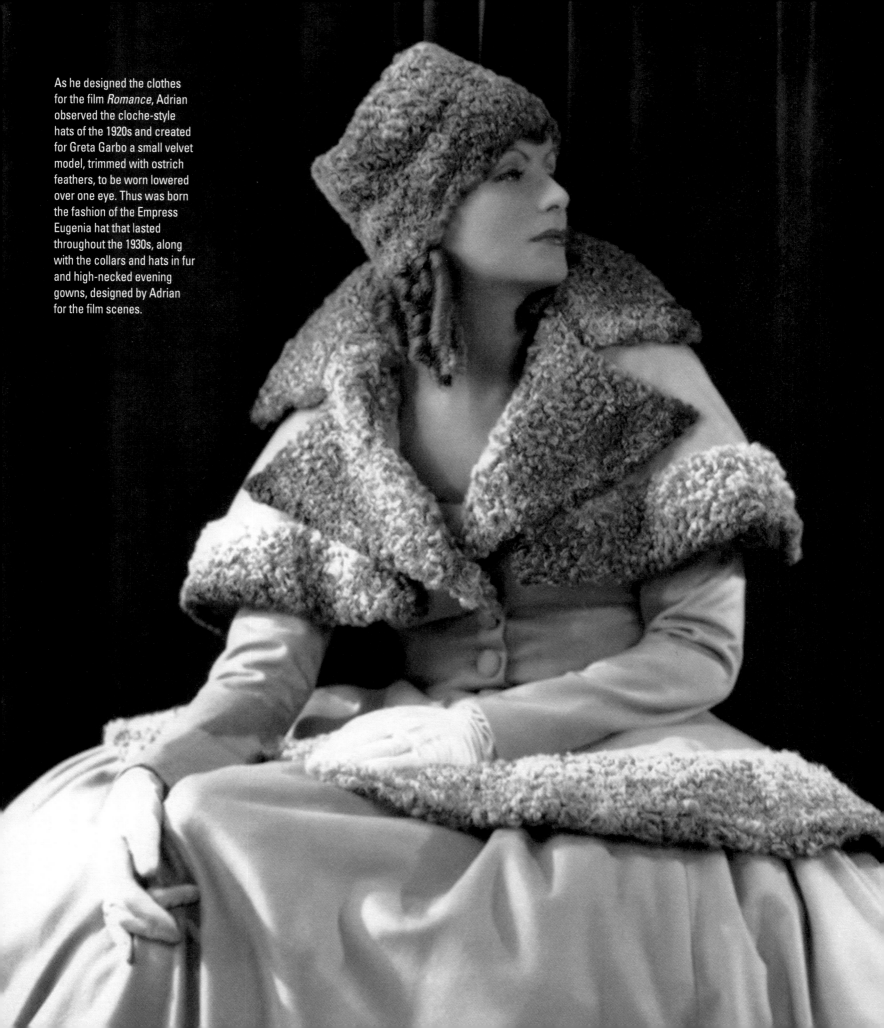

As he designed the clothes for the film *Romance*, Adrian observed the cloche-style hats of the 1920s and created for Greta Garbo a small velvet model, trimmed with ostrich feathers, to be worn lowered over one eye. Thus was born the fashion of the Empress Eugenia hat that lasted throughout the 1930s, along with the collars and hats in fur and high-necked evening gowns, designed by Adrian for the film scenes.

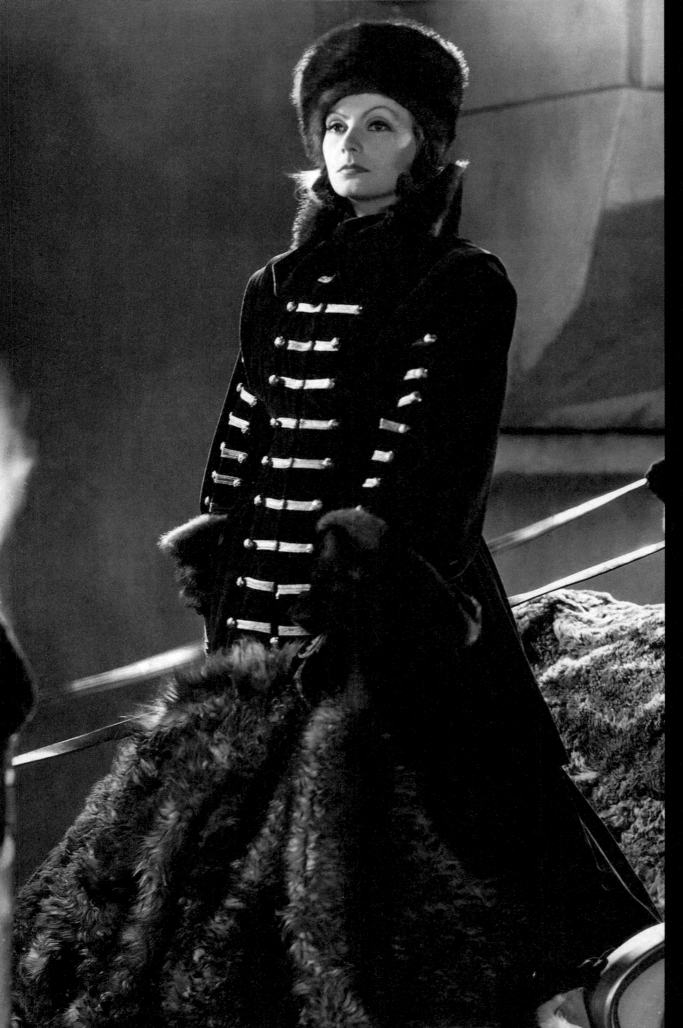

Queen Christina, released in 1933, was a film that immediately spread the fashion of double-breasted coats, of broad white or velvet collars and above all of women's trousers. In Robert Mamoulian's film, Greta Garbo wanted to wear men's clothes, thus giving her character an extraordinary presence.

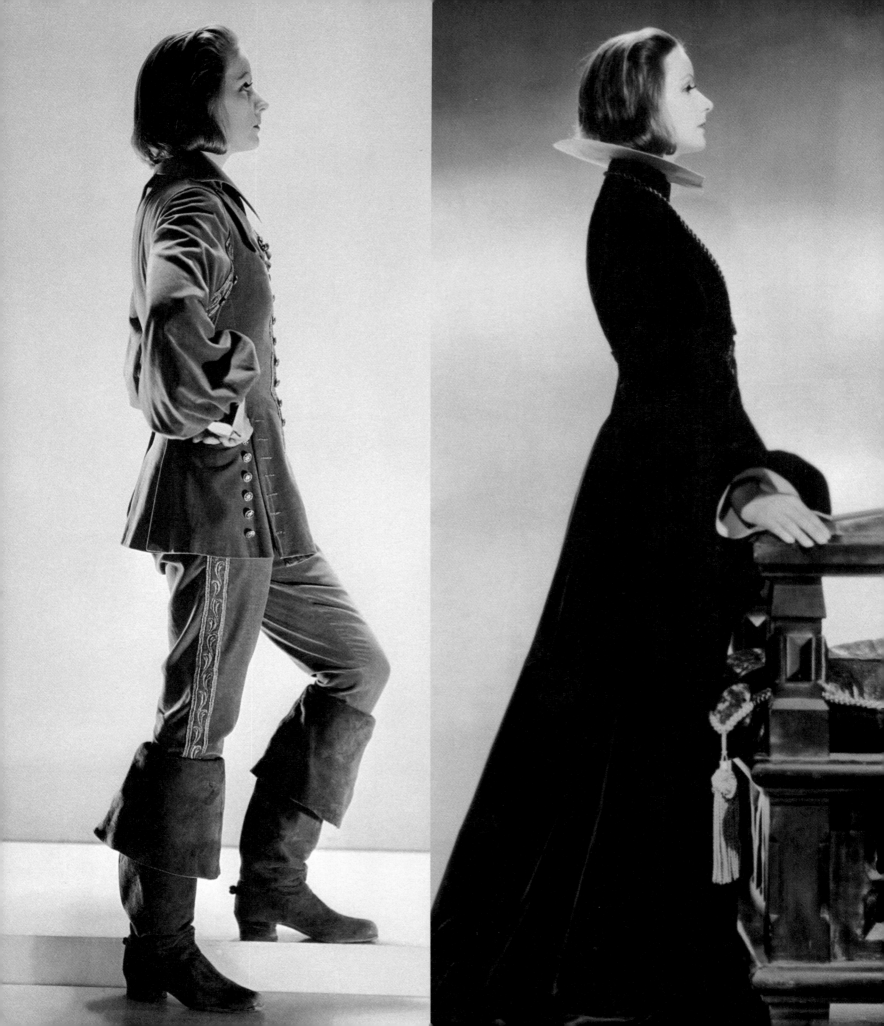

Anna Karenina, directed
by Clarence Brown in 1935,
representing the actress
in a new role as a romantic
woman and mother, earned
Garbo the title of actress of
the year by New York critics.

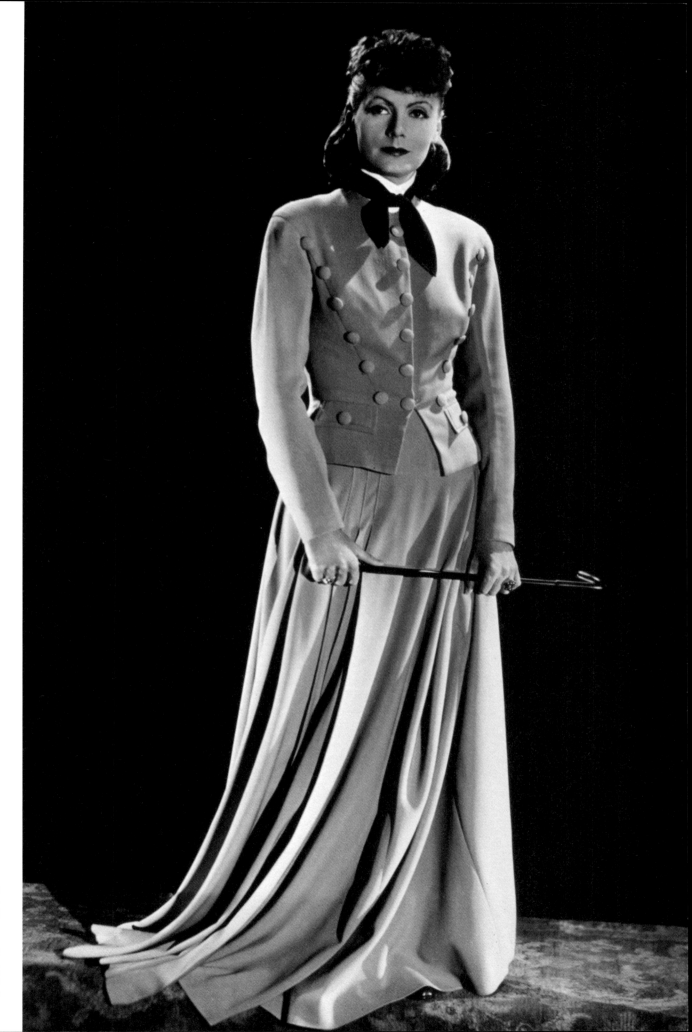

Photo Clarence Sinclair Bull

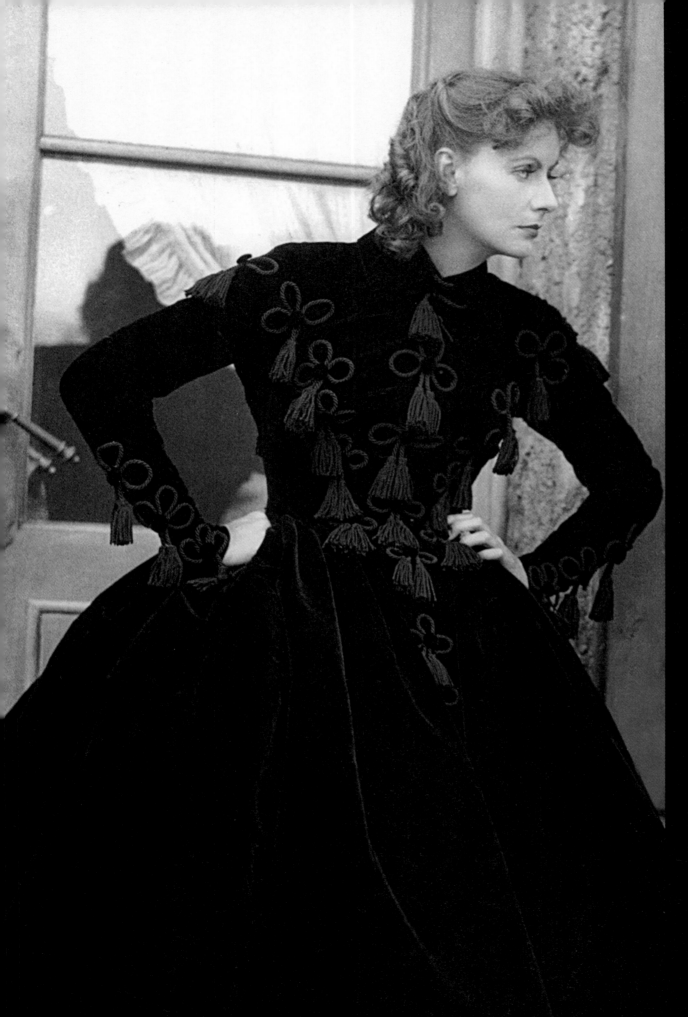

Greta Garbo's interpretation in *Camille* is emphasized by the beauty of the costumes in the film, which in part are inspired by the nineteenth-century neo-romantic vein that pervades the fashion of the age.

Photo Clarence Sinclair Bull, 1936

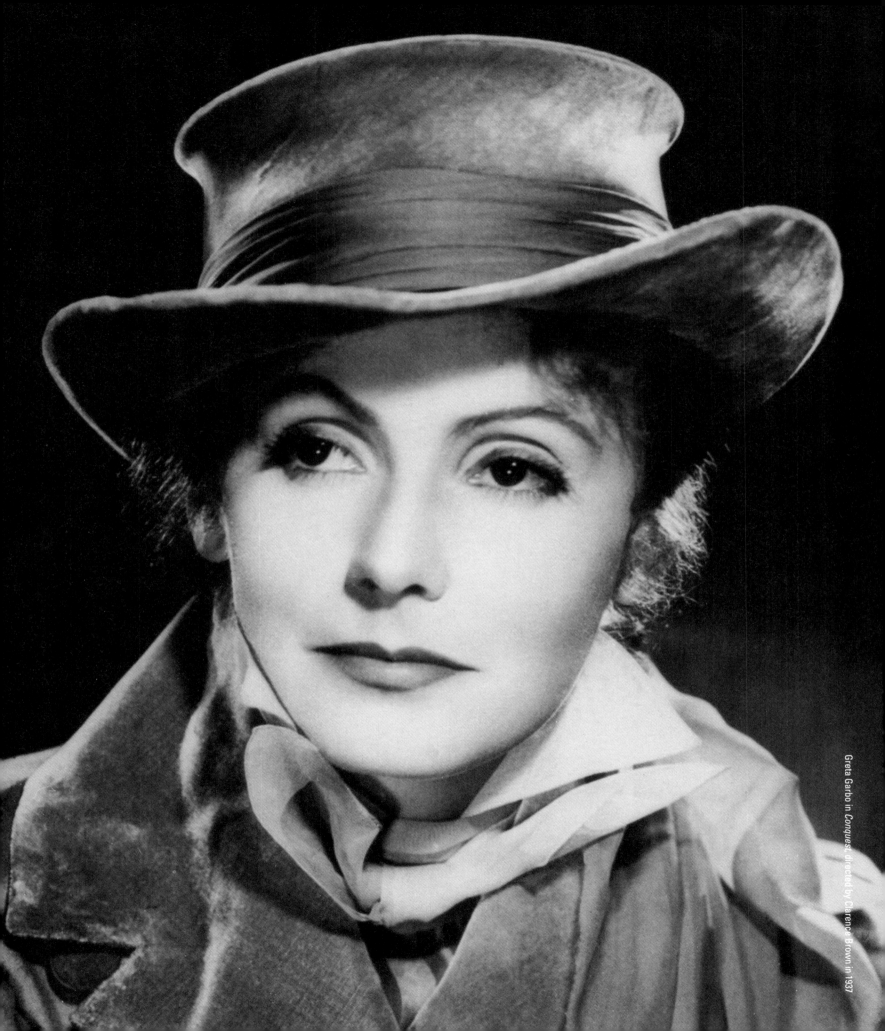

Avant-garde Dressing.

In Greta Garbo, the combination of an angelical face and an androgynous body unleashed unprecedented eroticism. In many films, Adrian's costumes served to emphasize this aspect, exerting a strong impact on the fashion of the age.

The cloche-style hats and berets, men's style shoes with laces, long trench coats, tweed suits, military-style jackets that imitated those Garbo purchased for her everyday use at the military emporium in Los Angeles, became a source of inspiration for many *couturiers*. The brilliant idea in the 1929 film *The Single Standard* of wearing the shirt and pants of her lover allowed men's clothing to burst onto the fashion scene of women's wear, even more so than the creations of Chanel had been able to accomplish. It became a source of imitation for actresses such as Marlene Dietrich and Katharine Hepburn, who confessed she wanted to resemble Greta Garbo, and for many other women during that time.

Greta Garbo posing on the set of the film *The Single Standard*, 1929. The pants suit intentionally calls to mind men's pyjamas.

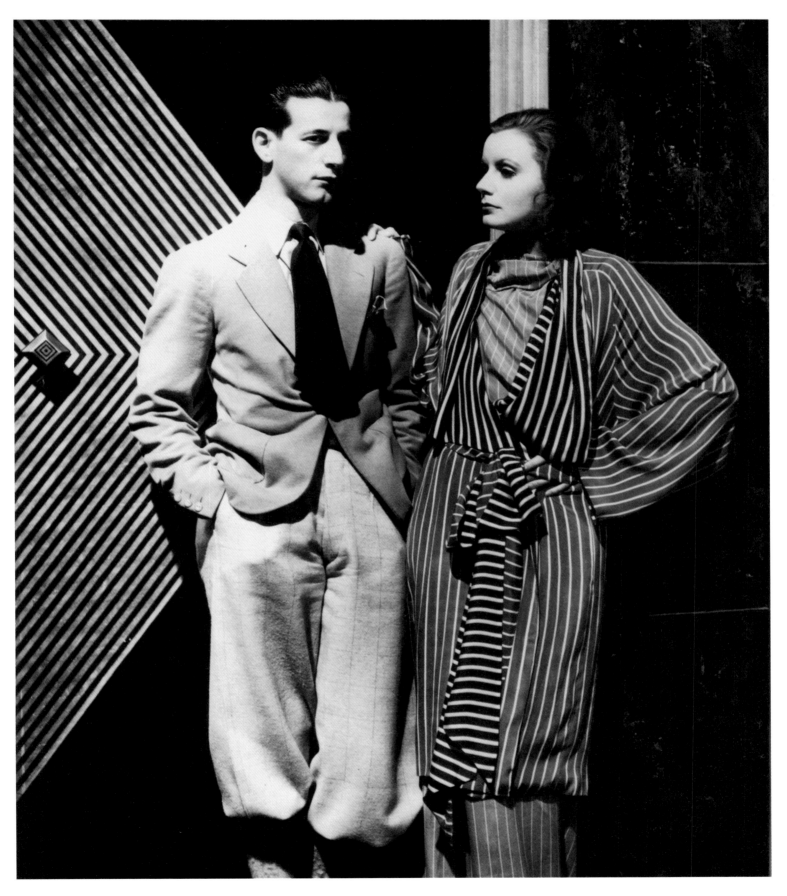

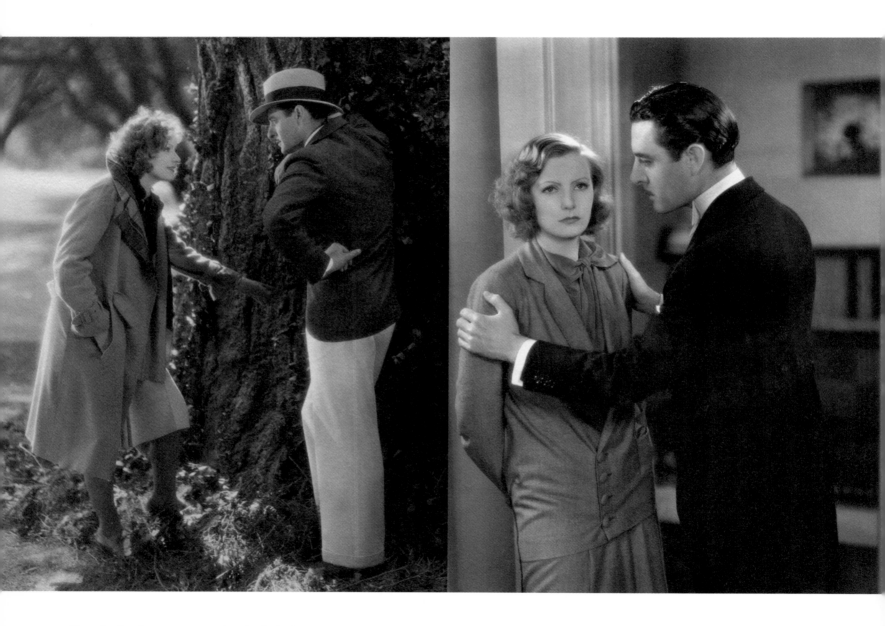

The sober headwear
and rigorous coats and suits,
which appear as early as
her first American films,
became synonymous with
Greta Garbo's style.
Following the release of the
film *A Woman of Affairs*,

in 1928, Garbo launched the
fashion of the cloche hat and
tweed, wool-lined trench coat
that, having appeared in
Women's Wear Daily, was
reproduced in thousands
of copies for American
department stores.

Photo James Manatt, 1928

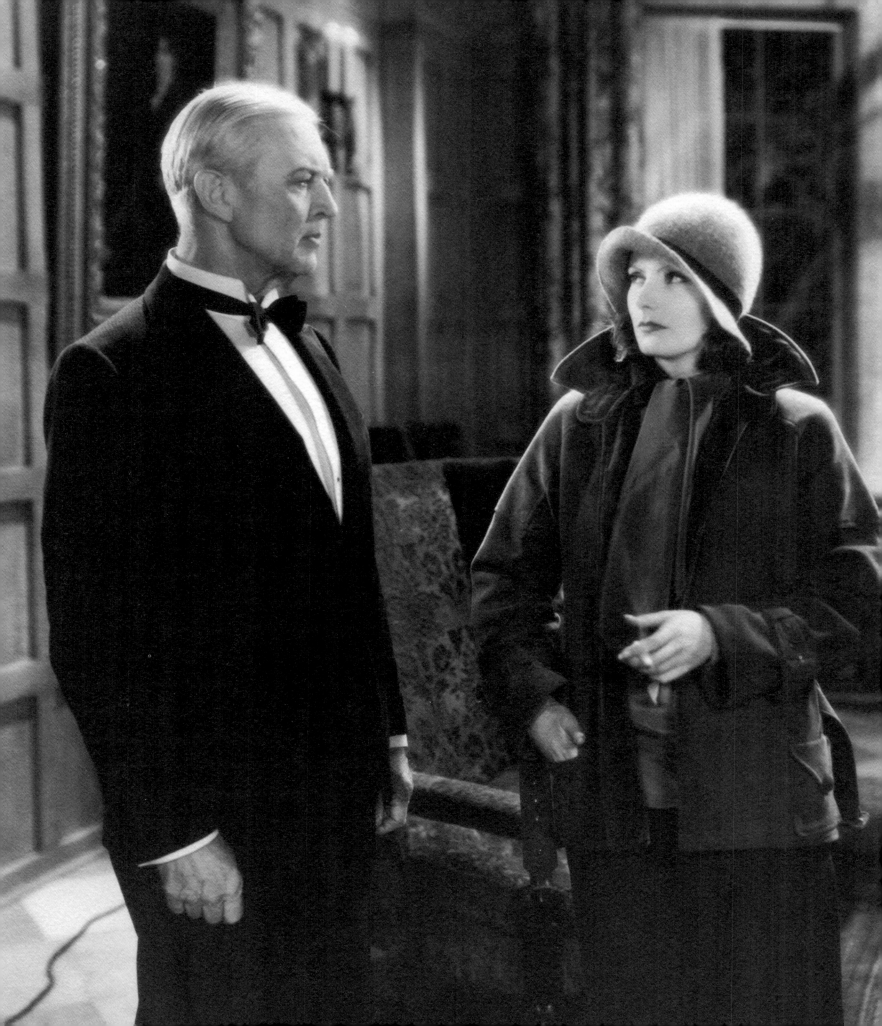

In *The Single Standard*, 1929, before Marlene Dietrich and Katharine Hepburn, who were influenced by the Swedish actress and in some way seem to represent the evolution of her style, Greta Garbo introduced trousers into women's fashion, wearing in a few scenes of the film the shirt and pants of her lover.

Photo James Manatt, 1929

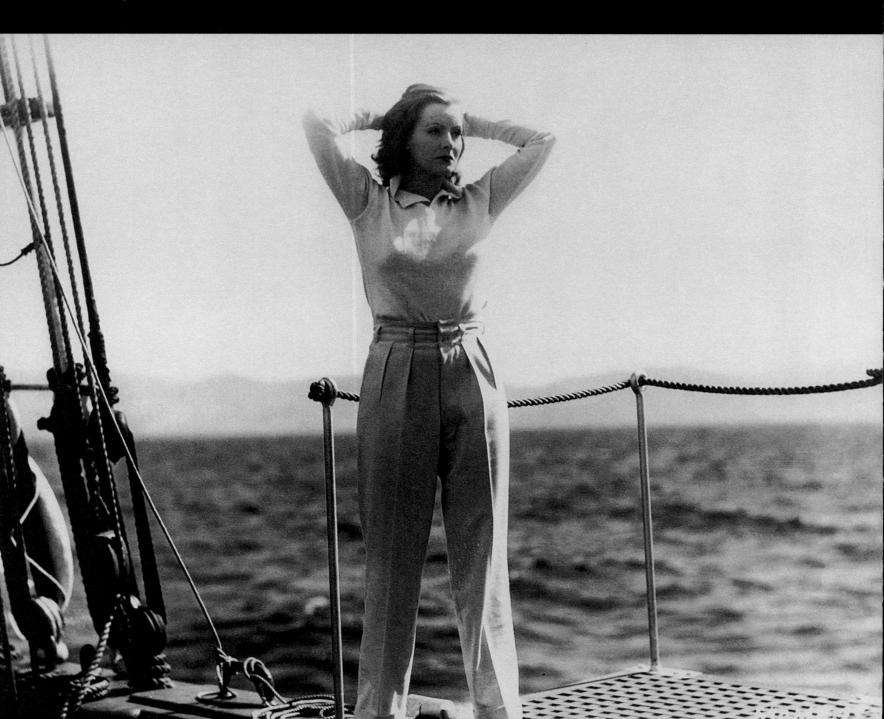

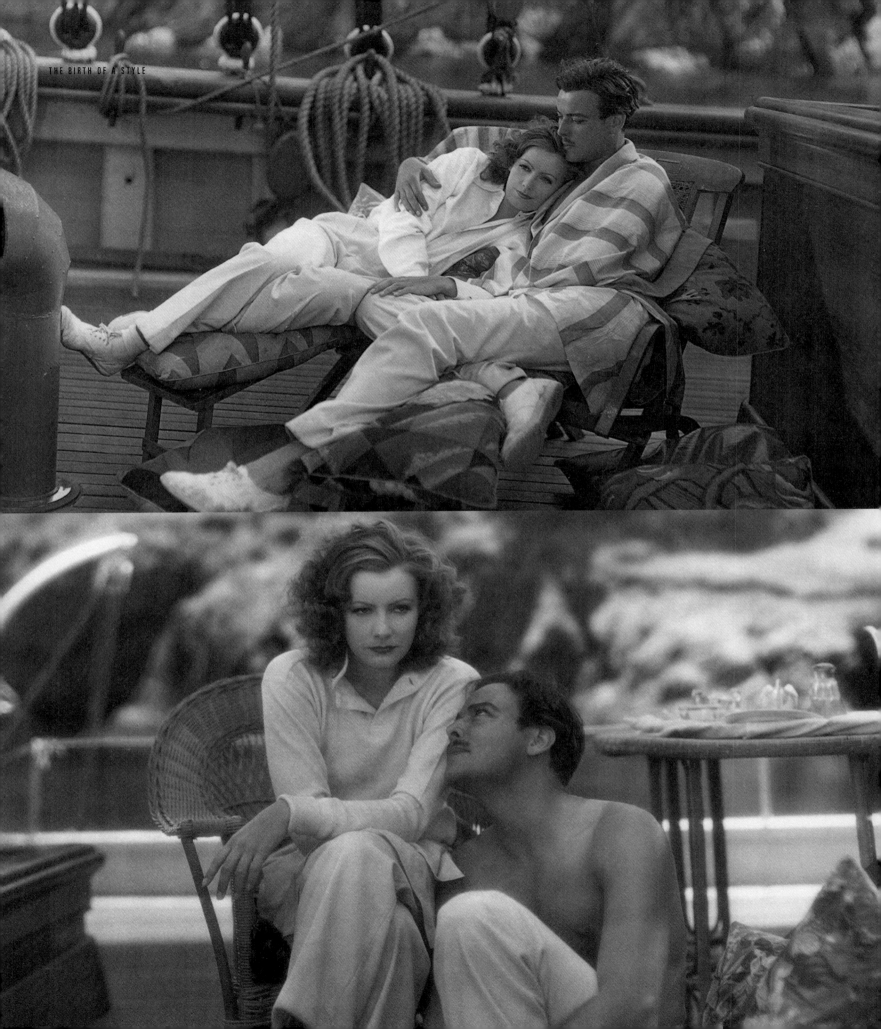

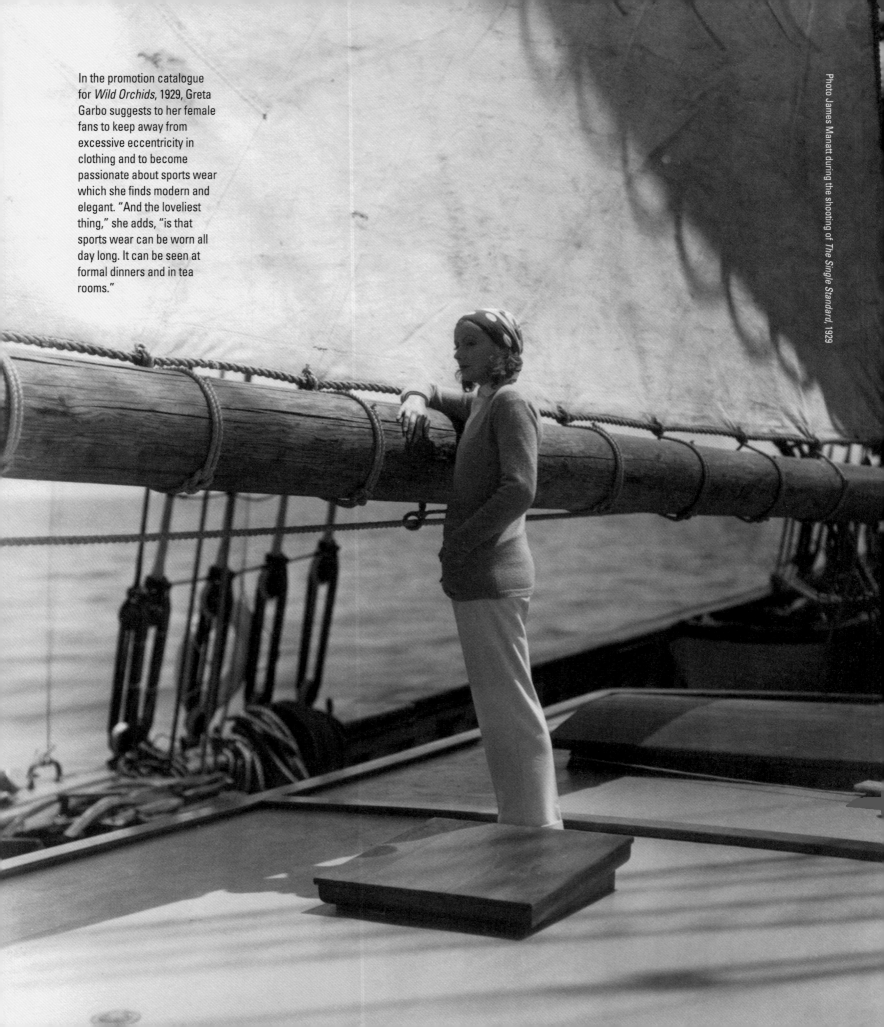

In the promotion catalogue for *Wild Orchids*, 1929, Greta Garbo suggests to her female fans to keep away from excessive eccentricity in clothing and to become passionate about sports wear which she finds modern and elegant. "And the loveliest thing," she adds, "is that sports wear can be worn all day long. It can be seen at formal dinners and in tea rooms."

Photo James Manatt during the shooting of *The Single Standard*, 1929

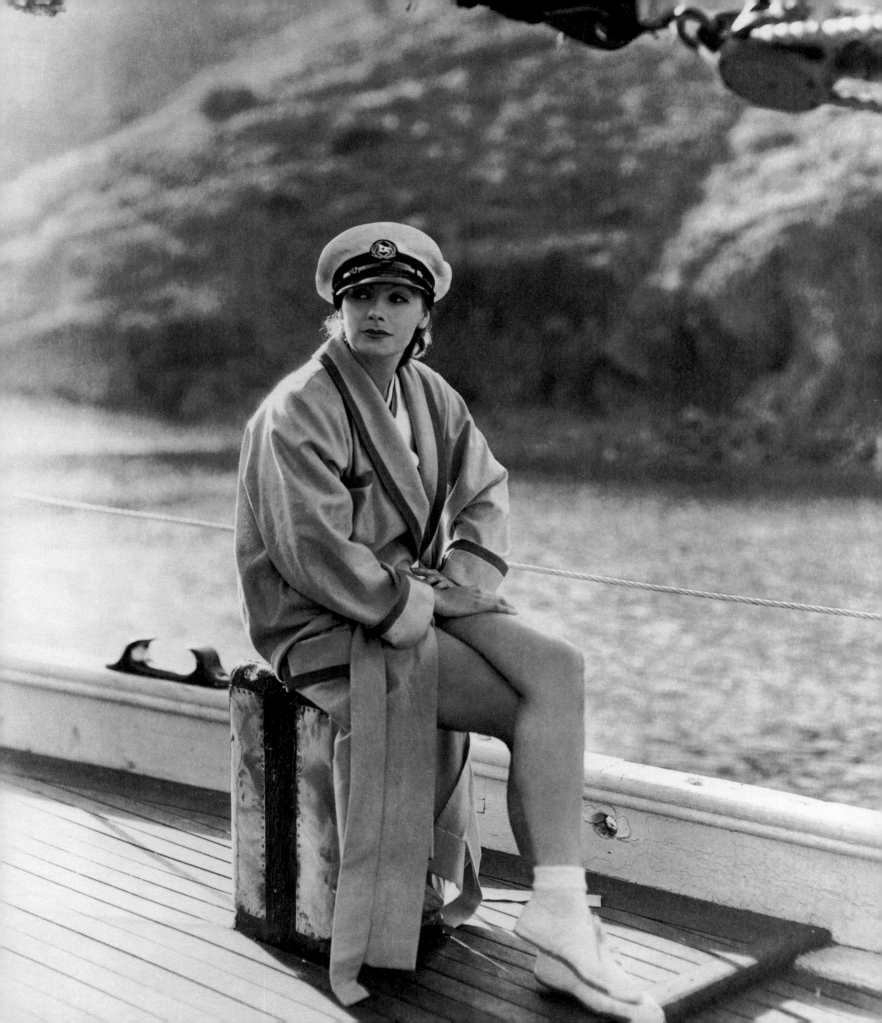

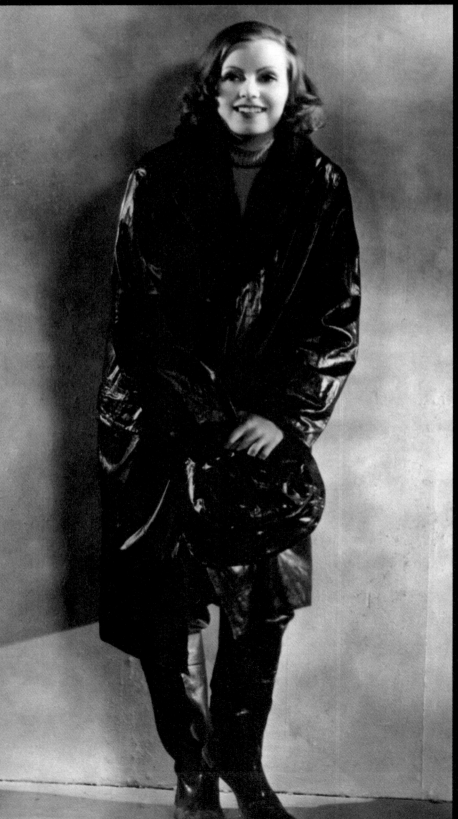

In *Anna Christie*, 1930, the first film in which it is possible to hear the deep and almost contralto voice of the Swedish actress, Greta Garbo introduced quite functional and sober clothing, made of laced shoes, leather jackets, heavy tweed outfits and check suits which established the sports style of the fashion of those years.

Also in *Susan Lenox Her Fall and Rise*, 1931, Greta Garbo appears absolutely herself. Her clothes, designed once again for her by Adrian, actually seem like the kind the actress bought for her everyday use in the military emporium of Los Angeles.

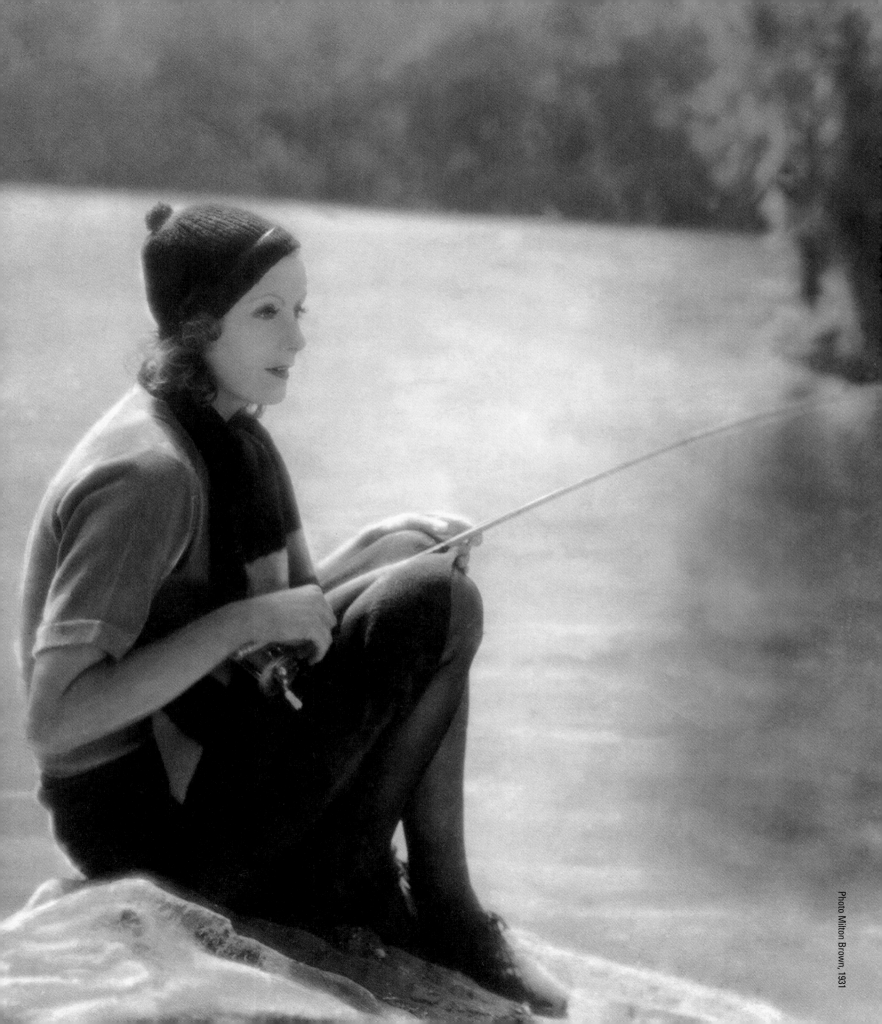

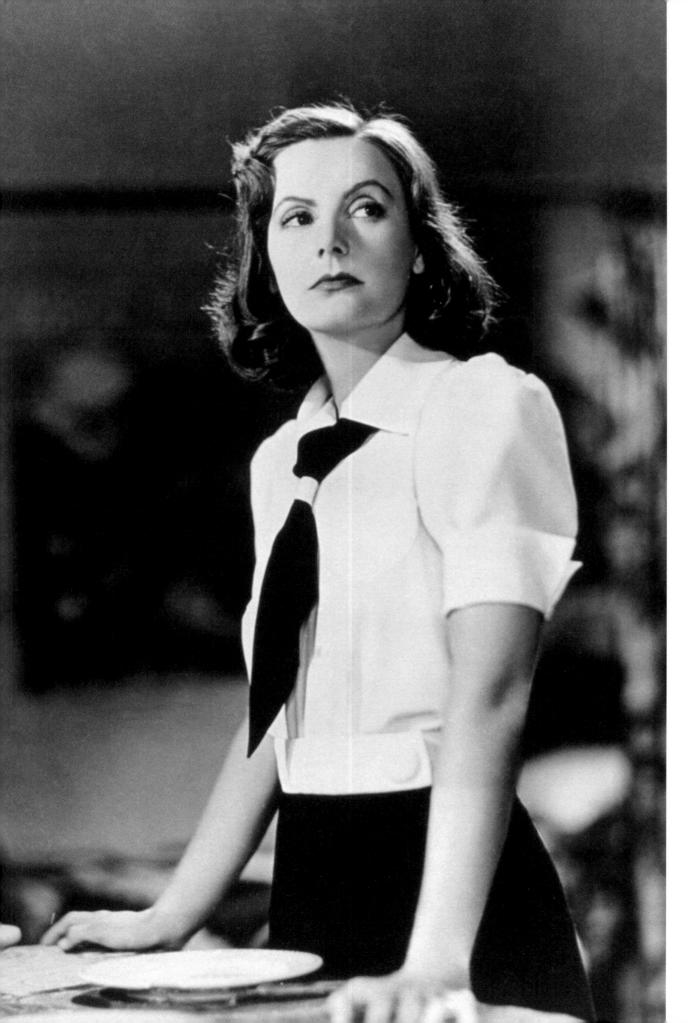

Greta Garbo in *Ninotchka*, the film directed by Ernst Lubitsch. This is Garbo's first comedy and shows she is a brilliant actress. Besides clothing, Greta Garbo also influenced make-up, quite simple and parsimonious in the use of cosmetics and in her pageboy hairstyle, which imposed the triumph of shoulder-length hair.

Photo Milton Brown, 1939

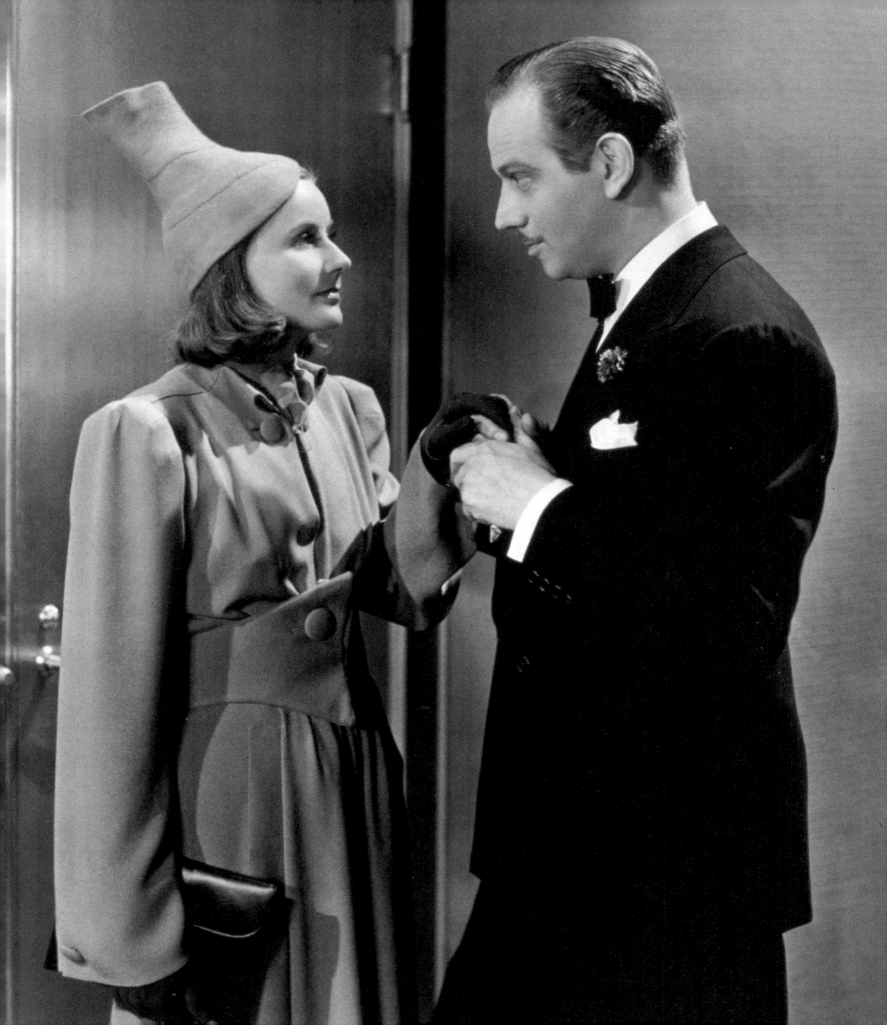

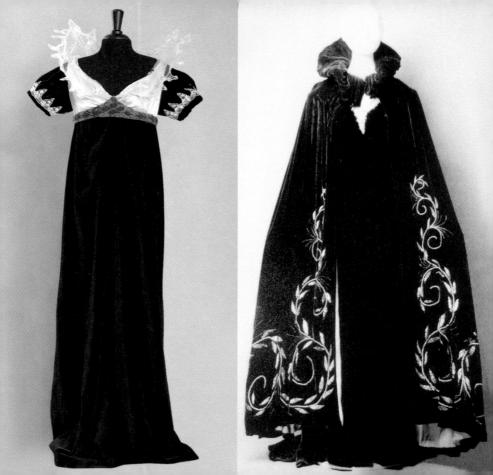

Ingrid Gunther, black velvet gown
worn by Greta Garbo in the movie
The Saga of Gösta Berling,
Svensk Filmindustri AB, 1924.
Courtesy Swedish Film Institute

Adrian, Black silk cape by worn
by Greta Garbo in *Inspiration*, 1931.
Costume and image courtesy
of Mr John LeBold Collection

Black crepe de chine evening
gown with rhinestone and sequins
embroidery worn by Greta Garbo
at an MGM party, 1930.
By kind concession Collections
La Cinémathèque française/Jaime
Ocampo Rangel

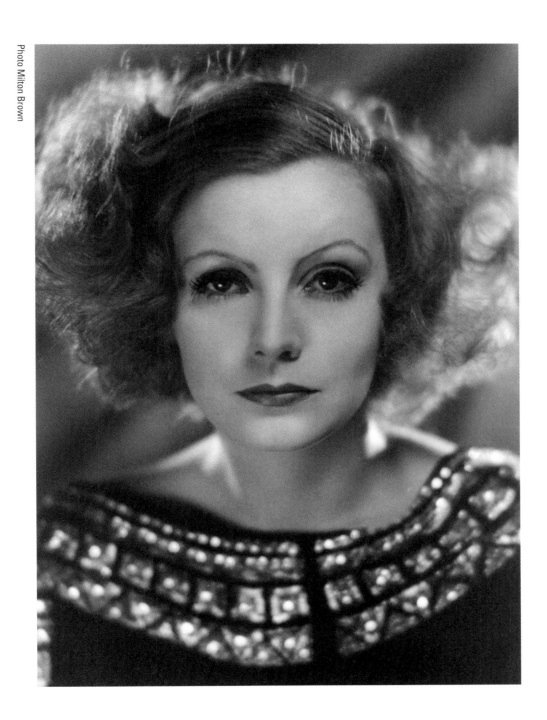

Photo Milton Brown

Adrian, gown worn by Greta Garbo
in *Inspiration*, 1931.
Gift of Mrs Thomas E. Burns jr., ©
image courtesy of the Drexel
Historic Costume Collection and
The Drexel Digital Museum Project.
Photography by Dave Gehosky

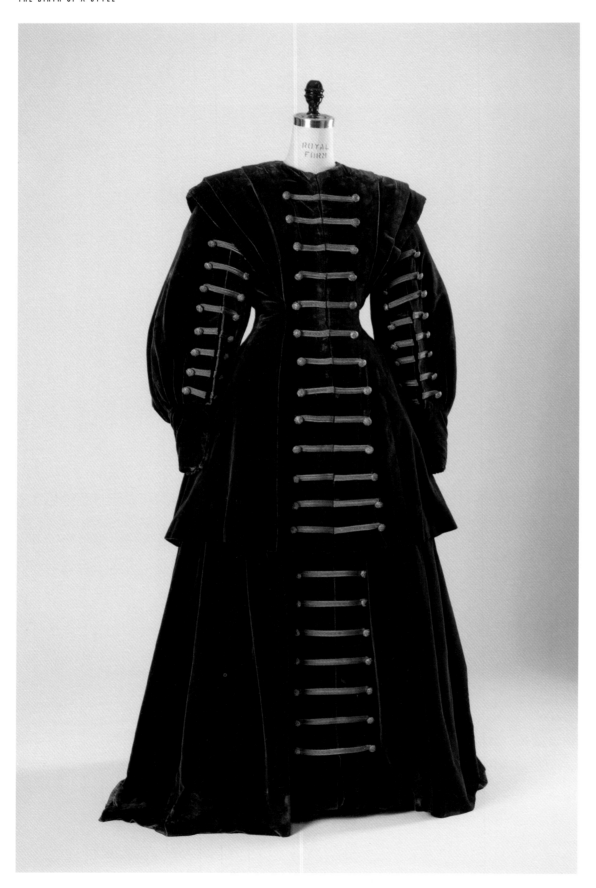

Adrian, dress from *Queen Christina* in green silk velvet with metal alamar eyelets, inspired by the seventeenth century, 1933. Courtesy of The Museum at the Fashion Institute of Technology, New York. Gift of Metro-Goldwyn-Mayer, Inc. © The Museum at FIT

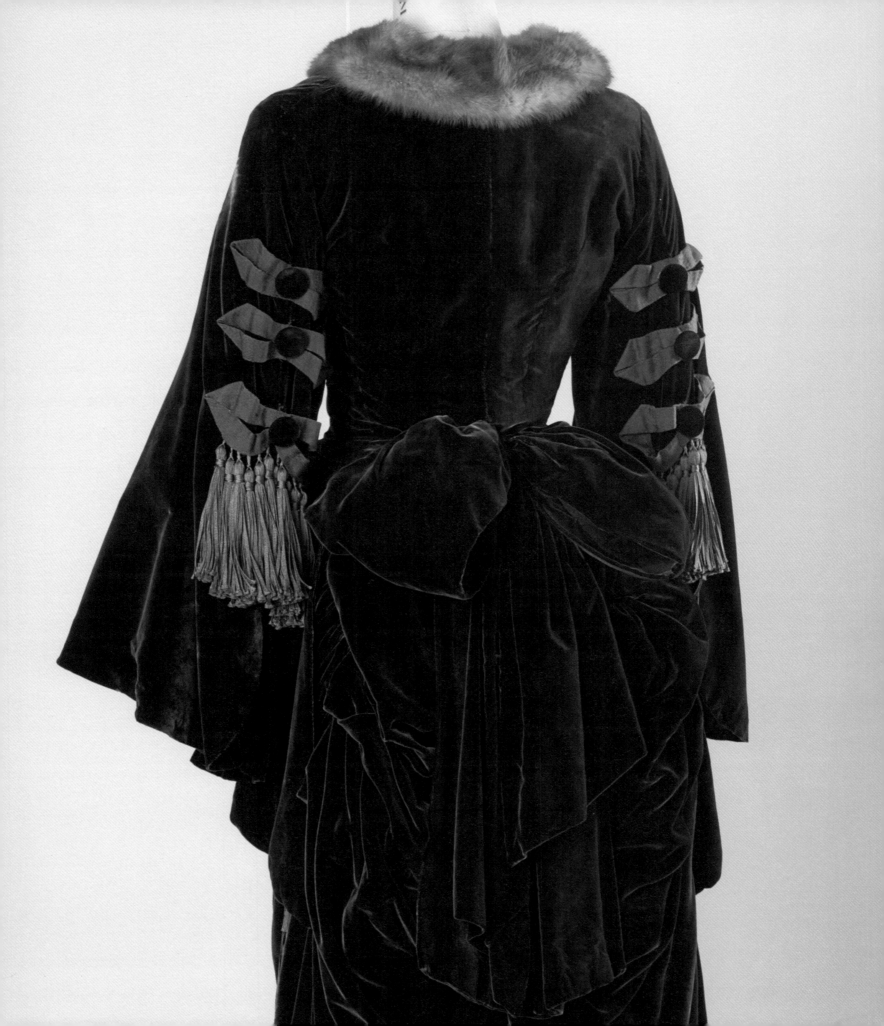

Adrian, brown silk velvet outfit with fox fur collar and silk trimmings. Made for Greta Garbo in *Anna Karenina*, 1935. Courtesy of The Museum at the Fashion Institute of Technology, New York. Gift of Metro-Goldwyn-Mayer, Inc. © The Museum at FIT

Adrian, grey wool coat with revers and collar in green velvet worn by Greta Garbo in the film *Conquest*, 1937. By kind concession Collections La Cinémathèque française/ Jaime Ocampo Rangel

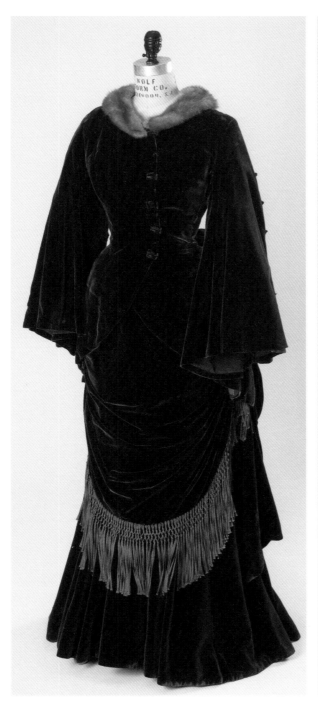

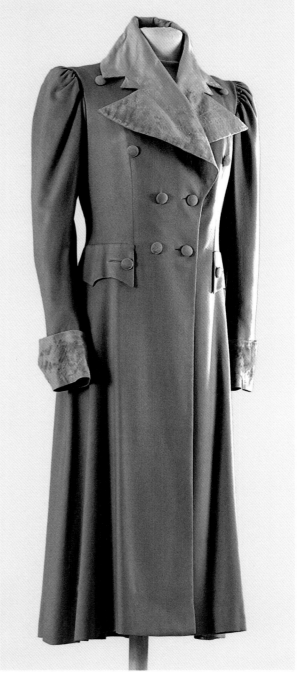

EVERYDAY

ELEGANCE

Beyond Fashion. Greta Garbo influenced fashion not only from the silver screen, but also from her own private life with her sports knit jackets, men's classic shirts, ties, flat shoes and above all pants, which she had sewn in Los Angeles by Watson, a tailor suggested to her and to Marlene Dietrich by her friend Mercedes de Acosta. Her style, like her longing for privacy, passing unobserved behind her large black sunglasses, with an attitude so unlike the temptress that had made her famous, constitute elements that make Greta Garbo a figure that is contemporary even today.

It has been written that unlike many of her fellow actresses, off the film set Greta Garbo did not seem to pay particular attention to her clothing, because she could allow herself to wear rope shoes and inexpensive shirts in her everyday life. But this does not mean she did not love fashion. Ever since her Hollywood days, she bought her shoes from Salvatore Ferragamo, who represented the high fashion of this accessory.

After retiring, in the 1940s, when she moved to New York, she became an assiduous customer of Valentina, the *couturière* for New York's high society and who suggested to Greta Garbo to keep her style, to dress for amusement and not take too seriously her clothing or yield to conventions. "Greta," wrote Cecil Beaton, an attentive observer of the society and customs of his time, "has the instinct of what suits her, and she possesses an innate confidence of taste that makes her able to assess a lovely dress and also appreciate it. For as much as she refuses to dedicate her time in transforming herself into an elegant woman, she has nevertheless been able to create with the extreme simplicity of the clothes she wears a new fashion of hers and, in so far as not being a conformist, she has, as an important factor, contributed to setting a tone for an entire period, inaugurating the fashion of flat shoes, of hats that hide the face, of dock workers' leather jackets, and of cowboy belts."

Greta Garbo, 1948. Photo Cecil Beaton

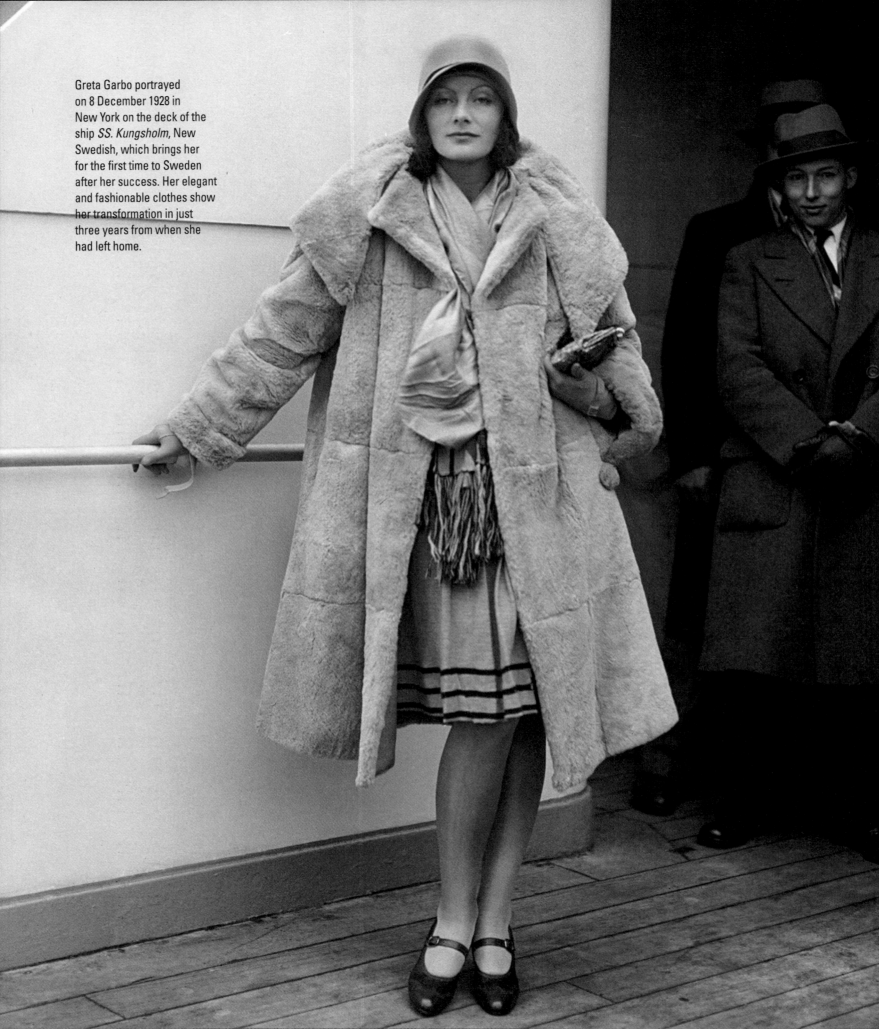

Greta Garbo portrayed on 8 December 1928 in New York on the deck of the ship *SS. Kungsholm*, New Swedish, which brings her for the first time to Sweden after her success. Her elegant and fashionable clothes show her transformation in just three years from when she had left home.

Greta Garbo in January 1929 upon her first return to Sweden from Hollywood with Mimi Pollack, her friend since her Drama Academy of Stockholm days.

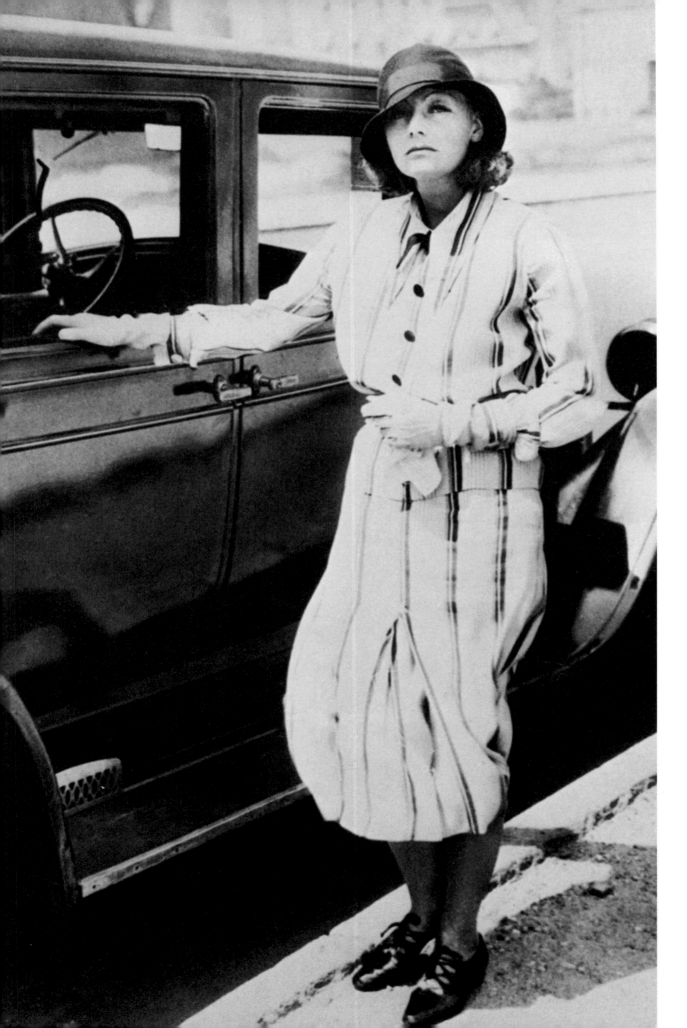

Greta Garbo in Los Angeles
in 1928 in a typical skirt
and shirt outfit. Simplicity
and comfort, a must for Garbo.

Greta Garbo greeting
a cheering crowd as
she arrives in San Diego
from Europe on 9 May 1933.

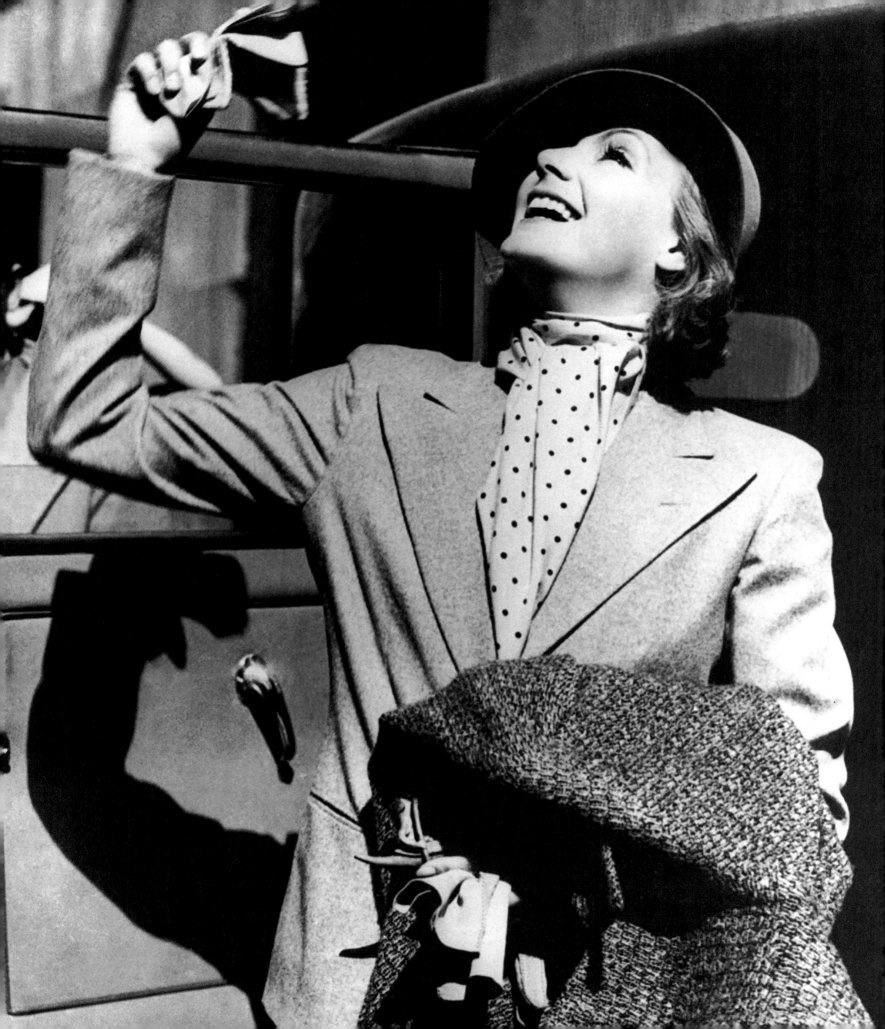

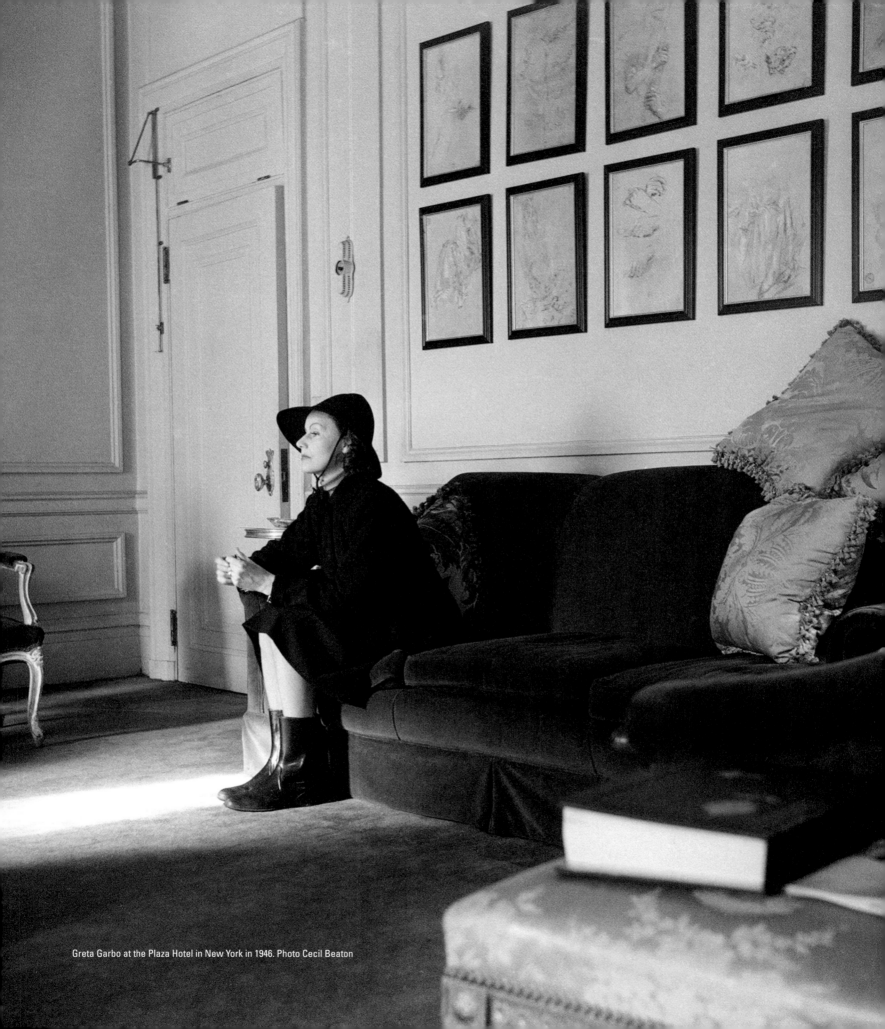

Greta Garbo at the Plaza Hotel in New York in 1946. Photo Cecil Beaton

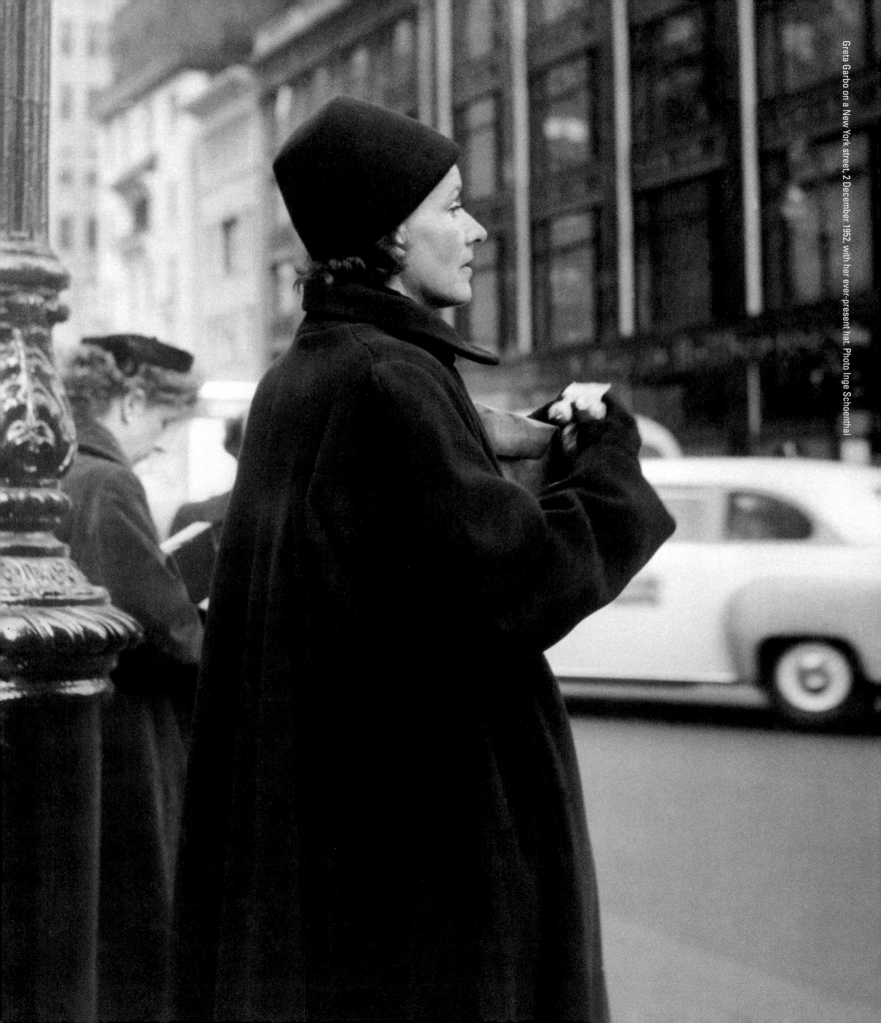

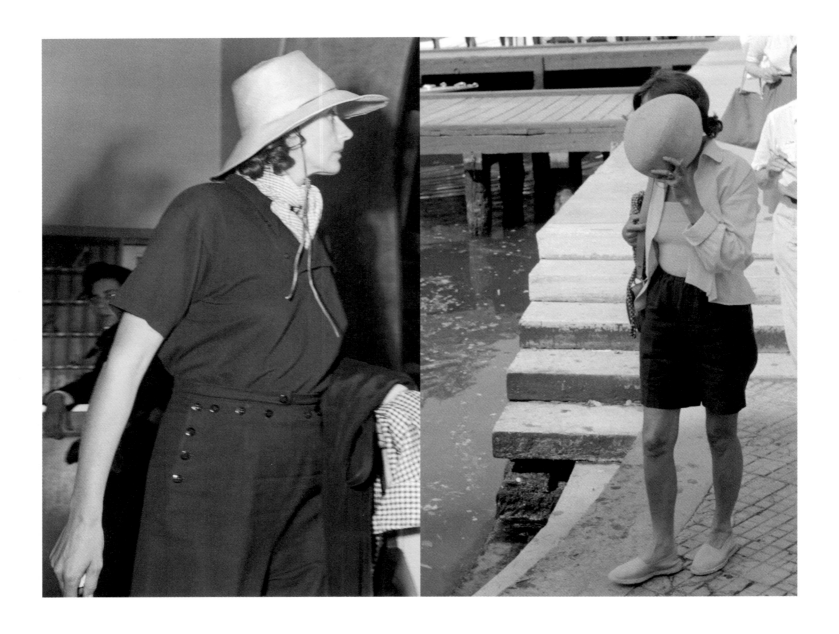

Garbo photographed in Paris, 18 September 1949. The actress in Venice in 1955, fending off paparazzi. On holiday in Greece, 28 August 1966

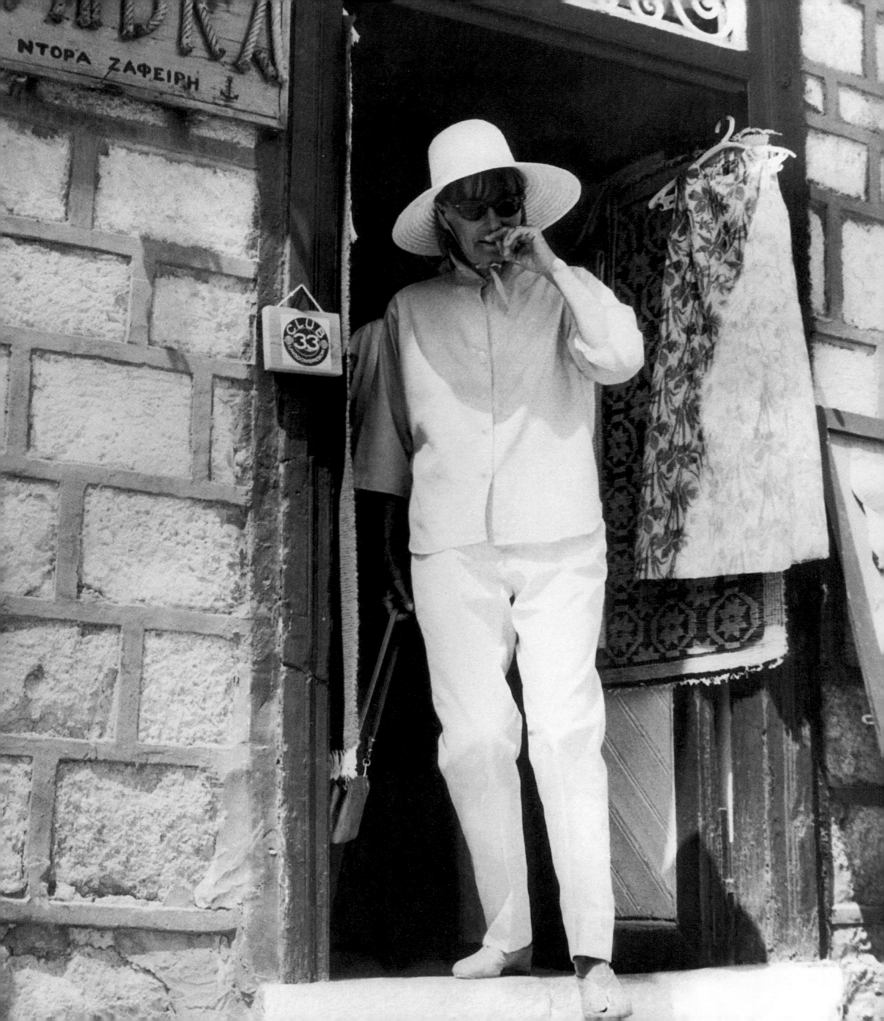

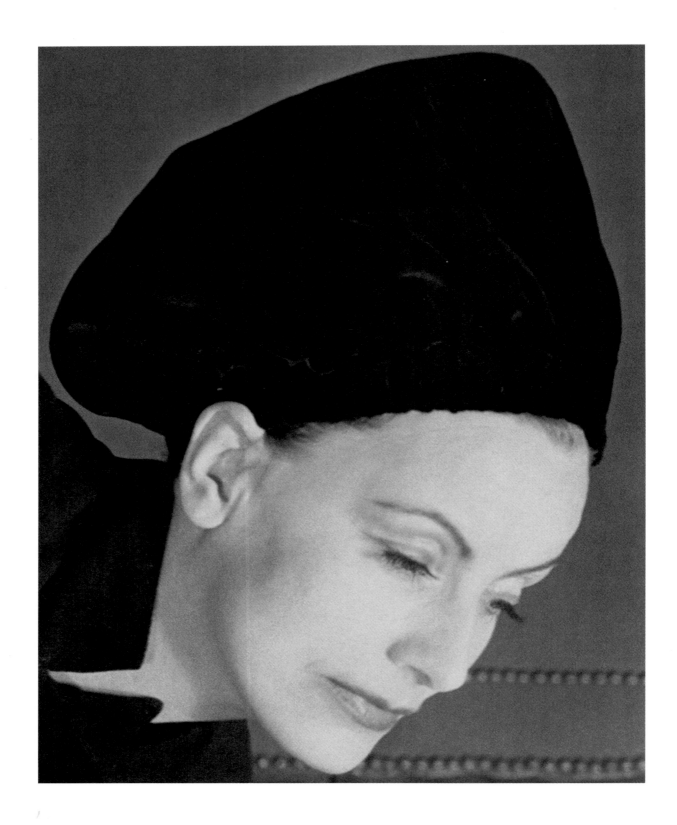

Greta Garbo wearing a turban, 1946. Photo Cecil Beaton

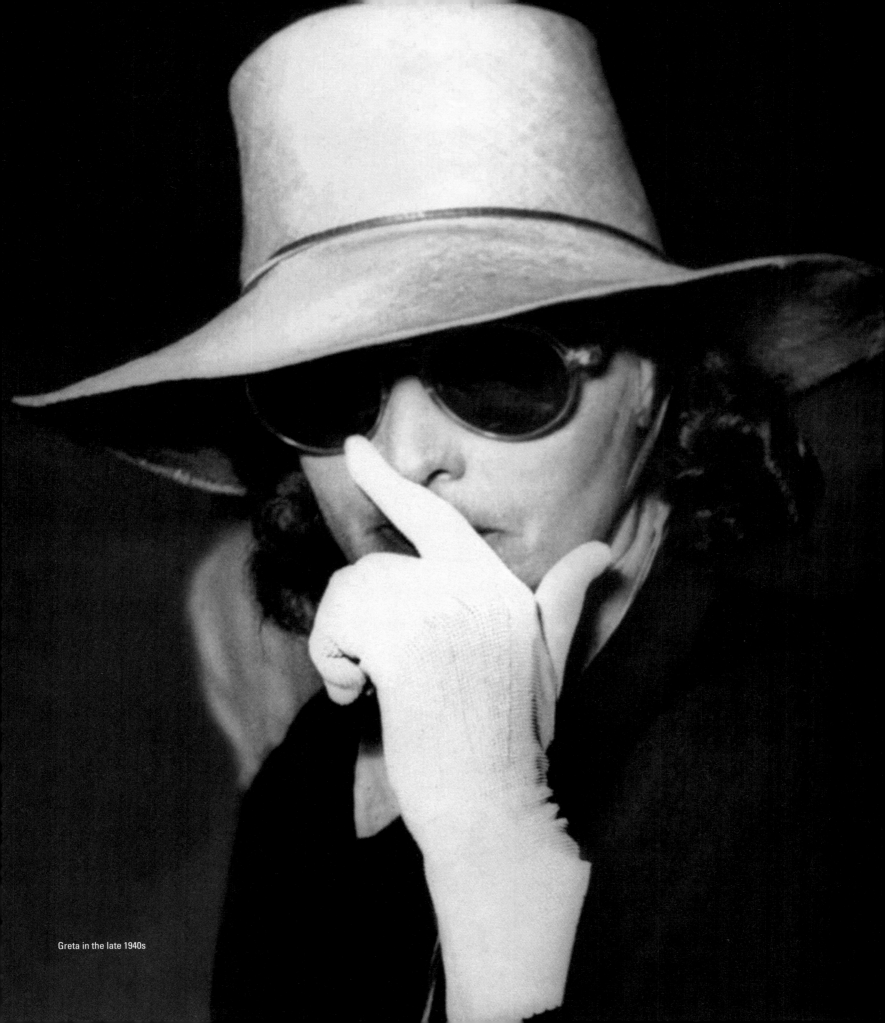

Greta in the late 1940s

Greta's Wardrobe.

Greta Garbo wasn't too keen on scene dresses, and she never owned an evening gown. "Her taste in clothes," says Beaton, "is a mix of what a street bandit, Robin Hood and someone from Ancient Greece would wear. She dons large pirate hats and the blouses and belts of a romantic knight, always unadorned and oftentimes with dull colours."

Yet the amount of accessories and clothes for personal use, recuperated from her wardrobe, paints the picture of a woman attentive to her way of dressing, though not a slave to fashion. The accounts of those who had been friends with her throughout her life outline an image that is different from the one found in photos and newspaper articles: a woman open to others, happy, with a great sense of humour, who lived alone but was not alone. In her personal wardrobe, we discover that alongside the predictable rigorous forms of her clothes, with few frills and sober colours, there is an unexpected inclination towards flower patterns and bright colours like turquoise, emerald green and hot pink which make Greta Garbo a radiant and feminine woman.

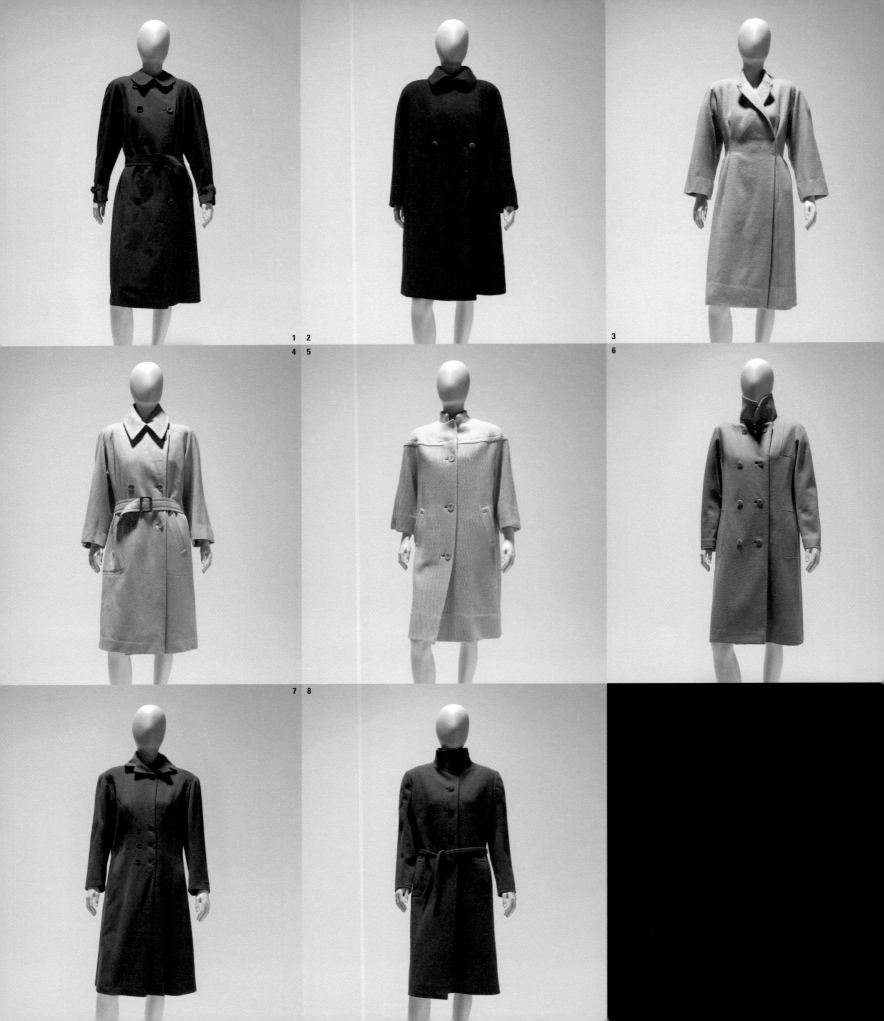

1 2
4 5
3
6
7 8

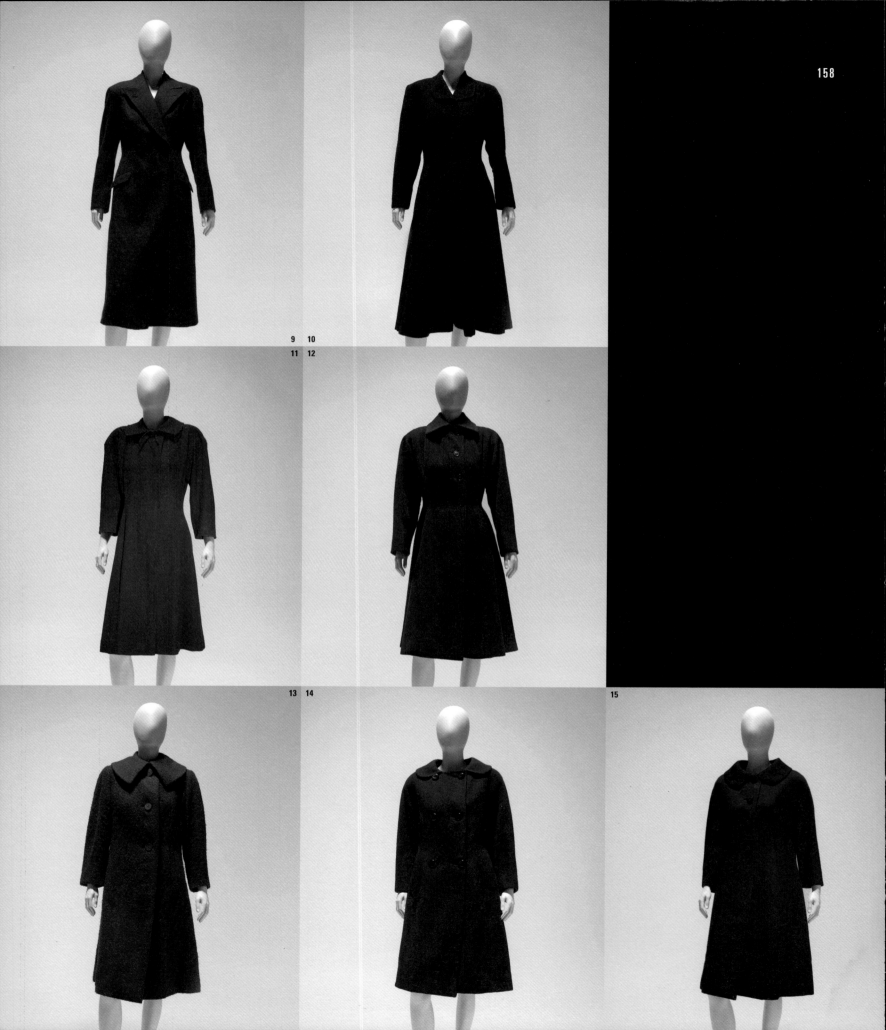

9 10
11 12

13 14

15

16 17
18 20

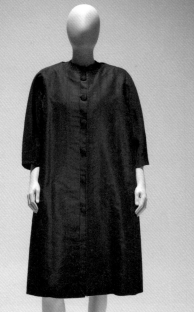

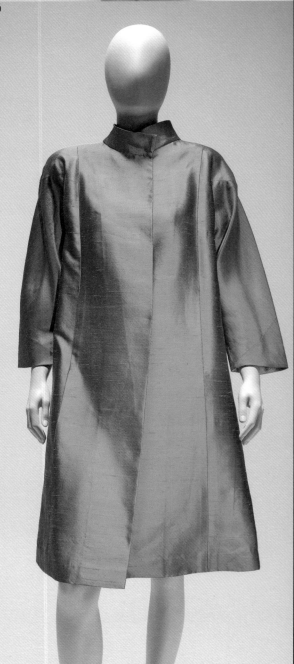

19

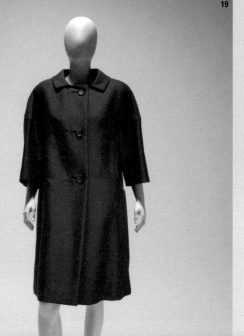

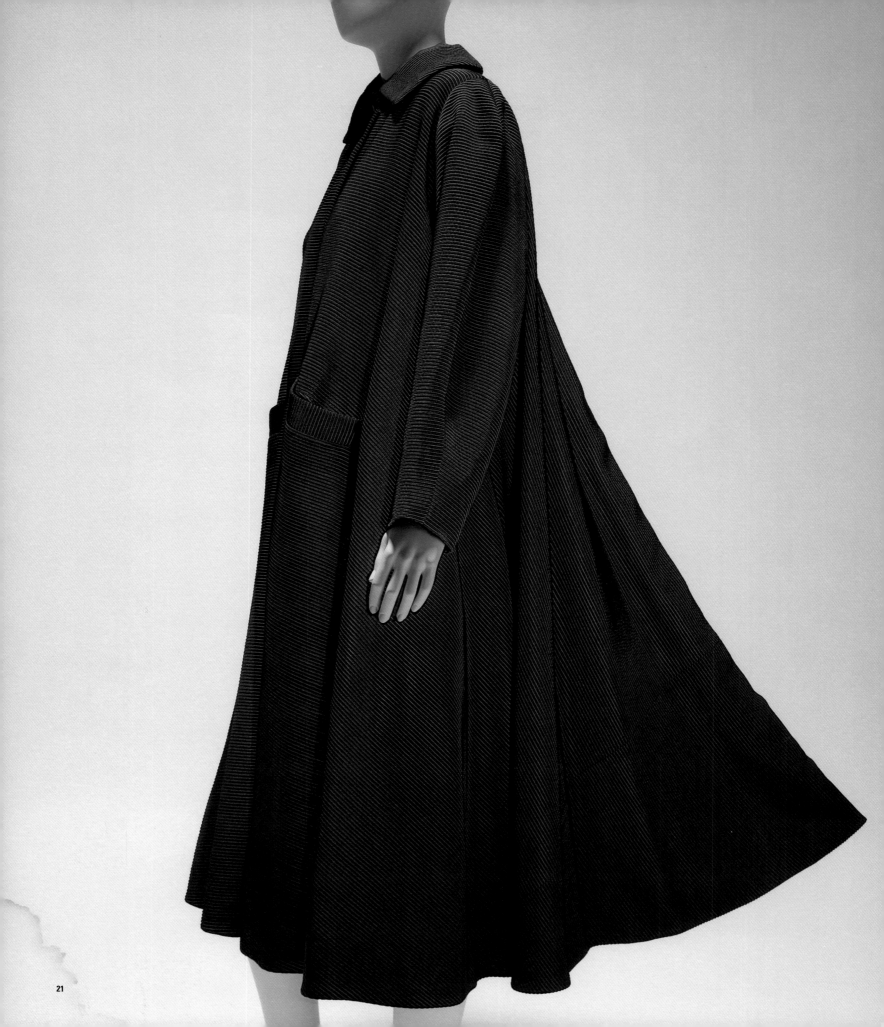

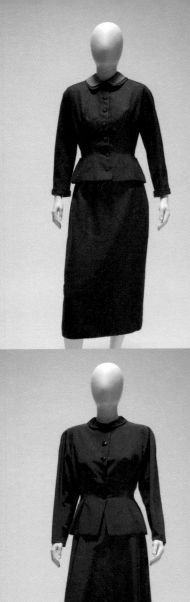
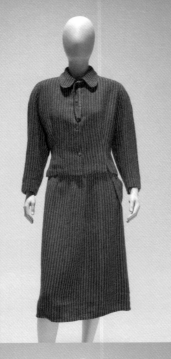
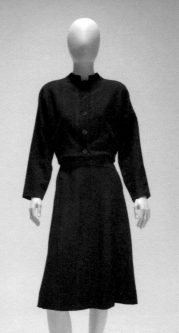

23 24
26 27 25
 30

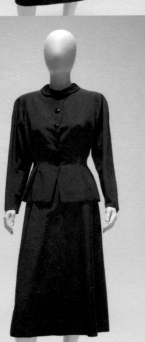
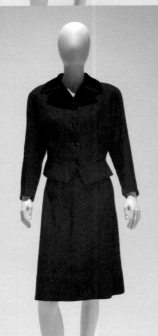
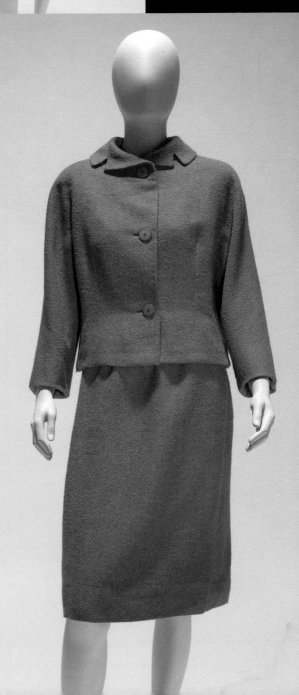

28 29

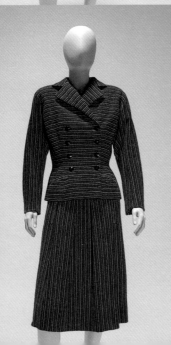
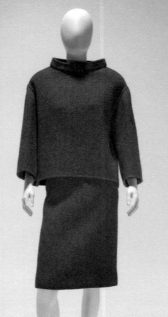

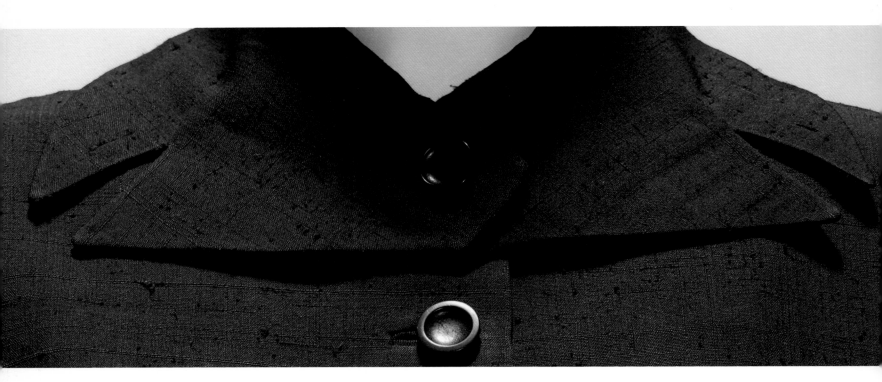

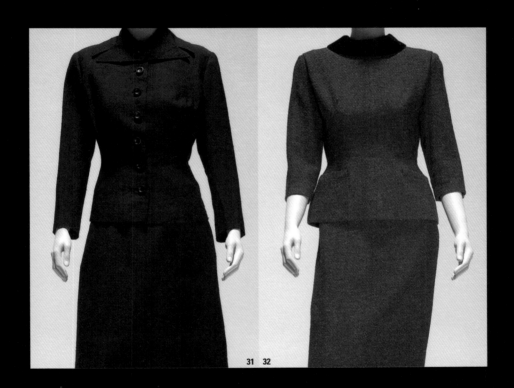

31 32

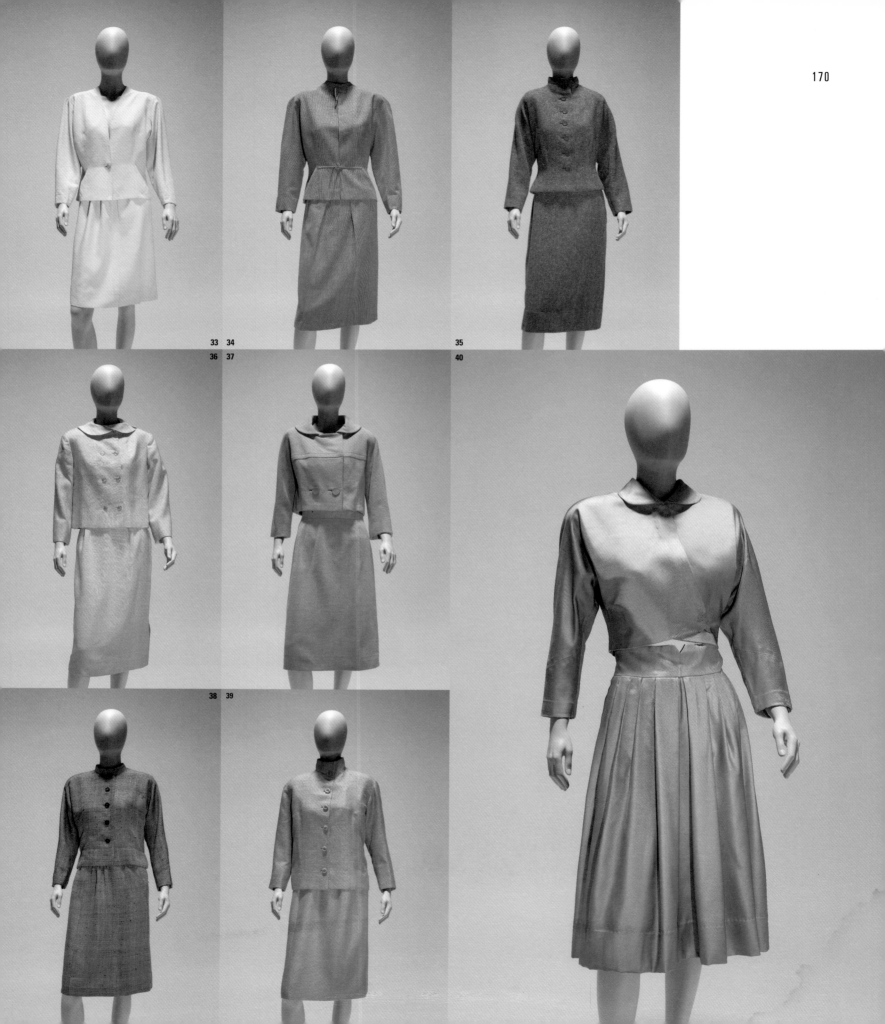

33 34

36 37 35

40

38 39

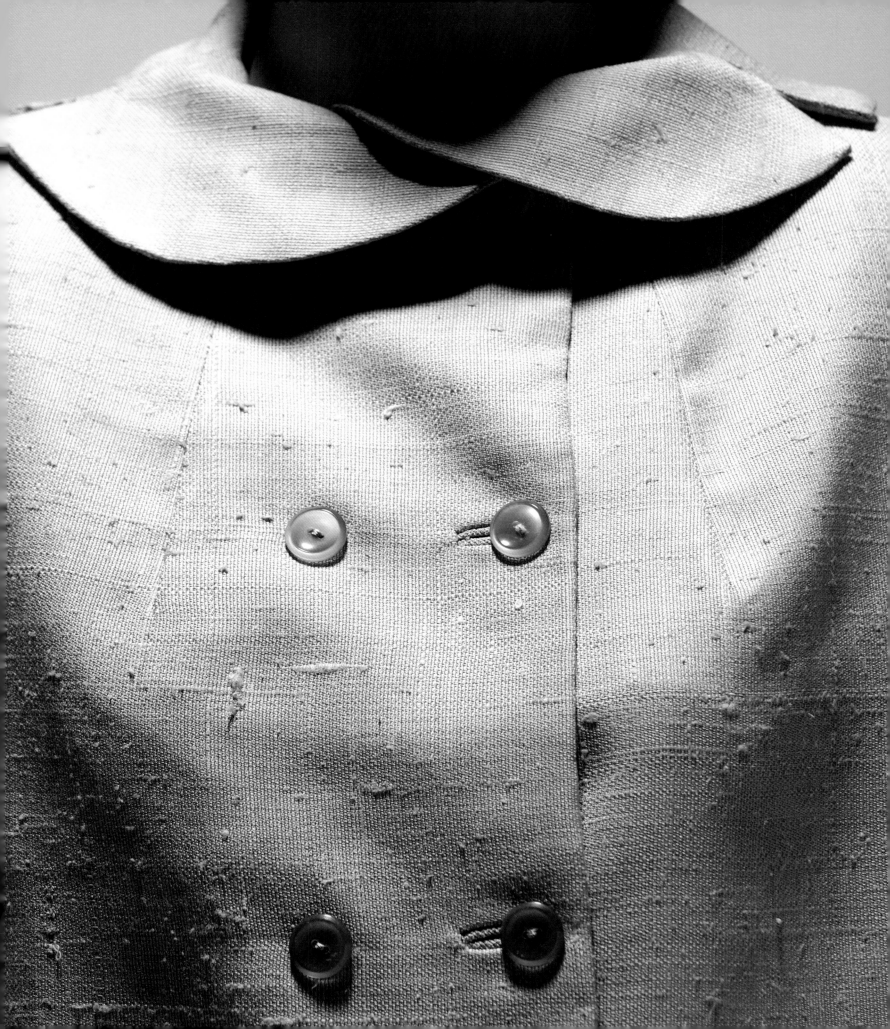

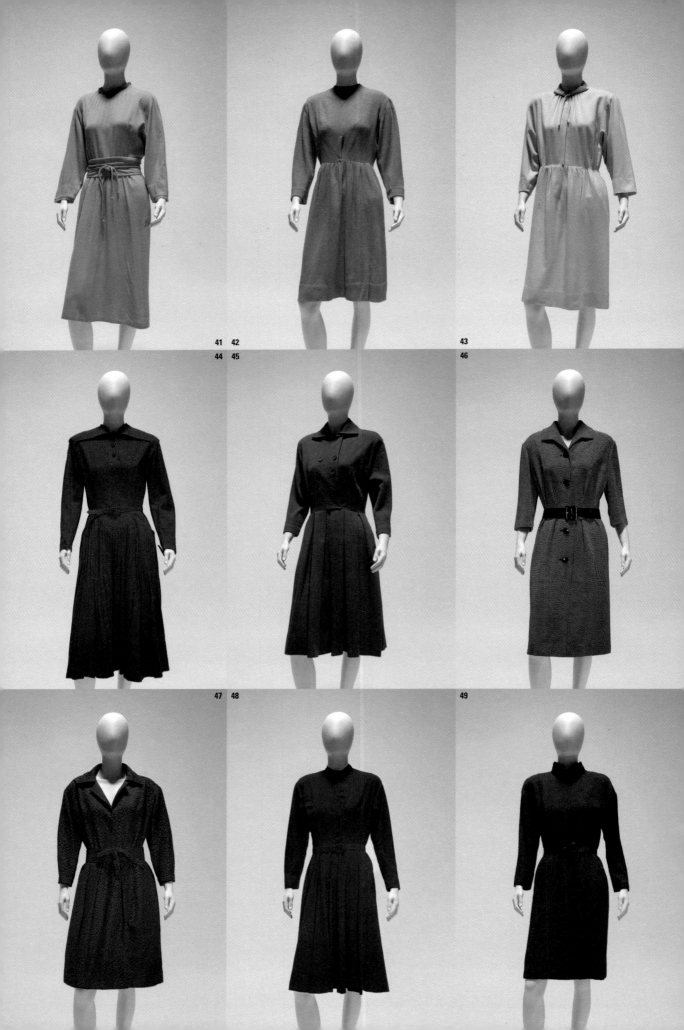

41 42

43

44 45

46

47 48

49

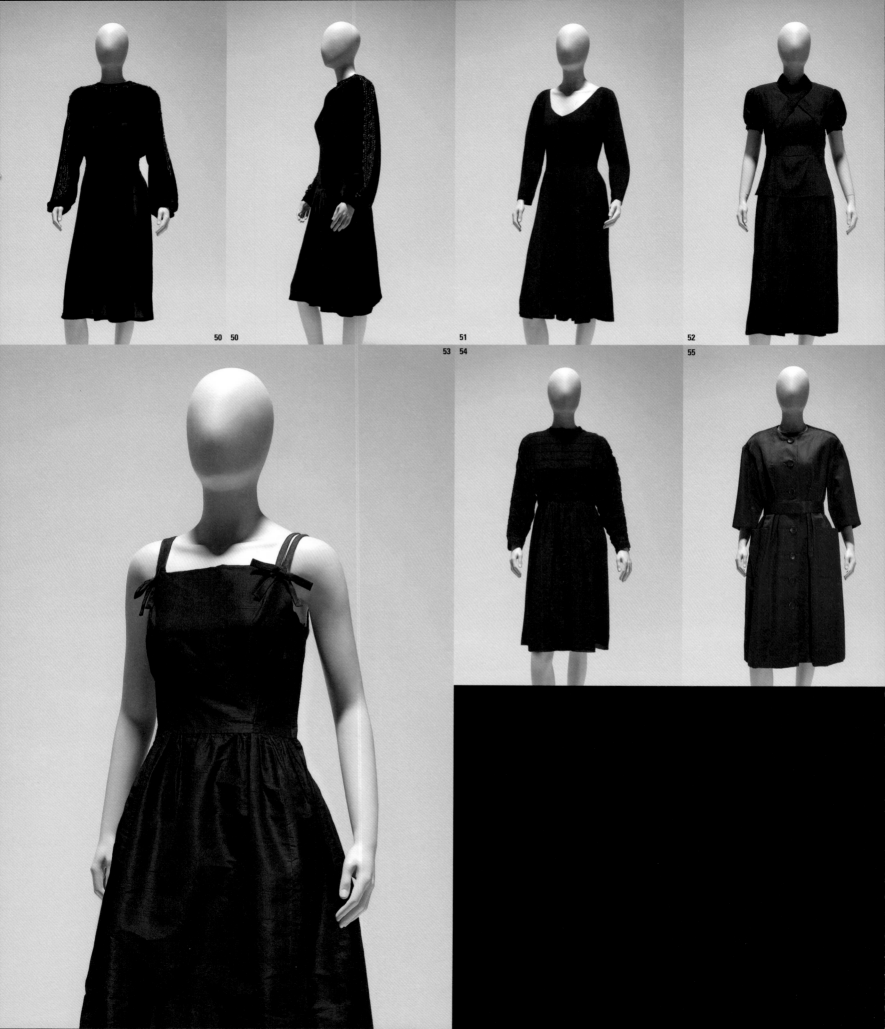

50 50
51
52
53 54
55

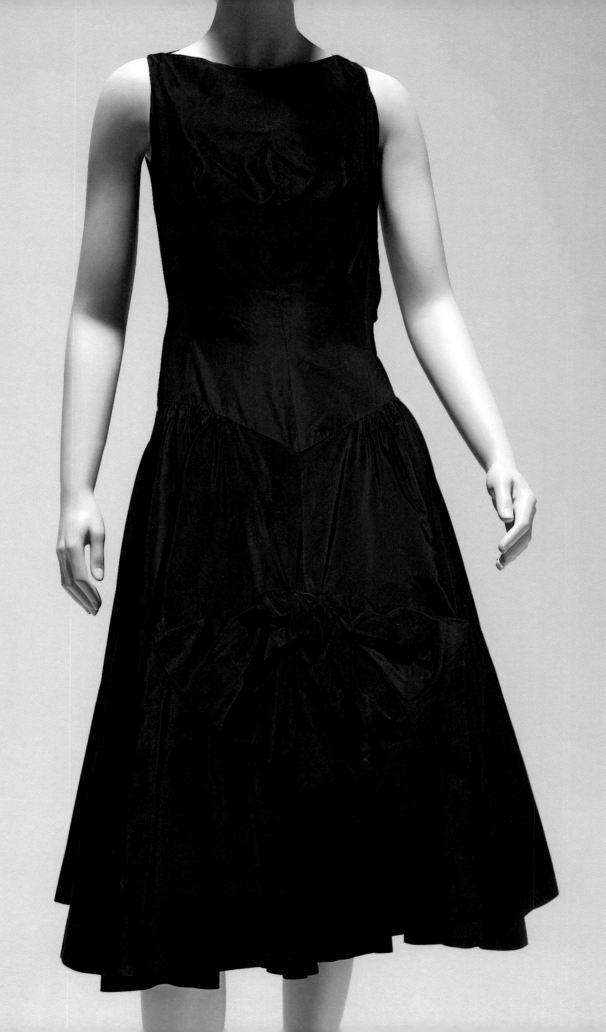

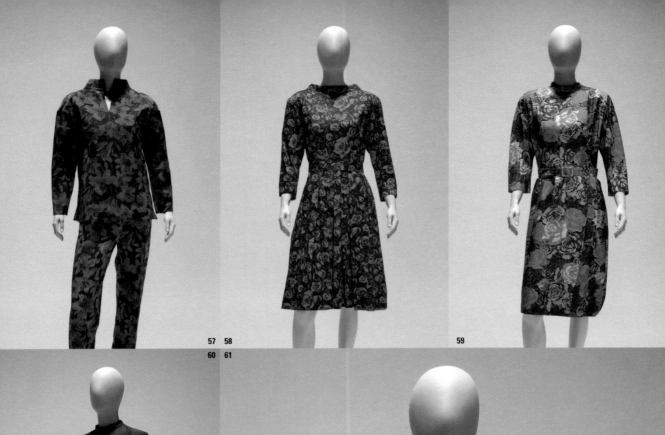

57 58

60 61

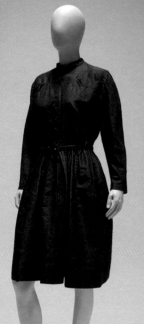

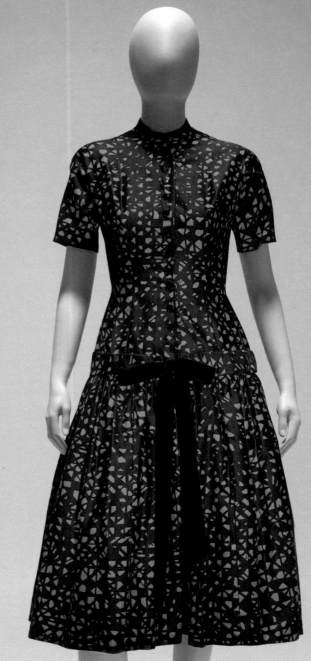

62

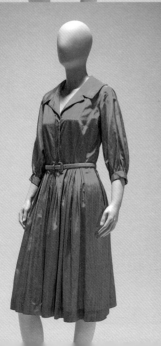

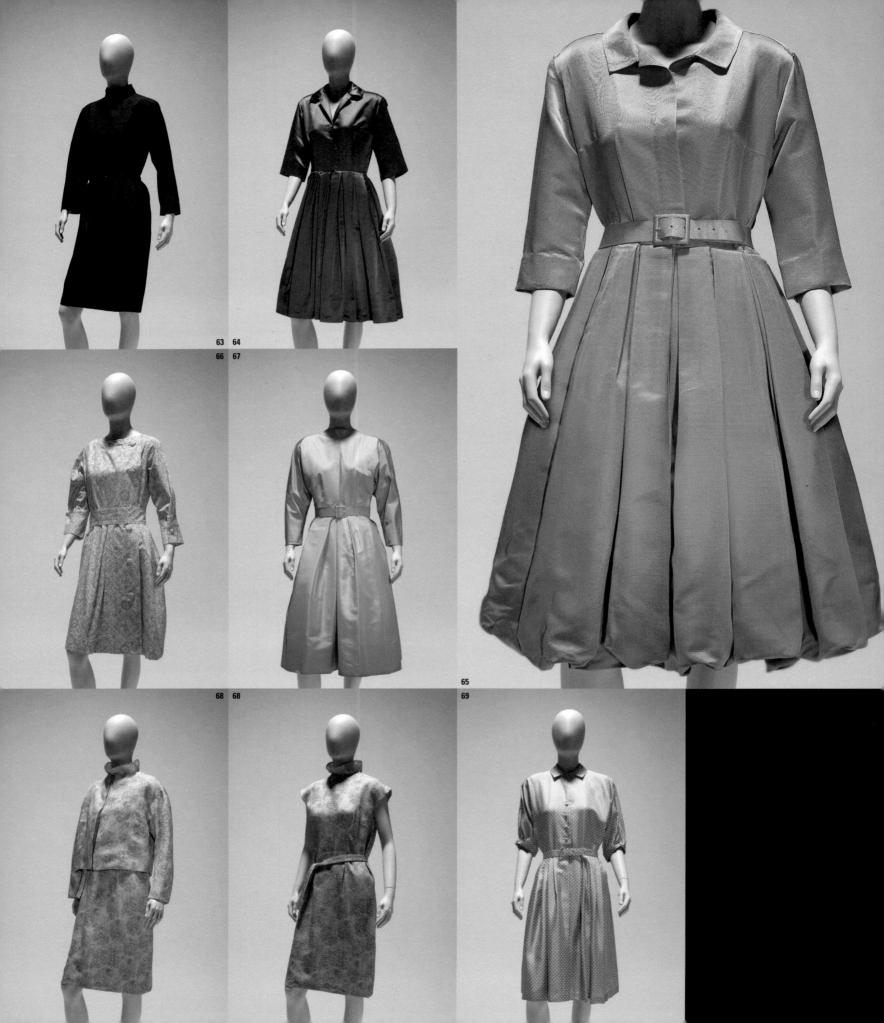

63 64
66 67

65

68 68

69

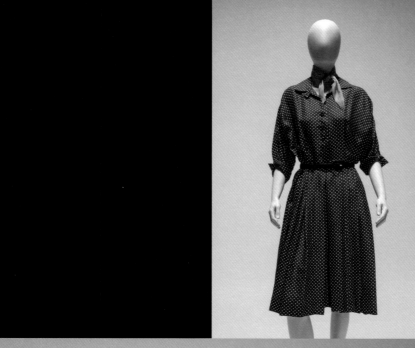

70 71
72 73

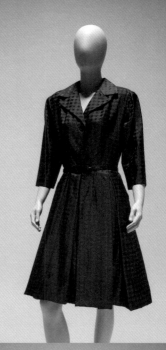

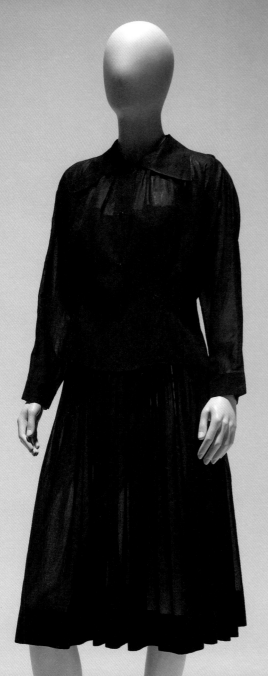

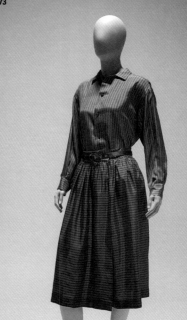

74

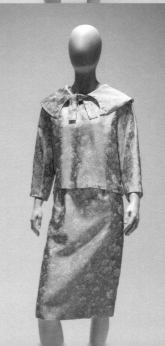

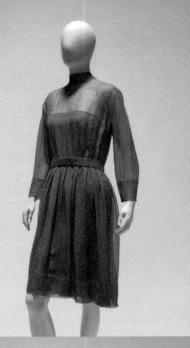
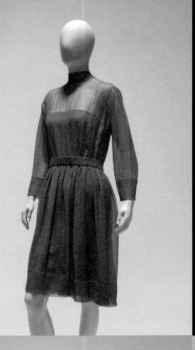

75 76

77 78

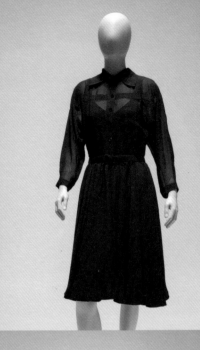
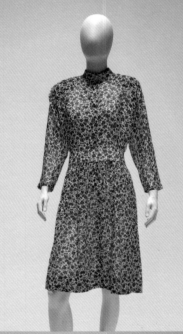

81

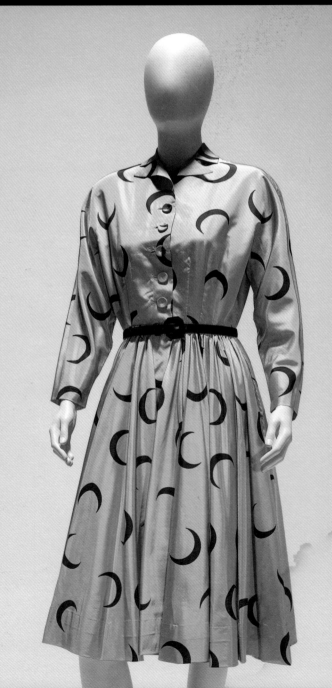

79 80

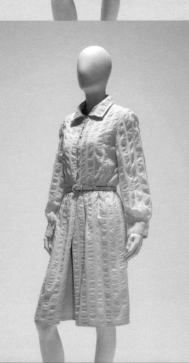
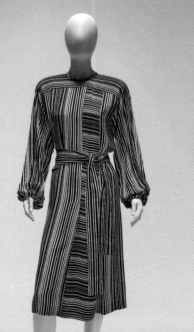

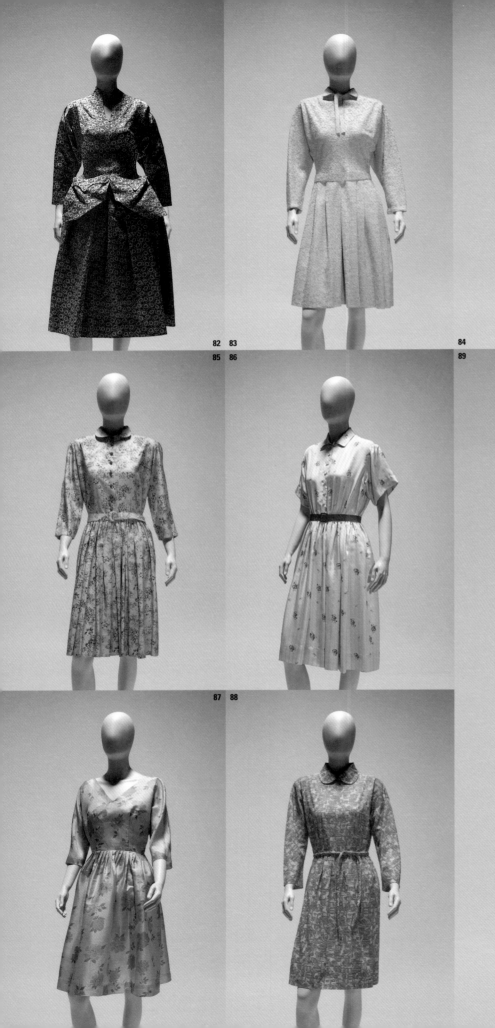

82 83

85 86

84

89

87 88

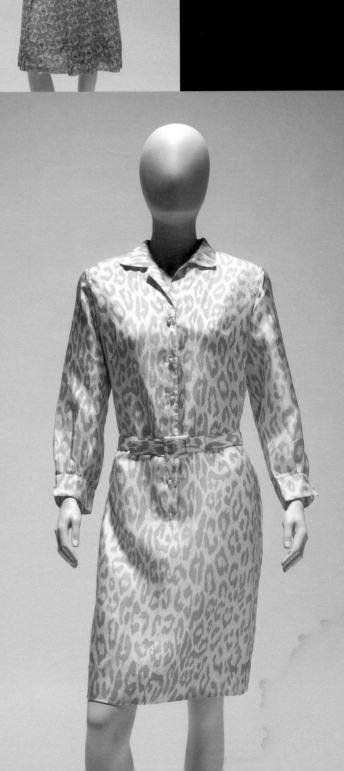

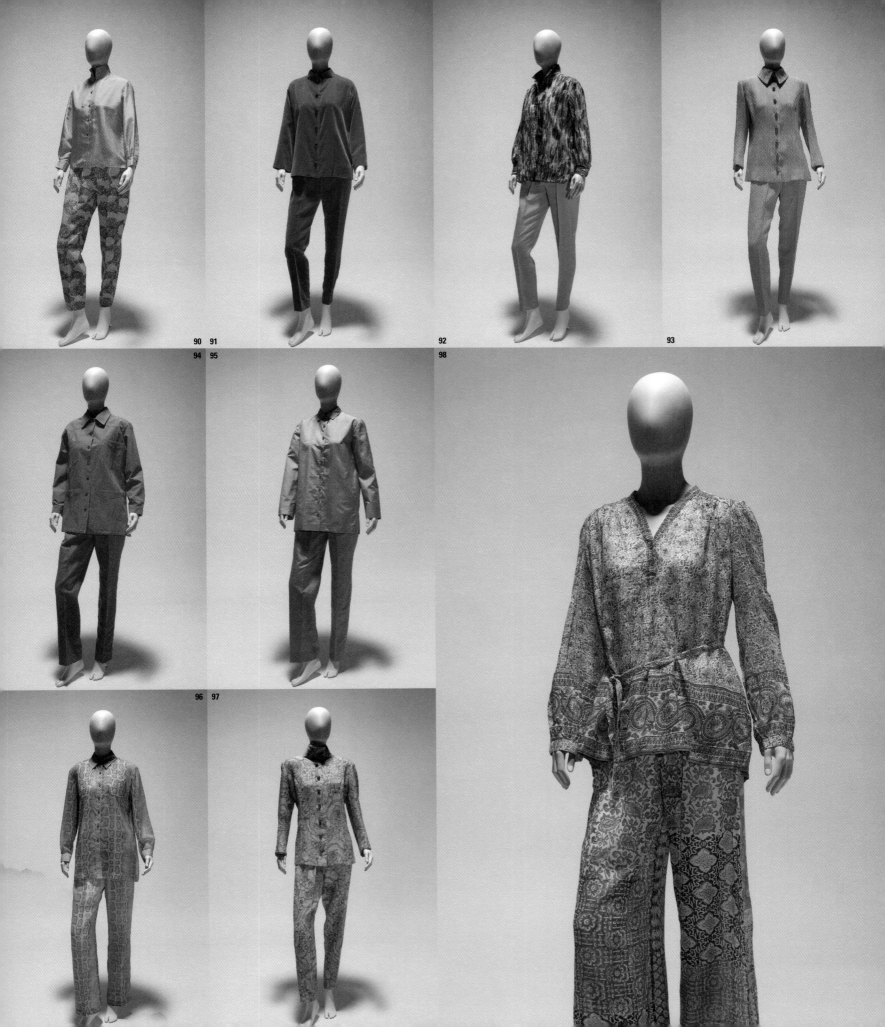

90 91

94 95

98

96 97

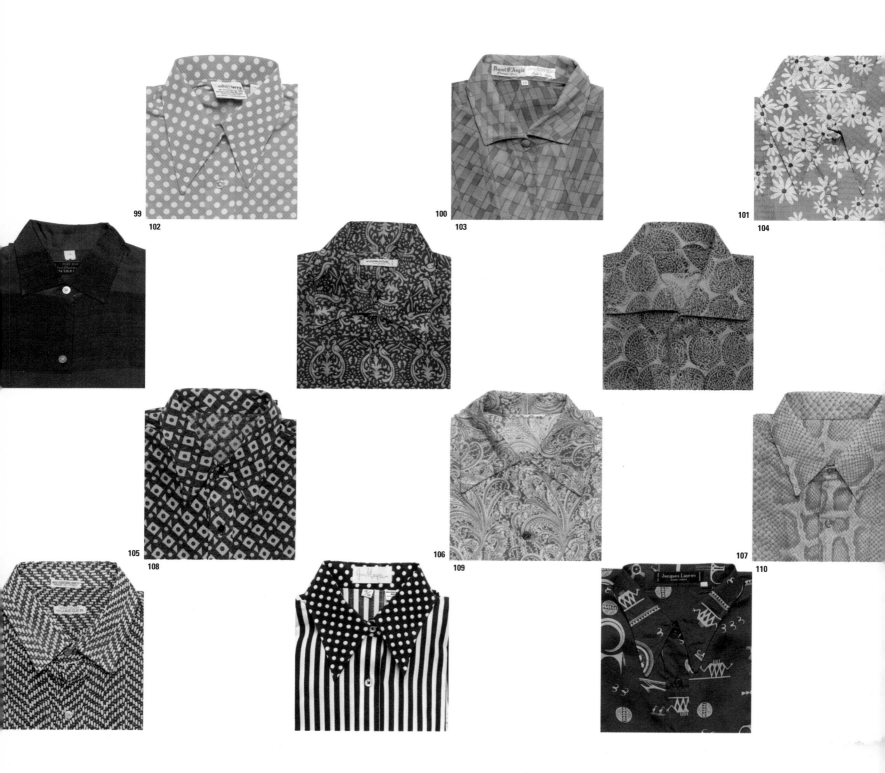

99

100

101

102

103

104

105

106

107

108

109

110

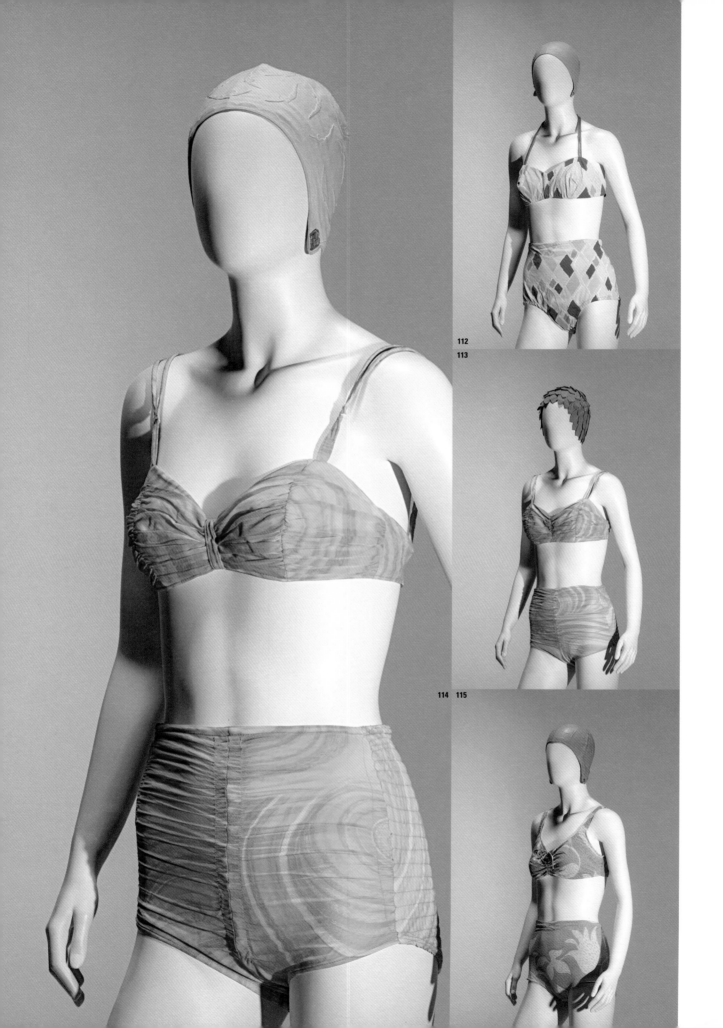

112
113

114 115

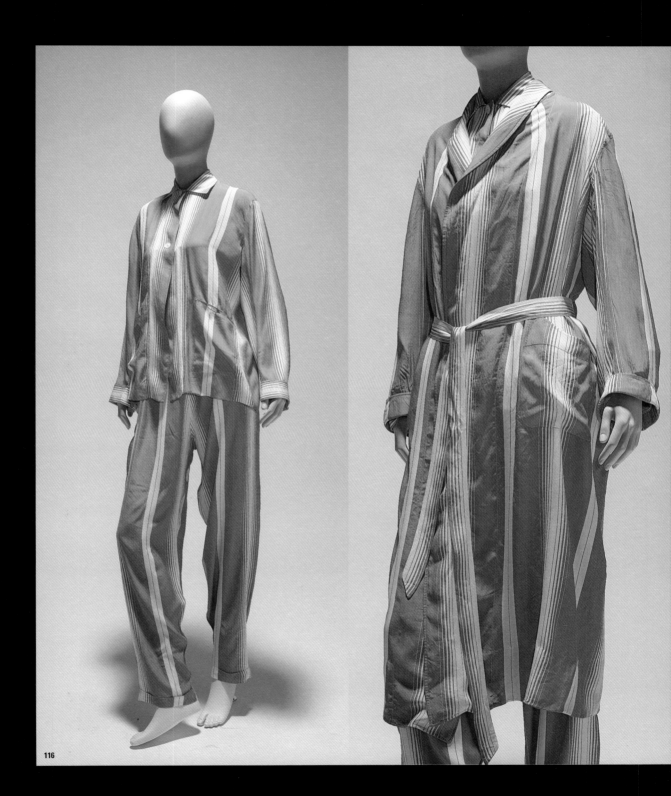

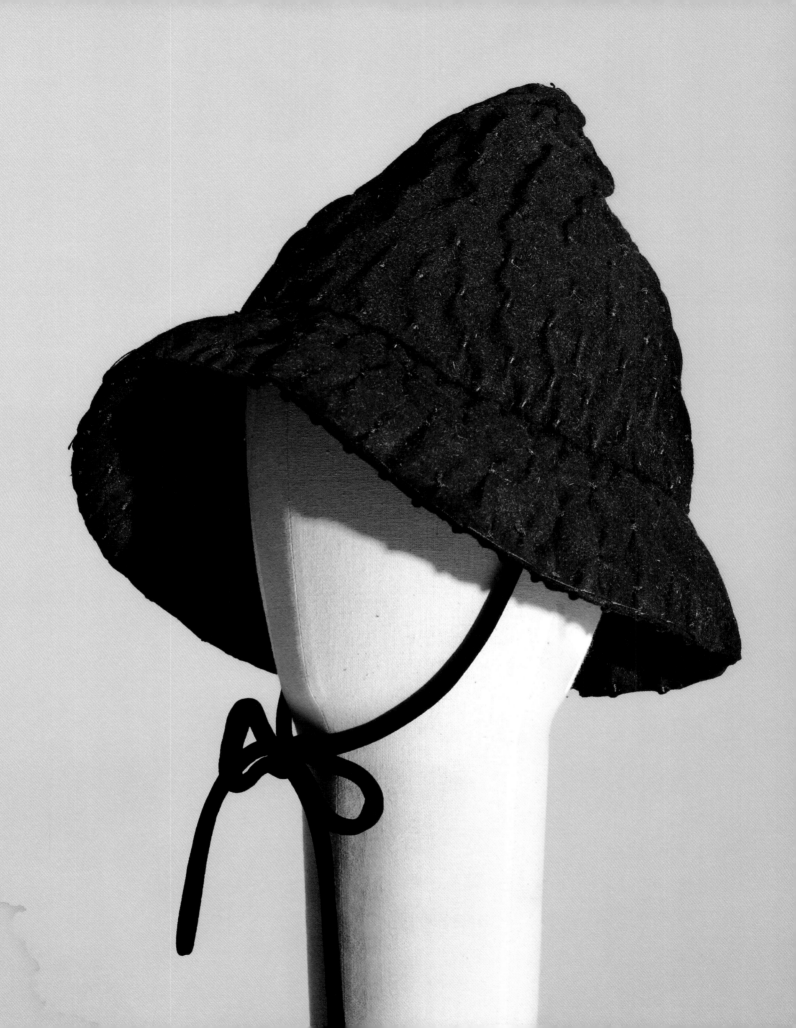

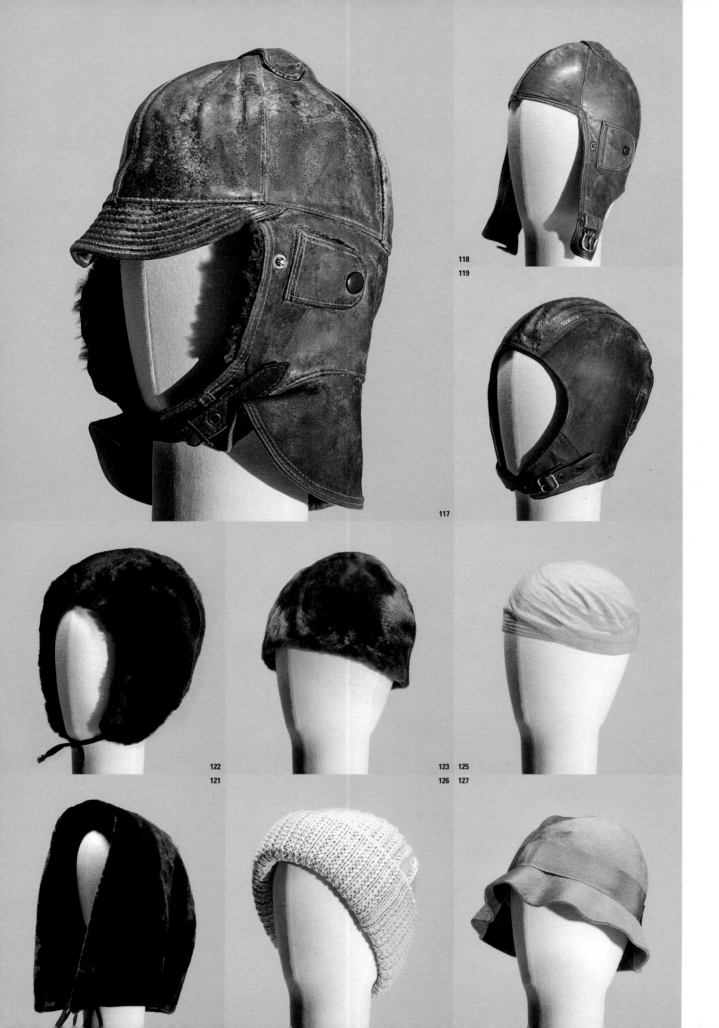

117

118
119

122
121

123 125
126 127

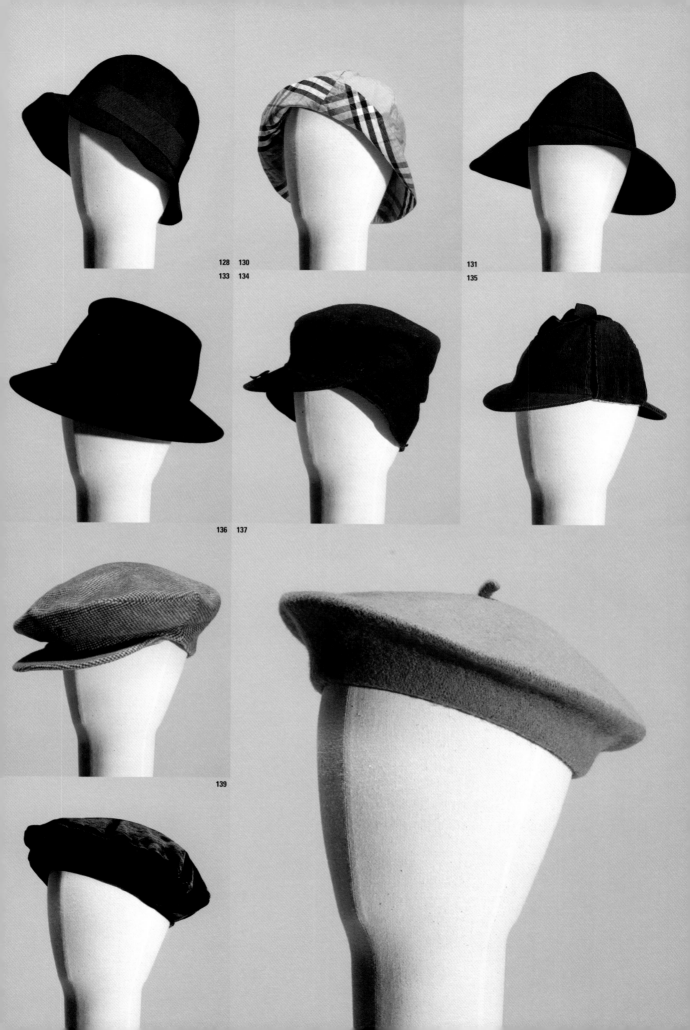

128 130
133 134 135

136 137

139

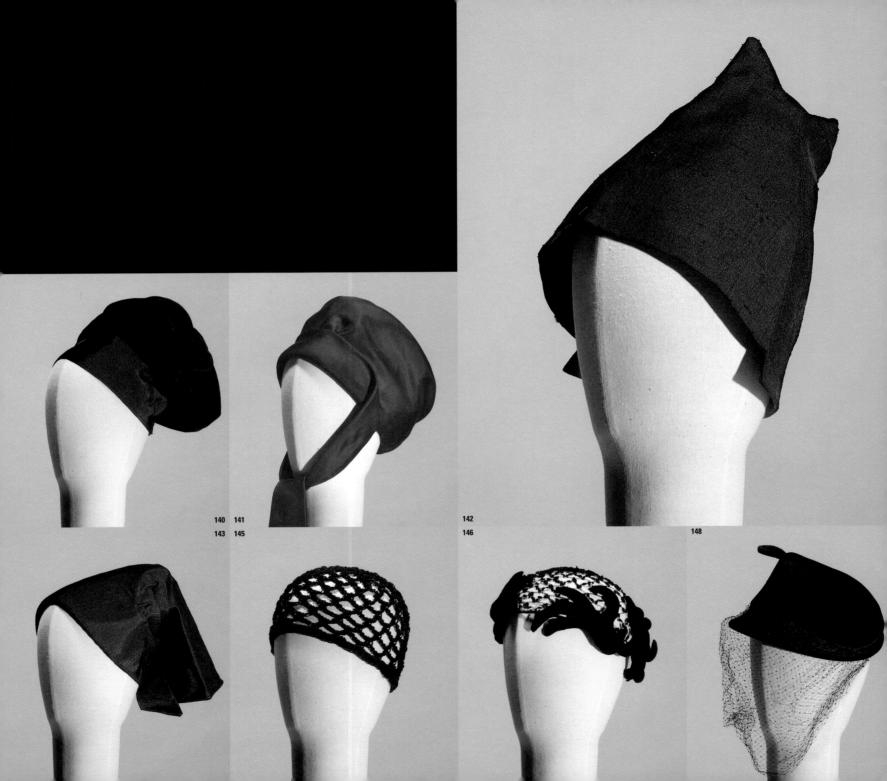

140 141
143 145

142
146

148

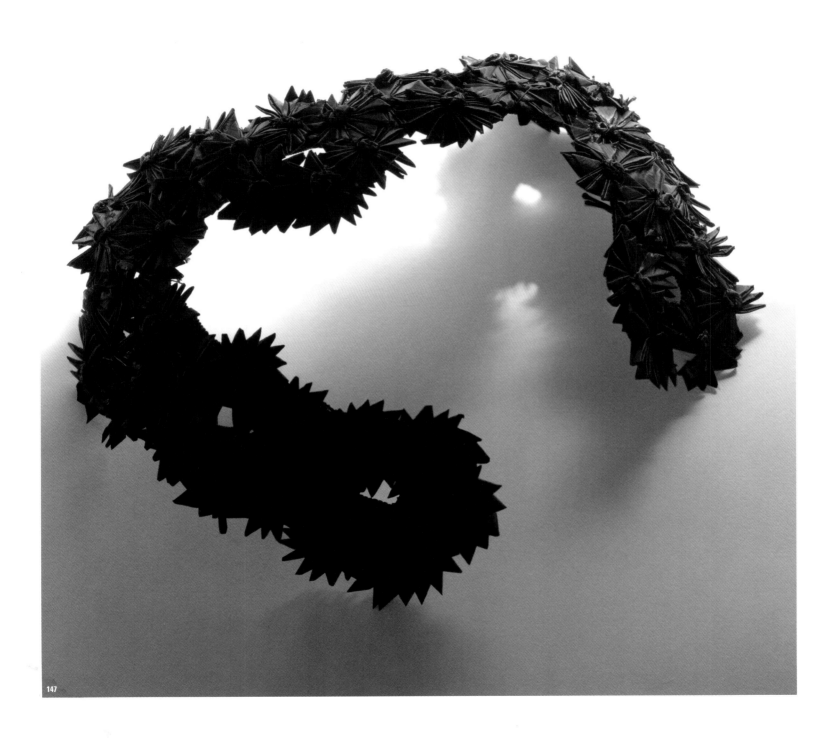

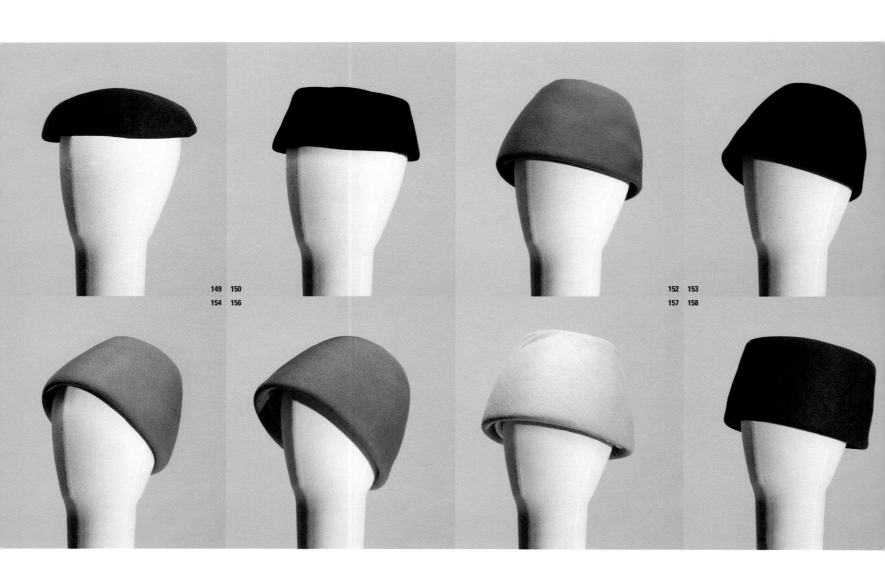

149 150
154 156

152 153
157 158

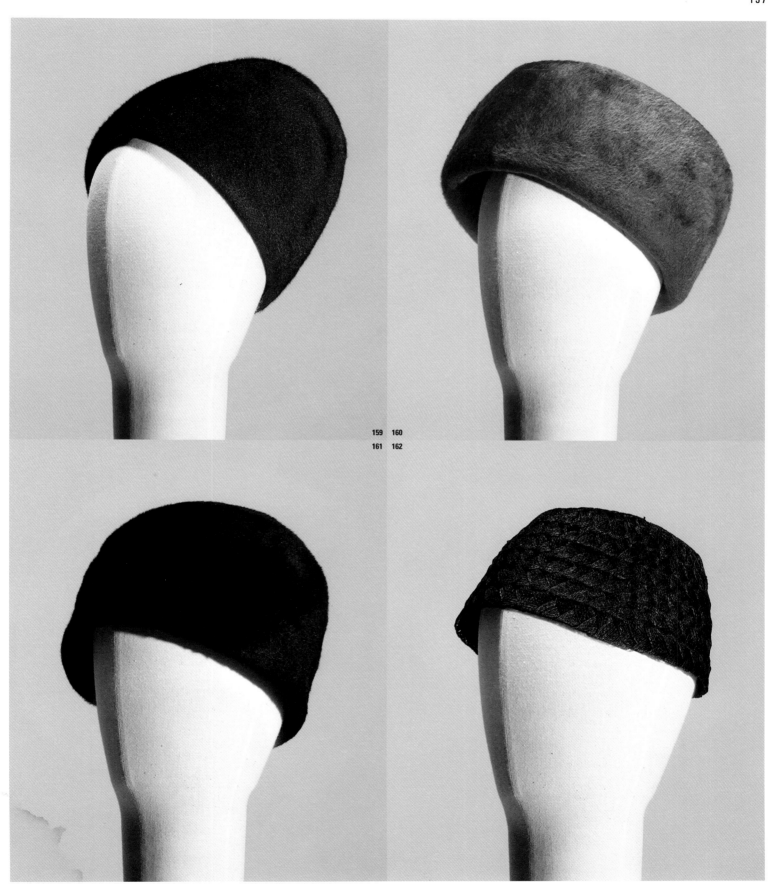

159 160
161 162

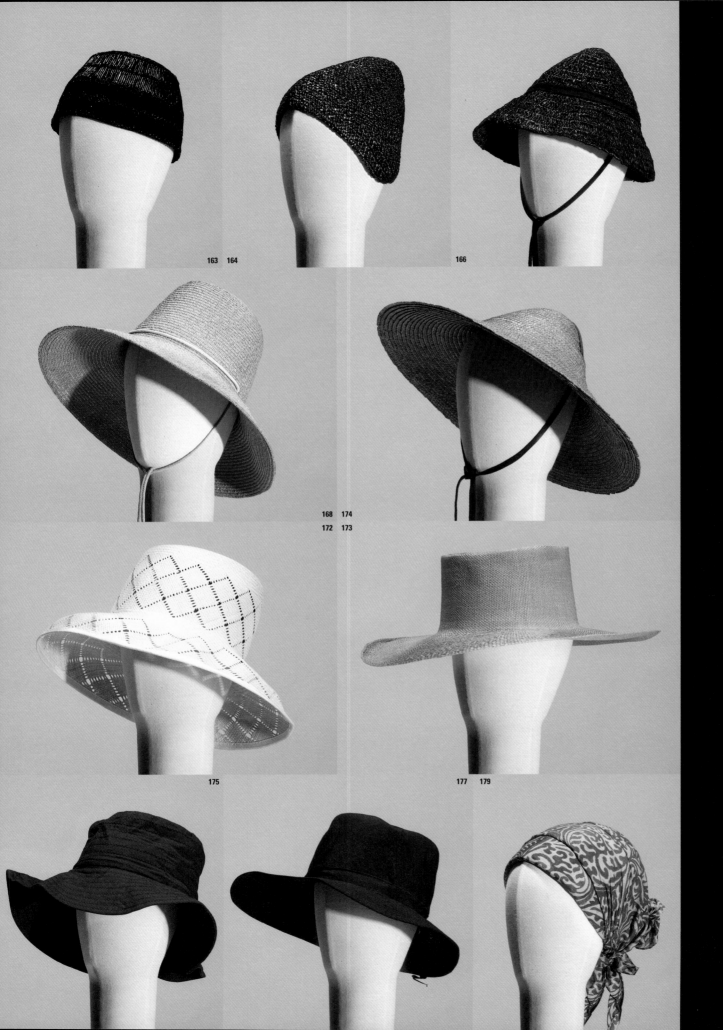

163 164

166

168 174
172 173

175

177 179

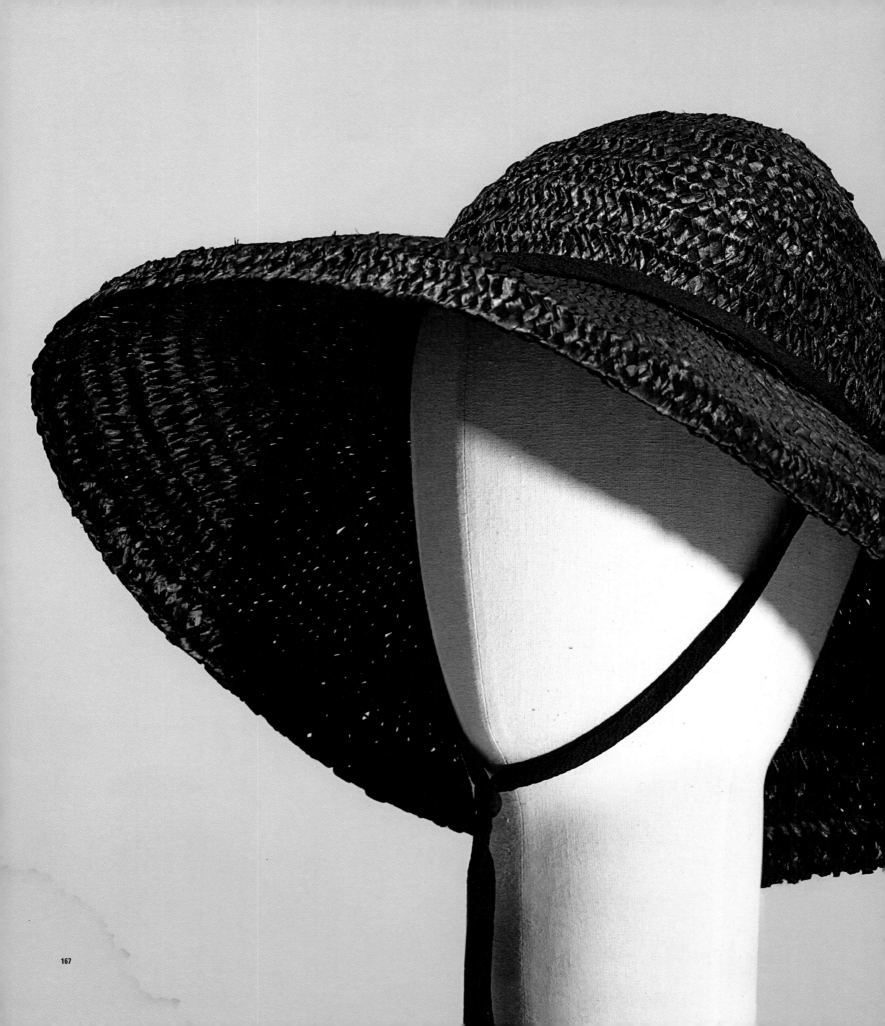

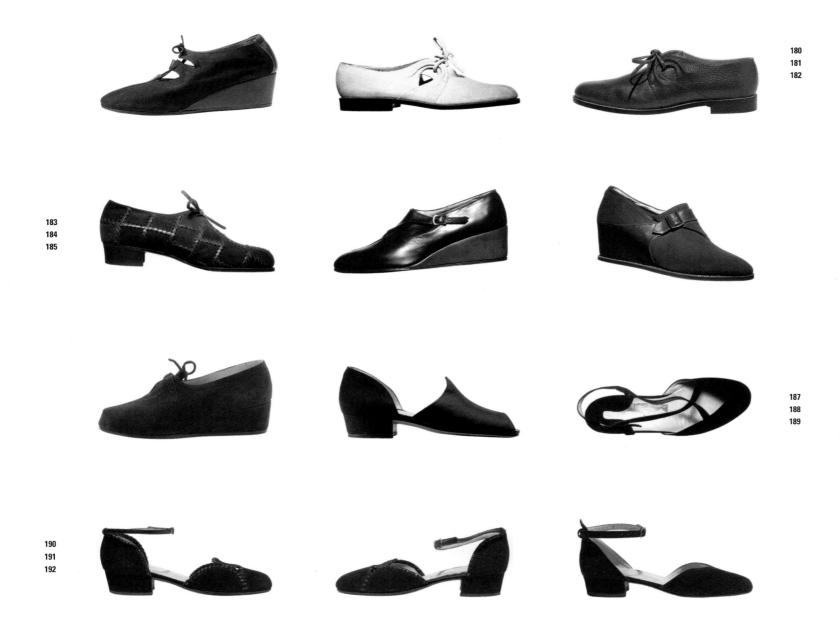

180
181
182

183
184
185

187
188
189

190
191
192

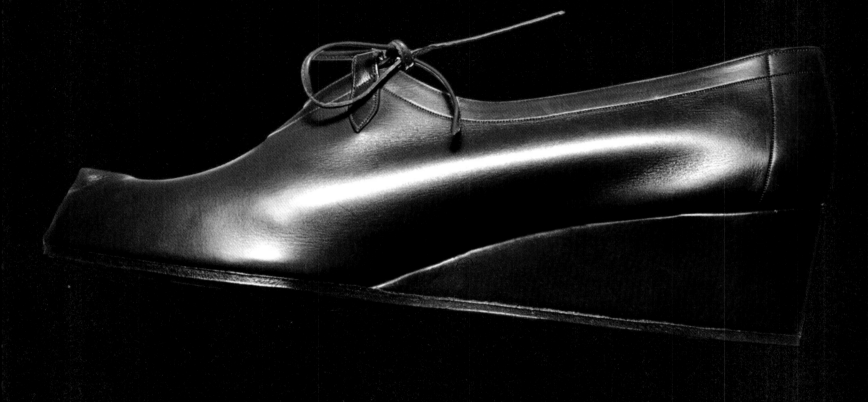

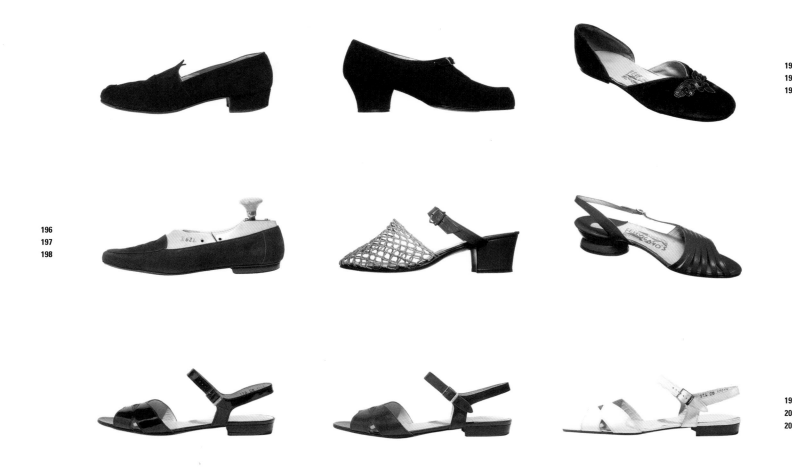

193
194
195

196
197
198

199
200
201

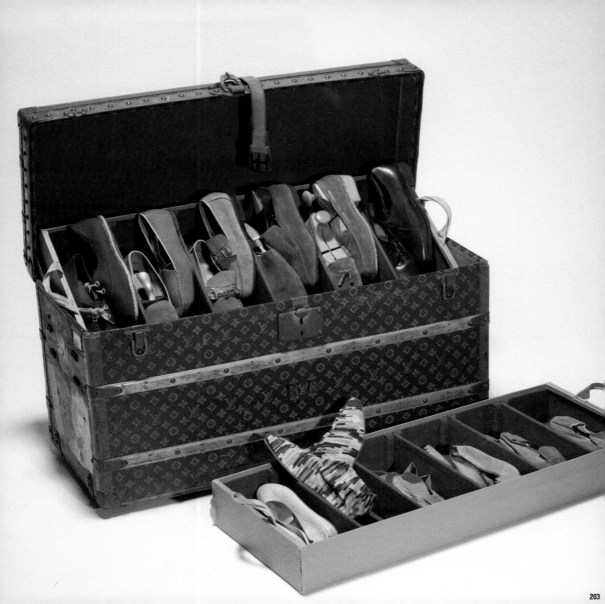

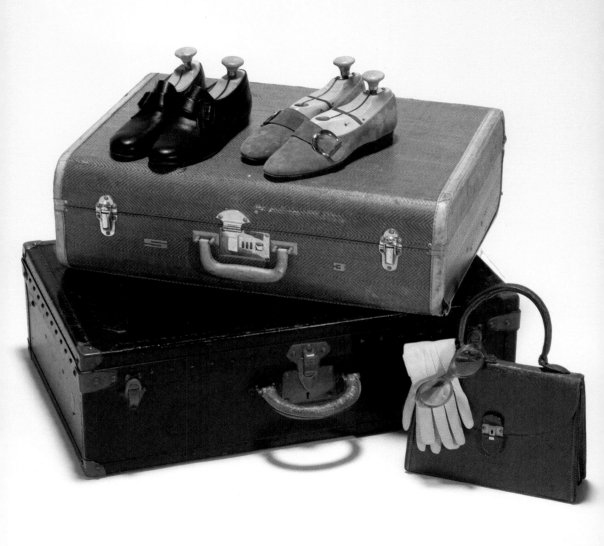

CATALOGUE OF THE WARDROBE ON DISPLAY

1 "Aquascutum Regent Street London", circa 1964
Brown cotton and polyester trench coat

2 "Ialongo Inc. New York", 1951
Brown double-breasted wool velour coat with wooden buttons

3 "Valentina", 1957
Ecru double-breasted Empire-style wool velour coat

4 Unknown manufacture, 1950
Herringbone wool trench coat in shades of ecru

5 Unknown manufacture, 1960–1961
Wool blend overcoat in shades of beige

6 Unknown manufacture, 1969–1970
Beige double-breasted knit overcoat

7 "Valentina", 1956
Chestnut-coloured double-breasted wool velour and cashmere coat

8 "Alaïa", 1982–1985
Wool jersey and polyamide overcoat with belt

9 Unknown manufacture, 1940
Grey double-breasted men's flannel coat

10 "Valentina" (?), 1948
Black wool broadcloth redingote

11 "Valentina", 1943
Navy wool redingote coat

12 "Valentina", 1949
Navy mouflon redingote coat

13 "Ialongo Inc. New York", 1956
Burgundy bouclé wool coat

14 Unknown manufacture, 1951
Black wool velour coat

15 "Tailored by Orginala", 1959
Blue knit overcoat with passementerie buttons

16 American manufacture (Hollywood), 1938–1940
Long orange red evening cape and skirt cut on the bias in silk, cotton, linen and lurex

17 "Valentina", early 1940s
Black silk velvet overcoat

18 "Valentina", mid-1950s
Black satin overcoat with silk lining and red-flower print

19 "Saks Fifth Avenue", 1962
Black ottoman wool overcoat

20 "Valentina", mid-1950s
Turquoise silk shantung overcoat

21 "Valentina", 1951
Black ottoman silk overcoat

22 Unknown manufacture, 1963
Silk brocade overcoat in shades of beige and gold

23 Unknown manufacture, early 1940s
Brown wool flannel suit with turquoise wool and velvet double collar

24 "Valentina", 1946
Wool and mohair suit in shades of beige and grey with woven pattern

25 "Valentina", 1951
Black wool gauze suit

26 "Valentina", 1951
Black ottoman silk suit

27 "Valentina", 1953
Black wool and cashmere suit with black velvet collar

28 "Valentina" (?), 1947
Suit with black-and-grey striped wool double-breasted jacket

29 "Givenchy", 1961
Grey mouflon suit

30 "Ialongo Inc. New York", early 1960s
Turquoise bouclé wool suit

31 "Valentina", 1947
Blue wool and silk suit

32 Unknown manufacture, 1954
Purple wool tweed two-piece outfit with black velvet collar

33 "Valentina", 1946
Cream-coloured silk shantung suit

34 "Valentina", 1946
Check-pattern wool suit

35 "Valentina", 1953
Wool suit in shades of brown and beige with woven pattern

36 "Ialongo Inc. New York", mid-1950s
Ecru linen and silk suit

37 "Valentina", 1956
Beige knit suit

38 "Valentina", 1953
Linen and silk suit with woven pattern

39 Unknown manufacture, 1960s
Beige linen and silk suit

40 "Valentina", 1955
Champagne-coloured ottoman silk suit

41 "Valentina" (?), 1943
Powder rose wool crêpe dress with belt

42 "Valentina" (?), 1946
Green/beige wool melange dress

43 "Valentina" (?), 1956
Light green wool dress (waist belt missing)

44 "Valentina, 1947
Grey wool dress with large pockets

45 Unknown manufacture, 1952–1953
Grey wool jersey dress with double-breasted corset

46 Unknown manufacture, mid-1950s
Black and white micro-pattern knit dress with black leather belt

47 "Valentina", early 1950s
Black satin jacquard chemise dress with belt and blue wool work

48 Unknown manufacture, 1949
Blue wool crêpe dress

49 "Valentina", early 1950s
Black jacquard silk dress with patent-leather belt

50 Unknown manufacture, late 1930s
Black silk velvet short dress with belt. Embroidery with white rhinestones, fumé glass beads and black jais

51 Unknown manufacture, late 1930s
Black silk sablé dress

52 Unknown manufacture,

early 1940s
Black rayon dress with
balloon sleeves

53 "Christian Dior", 1954
Black silk shantung dress
with straps and bows
(shortened skirt)

54 Unknown manufacture,
1961
Navy silk crêpe dress with
pleated corset

55 Unknown manufacture,
1958–1959
Doubled bluette satin robe
manteau dress with belt.
There is also a black satin
version

56 Unknown manufacture,
1956–1957
Black taffetas evening gown
with large front bow

57 Unknown manufacture,
mid-1950s
Blue ottoman silk trousers
outfit with turquoise flower
pattern

58 Unknown manufacture,
mid-1950s
Blue cotton dress with belt
and turquoise rose pattern

59 Unknown manufacture,
1959–1960
Turquoise silk satin dress
with sky–blue and black rose
pattern

60 Unknown manufacture,
1955–1957
Blue silk taffetas chemise
dress with belt

61 Unknown manufacture,
1956
Black cotton satin dress
with emerald green
geometric patterns
and large front black velvet
bow

62
Unknown manufacture,
mid-1950s
Green taffetas chemise dress
with moiré effect pattern

63 "Valentina", first half of
1950s
Black wool and silk shantung
dress

64 "Valentina", 1954
Grey silk satin dress

65 "Valentina", 1956
Turquoise ottoman silk dress
with belt and balloon skirt

66 Unknown manufacture,
early 1960s
Cotton chiné dress with belt
and flower pattern in shades
of sky-blue

67 Unknown manufacture,
early 1950s
Turquoise silk taffetas full-
length dress with belt

68 Unknown manufacture,
1963–1964
Silk jacquard sleeveless
dress with jacket in shades
of sky-blue and flower
pattern

69 Unknown manufacture,
1952–1953
Sky-blue silk satin chemise
dress with belt and white
polka dots

70 Unknown manufacture,
1952–1953
Blue silk chemise dress with
belt and white polka dots

71 "Valentina" (?), 1954–
1955
Black and grey check silk
taffetas chemise dress

72 "Valentina", 1950
Black cotton organdie shirt
and skirt

73 "Valentina" (?), 1956
Striped crêpe de chine skirt
in shades of grey

74 Unknown manufacture,
1963
Periwinkle silk twill two-part
dress with white flower
pattern. Worn by Greta
Garbo to the White House

75 Unknown manufacture,
1955
Brown silk georgette dress
with belt

76 Unknown manufacture,
1954
Chiffon dress with
micro-pattern in shades
of brown/beige

77 Unknown manufacture,
1955
Black silk satin chemise
dress with white polka dots
and small rust-coloured
flowers

78 Unknown manufacture,
1958–1959
White cotton muslin dress
with black flower pattern

79 Unknown manufacture,
1970s
Beige cotton chemise dress

80 Unknown manufacture,
1974–1975
Black and beige striped crêpe
de chine dress

81 "Valentina", circa 1955
Gold taffetas chemise dress
with petticoat and black
moon pattern

82 Unknown manufacture,
1957
Pink satin two-piece dress
with black pattern

83 "Valentina" (?),
1943–1944

Pink silk jacquard with white
lace effect

84 "Valentina", 1946
Pink cotton muslin shirt and
skirt with black pattern

85 Unknown manufacture,
late 1940s
Pink silk taffetas dress with
belt and black flower pattern

86 Unknown manufacture,
early 1950s
Pink striped silk satin chemise
dress with short sleeves and
pink leather waist belt. Coral
pink flower pattern

87 Unknown manufacture,
early 1950s
Gold silk taffetas V-neck
dress with sky-blue and pink
flower pattern

88 Unknown manufacture,
early 1960s
Cotton muslin dress with
pattern in shades of pink

89 Unknown manufacture,
circa 1965
Silk twill chemise dress in
shades of pink and *animalier*
pattern

90 "Emilio Pucci", 1960
Pink silk shantung shirt
with Emilioform trousers
and dahlia pattern in shades
of pink and purple

91 Unknown manufacture,
1960s
Fuchsia cotton velvet jacket
and trousers with jewel
buttons

92 "Emilio Pucci", 1961
Cotton shirt with flame
pattern and turquoise silk
shantung trousers

93 Unknown manufacture,
early 1970s

Pink fuchsia silk blend suit,
jacket and trousers

94 Unknown manufacture,
early 1970s
Tobacco-coloured heavy
cotton shirt and trousers

95 Unknown manufacture,
late 1960s
Coral pink silk Oriental-style
shirt and trousers

96 Unknown manufacture,
late 1960s
Cotton muslin shirt and
trousers with python pattern
in shades of beige

97 Unknown manufacture,
late 1960s
Jacquard silk blend jacket
and trousers in shades of
beige. Fuchsia buttons and
pink fuchsia gros collar and
wrist decorations

98 Unknown manufacture,
1968–1970
Cotton muslin jacket and
trousers with ethnic pattern

99 "Lucky Pierre", early 1970s
Fuchsia polyester shirt with
white-dot print

100 "Nucci d'Angiò Firenze",
first-half 1960s
Cotton shirt with geometric
pattern in fuchsia, green
and turquoise

101 Unknown manufacture,
late 1960s
Pink fuchsia cotton shirt
printed with white floral
motif

102 "Hai Silk Co. Ltd",
late 1950s
Tartan silk shantung in
shades of green and blue

103-104 "Saint Laurent Rive
Gauche", late 1960s

Silk shirt with ethnic motifs in shades of purple

105 "Saint Laurent", 1970s
Silk jersey shirt with geometric motif in shades of purple and beige

106 Unknown manufacture, 1960s
Cashmere pattern cotton shirt in shades of sky-blue and beige

107 Unknown manufacture, late 1960s
Cotton muslin shirt with python skin effect

108 "Carlo Palazzi for Jaeger", 1970s
Brown and white striped cotton shirt

109 "Gus Mayer", 1970s
White and black striped cotton shirt with collar and wrists in black with white dots

110 "Jacques Lauran Paris Lion", 1960s
Brown silk shirt with geometric pattern in shades of beige

111 Trousers in wool, velvet and silk, from the late 1950s to the 1980s
Brown velvet knicker-bockers, 1946. Cotton sailor pants, 1949

112 Unknown manufacture, 1959–1961
Cotton and lastex printed bathing suit

113-114 Unknown manufacture, early 1960s
Nylon printed bathing suit

115 Unknown manufacture, early 1960s
Lycra bathing suit

116 Unknown manufacture, 1960s
Beige and pink salmon striped silk robe and pyjamas

117 Unknown manufacture, 1924
Brown leather aviator hat with fur lining

118 Unknown manufacture, 1929
Brown leather aviator hat with cotton lining

119 Unknown manufacture, 1929
Dark brown leather aviator hat with cotton lining

120 Unknown manufacture, 1940s
Dark brown mink earmuffs

121 "Valentina" (?), 1945
Brown seal hood

122 "ЗMOCKBA", circa 1961
Black beaver cap

123 Unknown manufacture, late 1950s
Brown beaver cap hat

124 Unknown manufacture, 1959
Dark brown mink hat

125 Unknown manufacture, 1939-1940
Beige wool jersey turban

126 Unknown manufacture, late 1970s
Beige wool knit hat

127 Unknown manufacture, 1946
Camel wool velour cloche with gros grain band

128 "Knox New York", 1940s

Black felt cloche with gros grain band

129 Unknown manufacture, late 1960s
Brown suede cloche with leather trimming

130 "Burberry", 1970s
Cotton cloche with tartan lining

131 "Valentina"(?), 1946
Blue felt cloche

132 "Valentina", 1946
Black felt cloche

133 "Eileen Carson New York", 1976
Black felt cloche

134 "Valentina" (?), 1943
Blue wool hat

135 "Hilhouse and Co. London", 1940s
Green corduroy Deerstalker

136 "Knapp felt de luxe made especially for Schwab's Hollywood Calif", 1950s
Beige and brown check wool hat

137 "Made In Czeckoslovackia", 1939
Camel wool beret

138 "Euzkadi Industrie Argentine", 1940s
Blue broadcloth beret

139 Unknown manufacture, 1935
Black smooth velvet beret

140 Unknown manufacture, circa 1946
Turban in black velvet sections

141 "Mrs. John", 1945
Blue silk twill pill-box with ribbons to be tied below the chin

142 Unknown manufacture, circa 1950
Black silk and linen shantung hat

143 "Mr. Martin Bonwit Teller", 1952
Black silk shantung turban

144 Unknown manufacture, 1940s
Purple silk thread crochet hat

145 Unknown manufacture, 1940s
Brown silk thread crochet hat

146 "Tatiana of Saks Fifth Avenue", 1950s
Elegant black velvet hat and silk net with black jais beads

147 "Dana Marté Original Sullivan & Benson New Haven", 1950s
Synthetic raffia headgear with flower pattern

148 "Ere Nouvelle New York", late 1940s
Black velvet hat with veil

149 "Hexander and Oviatt Los Angeles Beret de luxe Mossant Made in France", 1940
Black wool flat hat

150 "Flechet Body made in France", circa 1950
Black velvet toque

151 Unknown manufacture, 1951
Black wool velour pill-box

152 Unknown manufacture, 1951
Sky-blue wool velour pill-box

153 "Mr. John", 1951
Brown wool velour pill-box

154 "Lilly Daché Paris New York", 1950–1952

Marrone glacé wool velour pill-box

155 "Body made in France", 1950s
Black wool velour pill-box

156 "Mr. John", 1950s
Chestnut wool velour pill-box

157 "Mr. John", mid-1950s
Beige wool broadcloth pill-box

158 "Lilly Daché Paris New York", early 1950s
Blue wool velour pill-box

159 Unknown manufacture, early 1960s
Black wool velour pill-box

160 "Givenchy", 1964
Brown mouflon pill-box

161 "Lilly Daché Paris New York", mid-1960s
Black mouflon hat

162 "Valentina", early 1950s
Black braided horsehair pill-box

163 Unknown manufacture, early 1950s
Black raffia pill-box

164 "Valentina", 1940s
Black braided raffia hat

165 Unknown manufacture, late 1940s
Small pagoda straw hat to be tied under the chin

166 "Valentina", late 1940s
Black braided raffia cloche hat to be tied under the chin

167 "Valentina", 1949
Large black braided raffia cloche hat to be tied under the chin

168 Italian manufacture ("Made in Italy" label), late 1940s
Large straw cloche hat to be tied under the chin

169 "Lilly Daché Paris New York", late 1940s–early 1950s
Large natural-colour braided straw hat to be tied under the chin

170 Unknown manufacture, 1953
Ecru linen hat

171 "Gobbi New York", 1950s
Braided straw hat with printed fabric band and silk rose

172 Colombian manufacture ("Made in Colombia" label), 1957
Straw hat

173 Japanese manufacture ("Made in Japan" label), 1960s
Pink synthetic straw hat

174 Unknown manufacture, 1940s
Large straw cloche hat to be tied under the chin

175 "Lilly Dachet Paris New York", 1959
Bluette cotton cloche hat

176 "Lilly Dachet Paris New York", 1959
Turquoise cotton cloche hat

177 Unknown manufacture, late 1950s
Blue cotton cloche hat

178 Unknown manufacture, late 1950s
Black wool blend cloche hat

179 "Mr. John", 1968–1969
Beige, green and red cotton

muslin turban with batik pattern

180 Salvatore Ferragamo, 1937
Brown suede ghillie with wedge

181 Salvatore Ferragamo, 1938
"Toria". White kangaroo-skin laced shoe

182 Salvatore Ferragamo, 1938
"Toria". Brown kangaroo-skin laced shoe

183 Salvatore Ferragamo, 1941
Brown patchwork suede laced shoe

184 Salvatore Ferragamo, 1941
Blue calf-skin shoe with buckle and red kid-skin wedge

185 Salvatore Ferragamo, 1942
"Attica". Brick red suede and calf-skin shoe with covered wedge

186 Salvatore Ferragamo, 1947
"Lauren". Brown calf-skin laced shoe with wedge

187 Salvatore Ferragamo, 1947
"Lauren". Brown suede laced shoe with wedge

188 Salvatore Ferragamo, 1949
Black satin shoe in two pieces

189 Salvatore Ferragamo, 1950
"Oxalia". Black suede sandal with closed toe

190 Salvatore Ferragamo, 1949

"Zita". Black patchwork suede shoe in two pieces

191 Salvatore Ferragamo, 1949
"Zita". Blue patchwork suede shoe in two pieces

192 Salvatore Ferragamo, 1950
Two pieces with ankle strap in black suede

193 Salvatore Ferragamo, 1950
Black suede closed shoe with modelled upper

194 Salvatore Ferragamo, 1950
"Greta". Black suede closed shoe with working in a unique piece. Buckle

195 Salvatore Ferragamo, 1953
"Darana". Two-part violet velvet ballerina with sequins embroidery

196 Salvatore Ferragamo, 1980s
Black suede closed shoe with embroidered toe cap signed Ferragamo

197 Salvatore Ferragamo, 1950–1952
"Cistia". Sandal with cord net upper. Ankle strap and brown calf-skin heel

198 Salvatore Ferragamo, 1952–1953
"Amalfi". Red kid-skin sandal

199-201 Salvatore Ferragamo, early 1980s
Black patent-leather sandal. Also in a white and black calf-skin version

202 Salvatore Ferragamo, 1964

Braided suede laced ballerina with shell-shaped sole

203 "Louis Vuitton" shoe box, 1940s. Men's-style shoes from various periods and summer scarves in shades of pink, including the Emilioform boots by Emilio Pucci

204 "Louis Vuitton" luggage, 1940s. Black calf-skin shoes with buckle, "Abercrombie & Fitch New York Chicago San Francisco", mid-1930s and in beige suede from the 1960s. Boar-skin "Gucci" purse with handle, 1940s, leather gloves and eyeglasses "Lugene New York", early 1960s

205 "Pierre Cardin", late 1960s
Men's striped canvas shoes with buckle

206 Leather gloves from various periods

207 "Koret De Pinna", 1956
Turquoise satin pochette. Accessory to outfit cat. 65

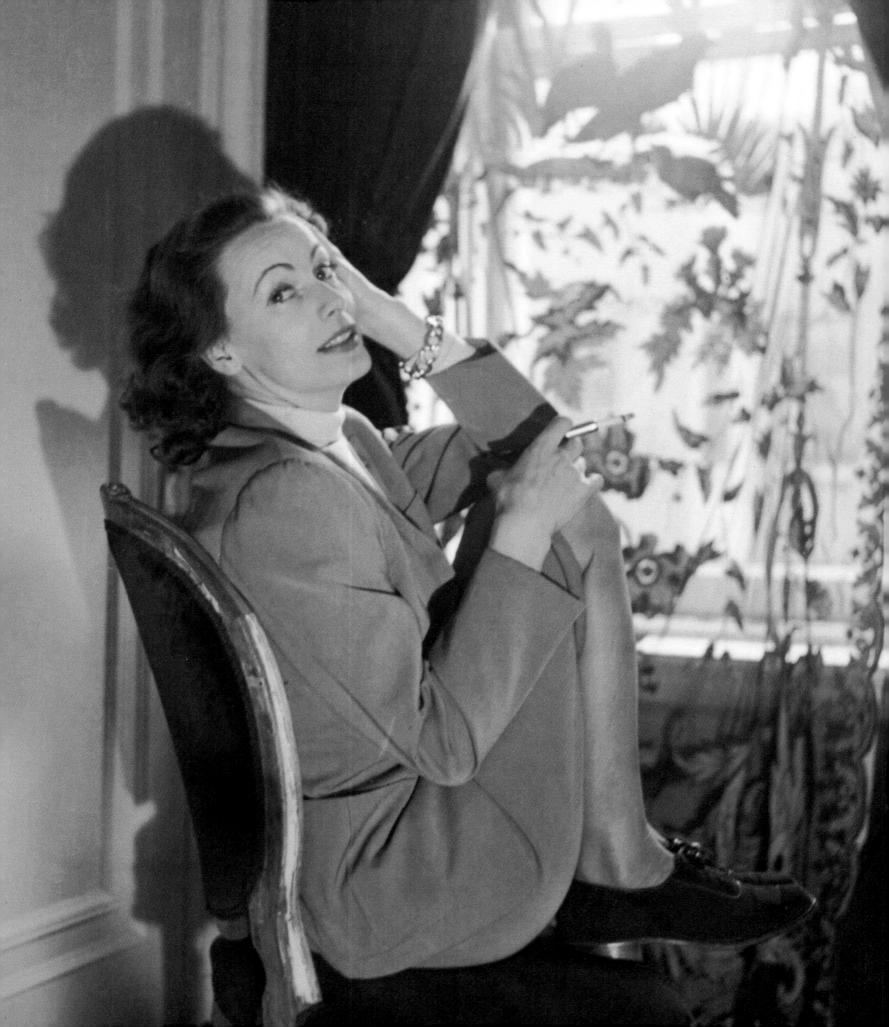

BIOGRAPHICAL NOTE

Born in Stockholm on 18 September 1905, the youngest of three siblings, Greta Lovisa Gustafsson was a shy and solitary child, born into a family of modest means. The daughter of a street sweeper and a maid, her father died when she was fourteen. She left school and began working at a barbershop and later as a clerk in a department store, until some ad photos of hers caught the attention of the entertainment world. Subsequently, she enrolled at the Royal Dramatic Theatre Academy, where she met the director Mauritz Stiller, who would be her teacher and mentor, a veritable Pygmalion who made her change her surname and launched her into the leading role in the film *The Saga of Gösta Berling* (1924). In 1925 she was called to Germany to act in *Die freudlose Gasse* by Georg W. Pabst, a complicated melodrama that revealed to the world her performing qualities and attracted the attention of the American producer Louis B. Mayer, the celebrated Metro Goldwyn Mayer tycoon. Thanks to him, Greta Garbo received a five-year contract; she then moved to Hollywood, which made her its own and turned her into a legend. From 1927 to 1937 the actress — soon nicknamed the "Divine" — starred in about twenty films in which she portrayed the tormented seductress, destined to an unhappy ending. Her first film in a leading role was *The Temptress* (1926), directed by Fred Niblo. Right after, it was *Flesh and the Devil* (1926) by Clarence Brown. These are portraits of women able to overwhelm the pride of any man and push him to madness, or of irresistible and fascinating lovers who are nevertheless merciless and indifferent to the fate of those who love or desire them. It was a triumph. In real life, Greta Garbo was introverted and inclined to solitude, which made her hieratic beauty even more impenetrable. But her touchy and gloomy personality could not tolerate at length the image of the *femme fatale* which Hollywood attempted to impose upon her. As early as her first talkie, *Anna Christie* (1930) by Clarence Brown, her character changed. She was always irresistible, but shadowy and all-consuming aspects also emerged. She also starred in *Mata Hari* (1931) by George Fitzmaurice, *Grand Hotel* (1932) by Edmund Goulding, *As You Desire Me* (1932) by Fitzmaurice, *Queen Christina* (1933) by Rouben Mamoulian, *Anna Karenina* (1935) by Clarence Brown, *Camille* (1937) by George Cukor. A complex and thwarted personality, an enigmatic character, with a totally interior charm and profound, penetrating gaze, Greta Garbo fled from any contact with Hollywood people, enveloping in a sort of mystery her aloof and timeless beauty. Elegant and inaccessible, after Stiller's death her indifference towards Hollywood grew even further and her choice for solitude became more pronounced. Lubitsch was able to convince her to play a brilliant part in *Ninotchka* (1939) alongside Melvyn Douglas, but the following film, *Two-Faced Woman* (1941), directed by George Cukor, seemed so banal to her that she decided to definitively lower the curtain upon the silver screen, leaving behind her own legend. She never won an Oscar, despite four nominations as Best Actress (for *Ninotchka*, *Camille*, *Romance* and *Anna Christie*). However, in 1954 she was given an Honorary Award for her unforgettable screen performances, but she did not attend the Oscars ceremony. She died at the age of 84, on 15 April 1990.

Greta Garbo at the Plaza Hotel in New York in 1946. Photo Cecil Beaton

FILMOGRAPHY

Short Films

Herr Och Fru Stockholm
Sweden, 1920. Directed by
Ragnar Ring. With Olga
Andersson, Erick Fröander,
Greta Garbo, Ragnar
Widestedt.

Konsum Stockholm Promo
Sweden, 1921. Directed by
Ragnar Ring. With Greta
Garbo, Lars Hanson.

Both these titles are
advertising short films
realized by PUB, the
Department Store where the
young Greta Garbo worked.

Feature Films

**Luffar-Petter
(Peter The Tramp)**
Sweden, 1922. Directed and
produced by Erik A.
Petschler. With Greta Garbo,
Erik A. Petschler, Gucken
Cederborg, Tyra Ryman.

The Saga of Gösta Berling
Sweden, 1924, Svensk
Filmindustri. Directed by
Mauritz Stiller. Photographed
by Henry B.Goodwin, Olaf
Ekstrand. Scenario Mauritz
Stiller and Regnar Hylten-
Cavallius. Cinematographer
Jiulius Jaenzon. With Greta
Garbo, Lars Hanson, Gerda
Lundeqvist, Mona
Martenson.

Die Freudlose Gasse
Germany, 1925, Sofar-film.
Directed by Georg Wilhelm
Pabst. Photographed by Curt
Oertel. Scenario by Willy
Haas. Cinematographer
Guido Seeber. With Greta
Garbo, Jaro Furth, Asta
Nielsen, Einar Hanson, Agnes
Esterhazy, Werner Krauss,
Loni Nest, Valeska Gert.

The Torrent
Usa, 1926, MGM Production
254. Directed by Monta Bell.
Photographed by Bertram
Longworth, Fred Morgan.
Scenario Dorothy Farnum.
Cinematographer William
Daniels. With Greta Garbo,
Ricardo Cortez, Gertrude
Olmstead, Edward Connelly,
Lucien Littlefield, Martha
Mattox, Lucy Beaumont,
Tully Marshall.

The Temptress
Usa, 1926, MGM Production
265. Directed by Fred Niblo,
who replaced Mauritz Stiller.
Photographed by Bertram
Longworth. Scenario
Dorothy Farnum.
Cinematographer Tony
Gaudio. With Greta Garbo,
Antonio Moreno, Roy
D'Arcy, Marc McDermott,
Lionel Barrymore, Virginia
Brown Faire, Armand Kaliz,
Alys Murrell.

Flesh and the Devil
Usa, 1926, MGM
Production 282. Directed
by Clarence Brown.
Photographed by Bertram
Longworth. Scenario
Benjamin Glazer.
Cinematographer William
Daniels. With Greta Garbo,
John Gilbert, Lars Hanson,
Barbara Kent, William
Orlamond, George Fawcett,
Eugenie Besserer, Marc
McDermott.

Love
Usa, 1927, MGM Production
310. Directed by Edmund
Goulding. Photographed
by Williams Grimes.
Cinematographer Williams
Daniels. With Greta Garbo,
John Gilbert, George
Fawcett, Emily Fitzroy,
Brandon Hurst, Philippe
de Lacy.

The Divine Woman
Usa, 1928, MGM Production
332. Directed by Victor
Seaastrome. Photographed
by Milton Brown. Scenario
Dorothy Farnum.
Cinematographer Oliver
Marsh. With Greta Garbo,
Lars Hanson, Lowell
Sherman, Polly Moran,
Dorothy Cumming, John
Mack Brown, Cesare
Gravina, Paulette Duval.

The Mysterious Lady
Usa, 1928, MGM
Production 374. Directed by
Fred Niblo. Photographed by
James Manatt. Scenario Bess
Meredyth. Cinematographer
Williams Daniels.
With Greta Garbo,
Conrad Nagel, Gustav von
Seyffertitz, Edward Connelly,
Albert Pollet, Richard
Alexander.

A Woman Of Affairs
Usa, 1928, MGM Production
380. Directed by Clarence
Brown. Photographed by
James Manatt. Scenario Bess
Meredyth. Cinematographer
Williams Daniels. With Greta
Garbo, John Gilbert, Lewis
Stone, John Mack Brown,
Douglas Fairsbanks Jr.,
Hobart Bosworth, Dorothy
Sebastian.

Wild Orchids
Usa, 1929, MGM
Production 353. Directed
by Sydney Franklin.
Photographed by James
Manatt. Scenario Hans Kraly,
Richard Schayer and Willis
Goldbeck. Cinematographer
William Daniels. With Greta
Garbo, Nils Asther, John
Mack Brown, Dorothy
Sebastian, Lane Chandler,
Robert Castle, Mahlon
Hamilton, Kathlyn
Williams.

The Single Standard
Usa, 1929, MGM Production
430. Directed
by John S. Robertson.
Photographed by James
Manatt. Scenario Josephine
Lovett. Cinematographer
Oliver Marsh. With Greta
Garbo, Nils Asther, John
Mack Brown, Dorothy
Sebastian, Lane Chandler,
Robert Castle, Mahlon
Hamilton, Kathlyn Williams.

The Kiss
Usa, 1929, MGM Production
440. Directed
by Jacques Feyder.
Photographed by Milton
Brown. Scenario, Hans Kraly.
Cinematographer William
Daniels. With Greta Garbo,
Conrad Nagel, Anders
Randolf, Holmes Herbert,
Lew Ayres, George Davis.

Anna Christie
Usa, 1930, MGM Production
456. Directed
by Clarence Brown.
Photographed by Milton
Brown. Scenario Frances
Marion. Cinematographer
William Daniels. With Greta
Garbo, Charles Bickford
Marie Dressler, George F.
Marion, James T. Mack, Lee
Phelps.

Romance
Usa, 1930, MGM Production
489. Directed by Clarence
Brown. Photographed by
Milton Brown. Scenario Bess
Meredyth and Edwin Justus
Mayer. Cinematographer
William Daniels. With Greta
Garbo, Lewis Stone, Gavin
Gordon, Elliott Nugent,
Florence Lake, Clara
Blandick, Henry Armetta.

Inspiration
Usa, 1931, MGM Production
476. Directed by Clarence
Brown. Photographed by
Milton Brown. Scenario
Gene Markey.
Cinematographer William
Daniels. With Greta Garbo,
Robert Montgomery, Lewis
Stone, Marjorie Rambeau,
Judith Vosselli, Beryl Mercer,
John Miljan, Edwin Maxwell.

**Susan Lenox: Her Fall
and Rise**
Usa, 1931, MGM Production
561. Directed by Robert
Z. Leonard. Photographed
by Milton Brown. Scenario,
Wanda Tuchock.
Cinematographer William
Daniels. With Greta Garbo,
Clark Gable, Jean Hersholt,
John Miljan, Alan Hale, Hale
Hamilton, Hilda Vaugh,
Russel Simpson.

Mata Hari
Usa, 1931, MGM Production
603. Directed
by George Fitzmaurice.
Photographed by Milton
Brown. Scenario Benjiamin
Glazer. Cinematographer
William Daniels. With Greta
Garbo, Ramon Navarro,
Lionel Barrymore, Lewis
Stone, C.Henry Gordon,
Karen Morley, Alec B.
Francis, Blanche Frederici.

Grand Hotel
Usa, 1932, MGM
Productions 603. Directed
by Edmund Goulding.
Photographed by Milton
Brown, Fred Archer, George
Hurrell. Scenario, William
A. Drake. Cinematographer
William Daniels. With Greta
Garbo, John Barrymore, Joan
Crawford, Wallace Beery,
Lionel Barrymore, Jean
Hersholt, Robert McWade,
Purnell B. Pratt.

As You Desire Me
Usa, 1932, MGM Production

BIBLIOGRAPHY

615. Directed by George Fitzmaurice. Scenario by Gene Markey. Cinematographer William Daniels. With Greta Garbo, Melvyn Douglas, Eric Von Stroheim, Owen Moore, Hedda Hopper, Rafaela Ottiano, Warburton Gamble, Albert Conti.

Queen Christina
Usa, 1933, MGM Production 688. Directed by Rouben Mamoulian. Photographed by Milton Brown. Scenario Salka Viertel. Cinematographer William Daniels. With Greta Garbo, John Gilbert, Ian Keith, Lewis Stone, Elizabeth Young, C. Aubrey Smith, Reginald Owen, Georges Renenvent.

The Painted Veil
Usa, 1934, MGM Production 776. Directed by Richard Boleslawski. Photographed by Milton Brown. Scenario John Meehan, Salka Viertel and Edith Fitzgerald. Cinematographer William Daniels. With Greta Garbo, Herbert Marshall, George Brent, Warner Oland, Jean Hersholt, Beulah Bondi, Katherine Alexander, Cecilia Parker.

Anna Karenina
Usa, 1935, MGM Production 815. Directed by Clarence Brown. Photographed by William Grimes. Scenario by Clemence Dane, Salka Viertel and S.N. Behrman. Cinematographer William Daniels. With Greta Garbo, Fredric March, Freddie Batholomew, Maureen O'Sullivan, May Robson, Basil Rathbone, Reginald Owen, Reginald Denny.

Camille
Usa, 1937, MGM Production 938. Directed by George Cukor. Photographed by William Grimes. Scenario Zoe Akins, Cinematographers William Daniels, Karl Freund. With Greta Garbo, Robert Taylor, Lionel Barrymore, Elizabeth Allan, Jessie Ralph, Henry Daniell, Leonore Ulric, Laura Hope Crews, Rex O'Malley.

Conquest
Usa, 1937, MGM Production 983. Directed by Clarence Brown. Photographed by William Grimes. Scenario Samuel Hoffenstein. Cinematographer Karl Freund. With Greta Garbo, Charles Boyer, Reginald Owen, Alan Marshal, Henry Stephenson, Leif Erickson, Dame May Whitty, C. Henry Gordon, Maria Ouspenskaya.

Ninotchka
Usa, 1939, MGM Production. Directed by Ernst Lubitsch. Photographed by William Grimes. Scenario Charles Charles Brackett, Billy Wilder, Walter Reisch. Cinematographer William Daniels. With Greta Garbo, Melvyn Douglas, Ina Claire, Sig Rumann, Felix Bressart, Alexander Granach, Bela Lugosi, Gregory Gaye.

Two-Faced Woman
Usa, 1941, MGM Production. Directed by George Cukor. Photographed by William Grimes. Scenario S.N. Behrman Salka Viertel and George Oppenheimer. Cinematographer Joseph Ruttenberg. With Greta Garbo, Melvyn Douglas, Constance Bennett, Roland Young, Robert Sterling, Ruth Gordon, Frances Carson, Bob Alton.

Alain Masson, *L'image et la parole. L'avénement du cinéma parlant,* Paris: La Différence, 1989.

Alexandre Vassiliev, *Beauty in Exile, The Artists, Models, and Nobility Who Fled The Russian Revolution*, New York: Harry N. Abrams, 2000.

Antoni Gronowicz, *Garbo her Story*, New York: Simon and Schuster, 1990.

Antoni Gronowicz, *Garbo la sua storia*, Milan: Frassinelli, 2005.

Béla Balázs, *Il film. Evoluzione ed essenza di un'arte nuova*, Turin: Einaudi, 1955.

Cecil Beaton, *Lo specchio della moda*, Milan: Garzanti, 1955.

Christian Esquevin, *Adrian Silver Screen to Custom Label*, New York: The Monacelli Press, Inc., 2008.

Cristina Jandelli, *Breve storia del divismo cinematografico*, Venice: Marsilio, 2007.

David Bordwell, Janet Staiger, Kristin Thompson, *The Classical Hollywood Cinema. Film Style &Mode of Production 1917-1960*, New York: Columbia University Press, 1985.

Deborah Nadoolman Landis, *Dressed. A century of Hollywood Costume Design*, New York: Collins, 2007.

Edward Maeder, *Hollywood and History: Costume Design in Film*, Los Angeles County Museum, New York: Thames and Hudson, 1987.

Giuseppe Marotta, *L'oro di Hollywood*, Milan: Bompiani, 1956.

Graydon Carter, David Friend, *Vanity Fair's Hollywood*, New York: Viking Studio, 2000.

Howard Gutner, *Gowns by Adrian The MGM Years 1928–1941*, New York: Harry N. Abrams, 2001.

Irene Brin, *Usi e costumi 1920–1940*, Palermo: Sellerio, 1989.

Jacqueline Nacache, *L'acteur de cinéma*, Paris: Armand Colin, 2005.

Jean Lacouture, *Divina. Il racconto della vita di Greta Garbo*, Rome: Edizioni e/o, 2005.

John Bainbridge, *Garbo*, New York, Chicago, San Francisco: Holt, Rinehart and Winston, 1955.

Karen Swenson, *Greta Garbo. A life apart*, New York: A Lisa DrewBook/ Scribner, 1997.

Klaus Mann, *La svolta, un padre scomodo, la Germania nazista: uno scrittore si racconta*, Milan: Il Saggiatore, 2001.

Kohle Yohannan, *Valentina American Couture and the Cult of Celebrity*, New York: Rizzoli Usa, 2009.

Maria Grazia Bevilacqua, *Greta Garbo, un viaggio alla ricerca della Divina*, Milan: Baldini Castoldi Dalai, 2003.

Mark A. Vieira, *Greta Garbo a cinematic Legacy*, New York: Harry N. Abrams, 2005.

Pietro Bianchi, *Maestri del Cinema*, Milan: Garzanti, 1972.

Regine e Peter W. Engelmeier, *Fashion in Film*, Munich: Prestel Verlag, 1997.

Revolution and Influenced the World of Fashion, New York: Harry N. Abrams, 2000.

Richard Dyer, *Star* (1979),

Turin: Edizioni Kaplan, 2003.

Robert Dance, Bruce Robertson, *Ruth Harriet Louise and Hollywood Glamour Photography*, Berkeley, Los Angeles London: University of California Press, 2002.

Roberto Campari, *Miti e Stelle del Cinema*, Rome-Bari: Laterza, 1985.

Roland Barthes, *Miti d'oggi*, Turin: Einaudi, 1974.

Salvatore Ferragamo, *Shoemaker of Dreams*, London: George G. Harrap & Co., 1957.

Scott Reisfield, Robert Dance, *Garbo Portraits of her Private Collection*, New York: Rizzoli Usa, 2005.

Sofia Gnoli, *Moda e cinema. La magia dell'abito sul grande schermo*, Città di Castello: Edimond, 2002.

Sotheby's, *The Greta Garbo Collection*, Toppan Graphics, Inc., Usa, 1990.

Vogue (USA), 1 September 1938, p. 83.

Vogue (USA), 15 October 1933, pp. 54, 74.

Vogue's Advance Trade Edition (USA), 15 December 1933, p. III.